BOLLINGEN SERIES XXXV · 36

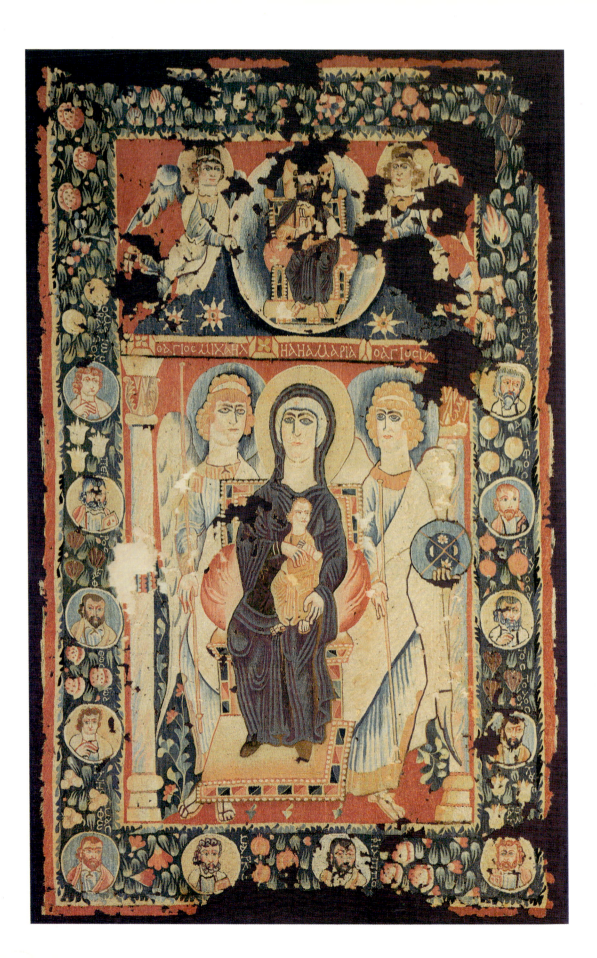

JAROSLAV PELIKAN

IMAGO DEI

THE BYZANTINE
APOLOGIA
FOR ICONS

The A. W. Mellon Lectures
in the Fine Arts, 1987
The National Gallery of Art
Washington, D.C.
Bollingen Series XXXV · 36

Princeton University Press
1990

The A. W. Mellon Lectures in the Fine Arts

DELIVERED AT THE NATIONAL GALLERY OF ART, WASHINGTON, D.C.

Copyright © 1990 by the Trustees of the National Gallery of Art, Washington, D.C.
Published by Princeton University Press, 41 William Street, Princeton, New Jersey 08540

This is the thirty-sixth volume of the A. W. Mellon Lectures in the Fine Arts,
which are delivered annually at the National Gallery of Art, Washington. The volumes of
lectures constitute Number XXXV in Bollingen Series, sponsored by Bollingen Foundation.

Manufactured and published in Great Britain by Yale University Press

Library of Congress Cataloging-in-Publication Data

Pelikan, Jaroslav Jan, 1923–
 Imago Dei: the Byzantine apologia for icons / Jaroslav Pelikan.
 p. cm. — (The A. W. Mellon lectures in the fine arts: 1987)
 (Bollingen series: XXXV. 36)
 Includes bibliographical references.
 ISBN 0-691-09970-7 (alk. paper)
 1. Iconoclasm. 2. Icons—Cult—History of doctrines—Early
church, ca. 30-600. 3. Icons—Cult—History of doctrines—Middle
Ages, 600-1500. 4. Icons—Cult—Byzantine Empire. 5. Byzantine
Empire—Church history. I. Title. II. Series. III. Series:
Bollingen series: 35. 36.
BR238.P44 1990
246′.53′09021—dc20
 90-36835
 CIP

1. (frontispiece) *Icon of the Virgin*. Egypt, Byzantine period, sixth century. Cleveland Museum of Art, Ohio

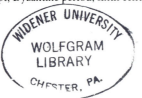

Contents

To my son Michael—
like his namesake (Figs. 48–50),
courageous and strong

Preface

It is somewhat unusual, but by no means unprecedented, for the Andrew W. Mellon Lectures in the Fine Arts at the National Gallery of Art to be given by a scholar who is not a historian of art. As students of medieval thought, Jacques Maritain, the first Mellon Lecturer (*Creative Intuition in Art and Poetry*, 1952), and his fellow Thomist, Etienne Gilson (*Painting and Reality*, 1955), were as a matter of fact closer to my own scholarly field than they were to art history. But they devoted their Mellon Lectures to the correlation between their philosophical reflections and the issues of aesthetics. Coming at some of the same issues from the perspective of the medieval Greek tradition rather than the Latin, I have been able to take advantage of the theological-philosophical literature produced by the Iconoclastic controversies, which addressed many of those questions more explicitly than Western Scholasticism did. I have also benefited greatly from the work of the other scholars listed in my bibliography, including in particular distinguished Byzantinists Western as well as Eastern. Above all, I have come to recognize yet once more in the course of this study how much I owe my late mentor in Byzantine and Russian theology, Father Georges V. Florovsky.

In placing the Byzantine dispute over the legitimacy of icons into the framework of the history of Christian theology, I have needed to draw lines of development both backwards and forwards, but chiefly backwards into the doctrinal history of the patristic era. Rather than identifying at each juncture the scholarly discussions of that history to which a reader may want to turn for more detail, I have included such discussions in the bibliography, including some of my own, especially my five-volume history of the development of Christian doctrine, *The Christian Tradition*. The tables of contents and indexes of such works will make it possible to learn about

the history of the trinitarian and christological doctrines by means of which all the various parties in the Iconoclastic controversies formulated their positions on the question of images. Also with the interest of the reader in mind, I have transliterated all words in the Greek and Cyrillic alphabets, and in the bibliography and notes have tried to concentrate as much as possible on works of scholarship that have appeared in Western languages. Most of the biblical quotations are from *The New English Bible*; translations of other works, where they exist, are indicated in the notes (although I have sometimes adapted or revised them), while the remaining translations are my own.

It was J. Carter Brown, Director of the National Gallery of Art, and Henry A. Millon, Dean of its Center for Advanced Study in the Visual Arts, who invited me to deliver the Mellon Lectures. The hospitality and friendship that they and their colleagues at the gallery extended to me throughout the preparation, delivery, and publication of the lectures will stay with me always, as will the gracious reception accorded me by my Sunday afternoon audiences in Washington. Over the past several decades I have learned much from my visits to the Dumbarton Oaks Center, where at various times Francis Dvornik, Ihor Ševčenko, John Meyendorff, Giles Constable, and William Loerke have shared with me their profound understanding of Byzantine culture, as has my Yale colleague, Deno Geanakoplos. On my visits to such past and present centers of Eastern Orthodox iconography as Turkey, Greece, the Soviet Union, Yugoslavia, and Bulgaria I have had the opportunity to see the icons in their native habitat. And I owe a special debt of gratitude to the Cleveland Museum of Art, custodian of the *Icon of the Virgin*: to its Director Emeritus, Sherman Lee, who gave me my first opportunity to become acquainted with the icon; to its current Director, Evan Turner, who facilitated my correspondence and my visits; and especially to Anne E. Wardwell, Curator of Textiles, who answered my many questions and arranged for me to obtain photographs of the tapestry. As a joint publication of Princeton University Press and Yale University Press London, this book has received the tender loving attention of Eric Van Tassel and Elizabeth Powers at Princeton and of John Nicoll and Faith Hart at Yale in London.

Illustrations

ix

Abbreviations

ACW	*Ancient Christian Writers*, ed. Johannes Quasten and Joseph C. Plumpe. Westminster, Maryland: Newman Press, 1946–.
Alberigo	Alberigo, Joseph, et al., eds. *Conciliorum oecumenicorum decreta*. 3d ed. Bologna: Istituto per le scienze religiose, 1973.
ANF	*The Ante-Nicene Fathers*. 10 vols. Reprint ed. Grand Rapids, Mich.: Wm. B. Eerdmans Publishing Company, 1956.
Attwater	Attwater, Donald, ed. *Eastern Catholic Worship*. New York: Devin-Adair Company, 1945.
Bauer–Gingrich	Bauer, Walter; Gingrich, F. Wilbur; et al., eds. *A Greek-English Lexicon of the New Testament and Other Early Christian Literature*. 2d ed. Chicago: The University of Chicago Press, 1979.
Brightman	Brightman, Frank Edward, ed. *Liturgies Eastern and Western*. Vol. 1: *Eastern Liturgies*. Oxford: Clarendon Press, 1896.
CCSL	*Corpus Christianorum: Series Latina*. Turnhout, Belgium: Typographi Brepols, 1953–.
Chadwick	Chadwick, Henry, ed. and tr. *Origen: "Contra Celsum."* Cambridge: Cambridge University Press, 1953.
CSEL	*Corpus scriptorum ecclesiasticorum latinorum*. Vienna: Apud C. Geroldi, 1866–.
CWS	*The Classics of Western Spirituality*. New York: Paulist Press, 1978–.
Deferrari–Barry	Deferrari, Roy J., and Barry, M. Inviolata, eds. *A Lexicon of St. Thomas Aquinas Based on the "Summa Theologica" and Selected Passages of His Other Works*. Washington, D.C.: Catholic University of America Press, 1948.
Denzinger	Denzinger, Heinrich, ed. *Enchiridion symbolorum definitionum et declarationum de rebus fidei et morum*. 36th ed. Barcelona, Freiburg, and Rome: Herder, 1976.
DTC	*Dictionnaire de théologie catholique*. 15 vols. and indexes. Paris: Letouzey et Ané, 1909–72.
GCS	*Die griechischen christlichen Schriftsteller der ersten drei Jahrhunderte*. Leipzig and Berlin: Akademie-Verlag, 1897–.
Geanakoplos	Geanakoplos, Deno John, ed. *Byzantium: Church, Society, and Civilization Seen through Contemporary Eyes*. Chicago: The University of Chicago Press, 1984.
Harvey	Harvey, W. Wigan, ed. Irenaeus of Lyons. *Adversus Haereses*. 2 vols. Cambridge: Cambridge University Press, 1857.
Lampe	Lampe, Geoffrey W. H., ed. *A Patristic Greek Lexicon*. Oxford: Clarendon Press, 1961.
LCL	*Loeb Classical Library*. Cambridge, Mass.: Harvard University Press, 1912–.

LTK	*Lexikon für Theologie und Kirche.* 2d ed. 10 vols. and index. Freiburg: Herder, 1957–65.
Liddell–Scott–Jones	Liddell, Henry George; Scott, Robert; and Jones, Henry Stuart, eds. *A Greek-English Lexicon.* 9th ed. Oxford: Clarendon Press, 1940.
Lightfoot	Lightfoot, Joseph Barber, ed. *The Apostolic Fathers.* London: Macmillan and Company, 1893.
Mango	Mango, Cyril. *The Art of the Byzantine Empire, 312–1453.* Medieval Academy Reprints. Toronto: University of Toronto Press, 1986.
Mansi	Mansi, J. D., ed. *Sacrorum conciliorum nova et amplissima collectio.* 57 vols. Florence: A. Zatta et al., 1759–1927.
Müller	Müller, Guido, ed. *Lexicon Athanasianum.* Berlin: Walter de Gruyter, 1952.
NPNF-I	*The Nicene and Post-Nicene Fathers of the Christian Church.* 1st ser. 12 vols. Reprint ed. Grand Rapids, Mich.: Wm. B. Eerdmans Publishing Company, 1979.
NPNF-II	*The Nicene and Post-Nicene Fathers of the Christian Church.* 2d ser. 14 vols. Reprint ed. Grand Rapids, Mich.: Wm. B. Eerdmans Publishing Company, 1979.
OED	*The Oxford English Dictionary.* 16 vols. Oxford: Oxford University Press, 1933–86.
PG	*Patrologia Graeca.* 162 vols. Paris: J. P. Migne, 1857–66.
PL	*Patrologia Latina.* 221 vols. Paris: J. P. Migne, 1844–64.
Prav. Slov.	*Polnyj pravoslavnyj bogoslovskyj enciklopedičeskyj slovar'* [Complete encyclopedic dictionary of Eastern Orthodoxy]. 2 vols. (1913); London: Variorum Reprints, 1971.
Preger	Preger, Th., ed. *Scriptores originum Constantinopolitanarum.* Leipzig: B. G. Teubner, 1907.
Roth	Roth, Catharine P., ed. and tr. St. Theodore the Studite. *On the Holy Icons.* Crestwood, N.Y.: St. Vladimir's Seminary Press, 1981.
Sahas	Sahas, Daniel J., ed. and tr. *Icon and Logos: Sources in Eighth-Century Iconoclasm.* Toronto: University of Toronto Press, 1986.
Sophocles	Sophocles, E. A., ed. *Greek Lexicon of the Roman and Byzantine Periods.* Boston: Little, Brown and Company, 1870.

The Idea in the Image

The historical problem with which this book deals can be identified by juxtaposing two statements about the legitimacy of representational religious art, both of them quotations from works by Greek authors. They were written five centuries or so apart:

> There are some people who find fault with us because we bow down before [*proskynousi*] and worship images. . . . Certain events that actually took place and that were seen by human beings have been written down for the remembrance and instruction of those of us who were not alive at that time, in order that, though we did not see them, we may still obtain the benefit of them . . . by hearing and believing them. But since not everyone is literate, nor does everyone have time for reading, our ancestors gave their permission to portray these same events in the form of images, as acts of heroic excellence [*aristeia*].[1]

And these were the images of heroic excellence whose "worship [*proskynēsis*]" he was defending against criticism by those who regarded it as wrong.

A striking statement of such criticism of any and all image-worship was the following:

> Christians and Jews are led to avoid temples and altars and images by the command: . . . "You shall not make a carved image for yourself nor the likeness of anything in the heavens above, or on the earth below, or in the waters under the earth. You shall not bow down to them or

1. John of Damascus *The Orthodox Faith* IV.16 (PG 94:1168–72; *NPNF*-II 9:88).

worship them [*ou proskynēseis autois, ou de mē latreuseis autois*]."[2] ... And not only do they avoid [such worship, *proskynēsis*, of images], but when necessary they readily come to the point of death to avoid defiling their conception of the God of the universe by any act of this kind contrary to his law.[3]

The second quotation comes from the greatest Christian thinker in the first three centuries of the history of the church, perhaps in all of Christian history, Origen of Alexandria, replying in the third century to the pagan philosopher Celsus, who had criticized Jews and Christians for their hostility to images. The first quotation, however, does not come from Celsus, nor from any other pagan philosopher before him, but from a Christian writer who came five centuries after Origen; it appears in a book entitled *The Orthodox Faith*, by the eighth-century theologian, John of Damascus, who bears, in the Latin West no less than in the Greek East, the title of "Doctor of the Church."

The two quotations, then, are in reverse chronological order, and the point of the second is actually not, despite superficial appearances, a reply to the point of the first. It is the purpose of this book to explore that puzzling circumstance: that a faith which began by attacking the worship of images and by resisting it to the death (as Origen said, and as he went on to prove by his own life and death) eventually embraced such worship and turned prohibition into permission—and permission into command. This it did during the Iconoclastic controversies of the eighth and ninth centuries, whose high point came in A.D. 787, when the Second Council of Nicaea restored the cult of images in the church and declared the worship of them to be orthodox and God-pleasing.[4] In the course of those controversies, Byzantine thought articulated its characteristic ideas about an entire range of issues, from politics to aesthetics to dogmatics. The conflict was, in the words of Adolf von Harnack, "probably the greatest and the most unexpected crisis through which the Byzantine church ever had to pass."[5] Therefore the apologia of the Byzantine church for the icons was nothing less than what another modern Western scholar has called it: "a battle of the Greek church for its distinctive identity and for its freedom."[6]

2. Ex. 20:4–5 (LXX).
3. Origen *Against Celsus* VII.64 (*GCS* 2:214; Chadwick 448).
4. Boespflug and Lossky 1987 is a collection of commemorative essays to mark the twelve-hundredth anniversary of the Second Council of Nicaea.
5. Harnack 1931, 2:482.
6. Schwarzlose 1890.

The ideas and the apologia deserve historical attention in their own right. This essay on icons, then, is not a study in the history of images but in the history of ideas—though of ideas about images and about their legitimacy. Vladimir Nabokov, himself the product of a Russian culture in which icons occupied a central position, drew the contrast between ideas and images in characteristically vivid terms. He defined literary imagery as "the evocation, by means of words, of something that is meant to appeal to the reader's sense of color, or sense of outline, or sense of sound, or sense of movement, or any other sense of perception, in such a way as to impress upon his mind a picture of fictitious life that becomes to him as living as any personal recollection."[7] For Nabokov, such imagery was primary. Commenting on the words of Lyovin in Tolstoy's *Anna Karenina*, "I have only found out what I knew all along. I have been set free from falsity, I have found the Master," Nabokov urged:

> After all we should always bear in mind that literature is not a pattern of *ideas* but a pattern of *images*. Ideas do not matter much in comparison to a book's imagery and magic. What interests us here is not what Lyovin thought, or what Leo [Tolstoy] thought, but that little bug that expresses so neatly the turn, the switch, the gesture of thought. . . . Let us keep an eye on the imagery and leave the ideas to pile up as they please. The word, the expression, the image is the true function of literature. *Not* ideas.[8]

Whatever may be the validity of that judgment as applied to literature, and specifically to Tolstoy, it does not do justice to the intricate relation between image and idea in philosophy and theology, above all in Byzantine (or, for that matter, Russian) philosophy and theology, for which, as another modern interpreter has put it, "the interior space of the church" was to be seen as the "carrier of an idea."[9] The interrelation between image and idea, as each of these served to define the Byzantine and Russian icon, was expressed by John of Damascus when, in his taxonomy of "images," he defined as an "image [*eikōn*]," in the second sense of the word, "the [preexistent] idea in God of the things that are to come to be through God [*hē en tōi theōi tōn hyp' autou esomenōn ennoia*]."[10] The inseparability of the "image [*eikōn*]" and the "idea [*ennoia*]" in the icon is the subject matter of this book.

7. Nabokov 1981, 199.
8. Nabokov 1981, 166; Nabokov's italics.
9. Michelis 1977, 133, quoting Joseph Strzygowski.
10. John of Damascus *Orations on the Holy Icons* III.19 (*PG* 94:1340).

3

As its bibliography indicates, however, this book is deeply indebted to the works of scholars in the history of art and has drawn upon their insights throughout. It will also be evident in the illustrations from icons, chiefly Byzantine but occasionally also Slavic, that this theological-philosophical analysis is likewise informed by the specific forms of the icons, also by later icons but in a special way by the forms of "the icons before Iconoclasm."[11] There are, to be sure, very few of these surviving. In 1955 Ernst Kitzinger, a leading authority on them, counted fourteen, a figure that has been frequently cited.[12] Some of the most important of these were preserved in the Monastery of Saint Catherine on Mount Sinai, where "from the 6th century on, i.e. not long after icons were invented and soon thereafter introduced into the service of the church, every century is represented right down to modern times."[13] Recently at least two additional icons have joined the roster of pre-Iconoclastic survivals. One of them is, not altogether surprisingly, from the Pantheon in Rome, while the other is from Santa Maria di Trastevere also in Rome.[14]

Yet another such survival is the sixth-century wool tapestry *Icon of the Virgin* in the collection of the Cleveland Museum of Art (Fig. 1). It measures 110 by 178 centimeters and was acquired by the Cleveland Museum from a private Egyptian owner in 1968.[15] There are two "zones" on the icon, the total area of the lower being more than four times that of the upper. The upper zone of the tapestry, which is badly damaged, presents the figure of Christ in Majesty, seated on a throne. He is flanked by two angels. The lower zone, also damaged but far better preserved than the upper, presents the Virgin Mary in Majesty, also on a throne and also flanked by two angels; the Christ Child is on her lap. She is identified by the Greek inscription: "*hē hēa* [*hagia*] *Maria*, Saint Mary." The angel on her left, the viewer's right, is labeled: "*ho hagios Ga*[*briēl*], Saint Gabriel"; the one on her left, "*ho hagios Michaēl*, Saint Michael." On the three sides not bordering the upper zone there appear twelve medallions, each labeled with the name of an apostle/evangelist. Those on the right side, reading from top to bottom, are: "*Andreas*, Andrew [printed in mirror reverse]; [*M*]*atteos* [*Maththaios*], Matthew; *Paulos atostolos* [*apostolos*], Paul the apostle; *Loukas*, Luke." Those on

11. Baynes 1951, 93–106.
12. Kitzinger 1955, 139.
13. Kurt Weitzmann in Galey 1980, 90.
14. Bertelli 1961a and 1961b.
15. Shepherd 1969 is still the most detailed description available, which has guided me in my own research into this unique relic.

the left side are: "*Bareolomaiōs* [*Bartholomaios*], Bartholomew; *Petros*, Peter; *Matheōs* [*Maththias, Matthias*], Matthias; *Iōannēs*, John." The bottom row, reading from left to right, has: "*Thōmas*, Thomas; *Marko*[*s*], Mark; *Philip-po*[*s*], Philip; *Iakō*[*bos*], James."

This is the only pre-Iconoclastic icon known to be in North America. In its composition and motifs it manages to combine many of the ideas that are determinative for the Iconoclastic controversy, fundamental to the Byzantine apologia for the icons, and central to the Christian culture of the Eastern Roman Empire and its daughter Christian cultures in Russia, the Balkans, and the Middle East, including Byzantine Egypt, where the tapestry was probably woven and from where it came to Cleveland. Therefore this *Icon of the Virgin* also provides the iconographic "text" for this volume.

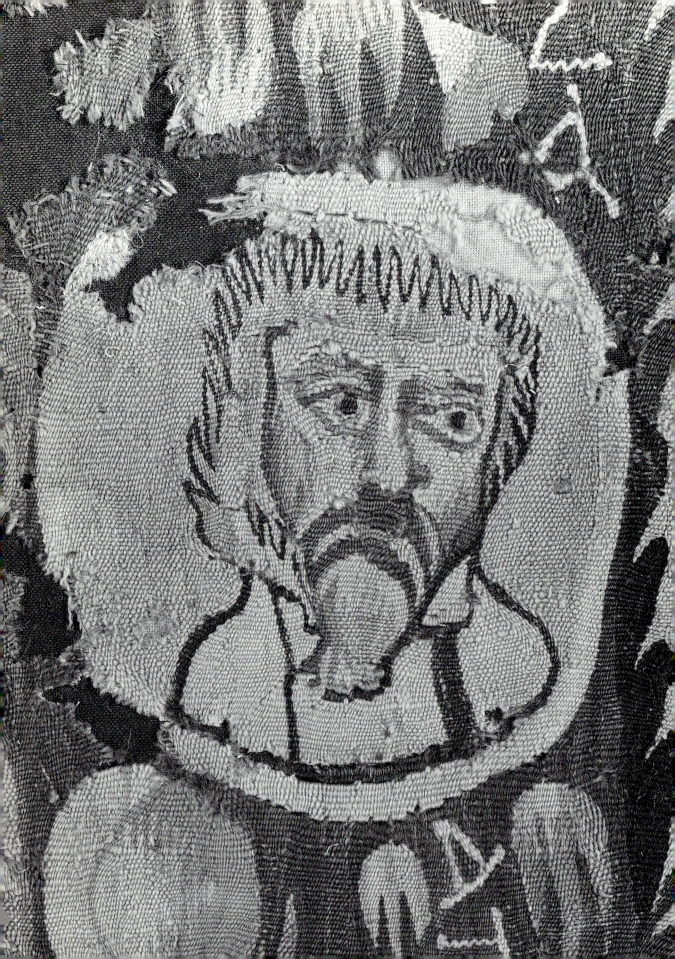

THE CONTEXT

Religion and "Realpolitik" Byzantine Style

Whatever else it may have been, the Byzantine conflict over icons was a political struggle. In fact, Iconoclasm was, in the words of one historian, "one of the greatest political and cultural crises of Byzantium, the greatest one between the Monophysite trouble and the Latin invasion of Constantinople in 1204."[1] It is the central thesis of this book that the conflict over Iconoclasm was always much more than a political struggle; at the same time, it was certainly never less than political. Therefore the historian of Iconoclasm must always remember that the identification of the "specifically religious" issues that were at stake in the conflict and of the "real theological problems" underlying them in this "real struggle for 'Orthodoxy'"—which is the subject of this book—should not be permitted to "deny or minimize the political and social aspects of the conflict." For it bears repeating that "all doctrinal movements in the Early Church (and possibly, all doctrinal and philosophical movements) were, in some sense, 'politically involved.'" But then it must be added that "in the Iconoclastic conflict the political strife itself had a very definite theological connotation and the 'Caesaropapalism' of the Iconoclastic emperors was itself a kind of theological doctrine."[2]

All the components of a political struggle were present in this crisis. For Iconoclasm can be interpreted as "from its beginning an attack upon the visible representation of the *Civitas Dei* on this earth." This was true in an obvious way, because any attack upon icons "was *ipso facto* an attack against the Church." But beyond that, "the emperors showed unmistakably

1. Ladner 1940, 127.
2. Florovsky 1972, 2:102–03.

2. Medallion of Saint Andrew, detail from *Icon of the Virgin*

that even in maintaining the belief in the supreme, supernatural government of Christ, they did not wish to permit on this earth any other but their own image or more exactly the imagery of their own imperial natural world."[3] The Byzantine emperors who were opponents of images strove to abolish them by absolute decree; and then, by a decree no less absolute, the Byzantine empresses who were defenders of images restored them. Or, as one modern popular account has put it in somewhat overblown language, "the icons proved victorious, and their victory was lasting. Six Emperors had fought against them, and two Empresses had led them home in triumph. This was an affray between the masculine and the feminine. Against the immaterial principle of maleness there had arisen and had conquered— eternal, timeless, and world–wide—the essence of womanhood, the divinity of spiritualized matter."[4] A more balanced summary appears in another general account: "The premature reformation, twice attempted, and each time successful as a government measure, never laid hold of the Church, and ultimately failed entirely, the old order re-establishing itself as completely as though nothing had ever happened to interfere with it."[5] At the same time, scholars are obliged to acknowledge that "while there were good reasons for the outbreak of Iconoclasm in the beginning of the eighth century, the historian is at a loss to account for its collapse in 786."[6]

As the icons had been omnipresent throughout Byzantine society, so the effort to uproot them permeated the society and the bureaucracy. Taxation and expropriation were instruments of government policy against the owners of images and against the artists who had created them. The army and the secret police carried out the imperial legislation, whatever it may have been at the time, with thorough and often ruthless vigor. Demagogues on both sides whipped up the passions of the common people, for or against (though especially for) the icons. Prelates on both sides curried the favor of their political patrons, while scheming to accomplish their own political purposes. Politicians on both sides also schemed, and often enough all too successfully, to co-opt theologians and ecclesiastics as comrades-in-arms against their own fellow clergy. Pamphleteers, both clerical and lay, composed extensive diatribes, in which high-flown metaphysical speculation mingled with vicious personal invective. Everyone decried the interference of magistrates and politicians in the affairs of the church—unless, of course,

3. Ladner 1940, 134.
4. Diener 1938, 152.
5. Adeney 1932, 202.
6. Alexander 1958, 19–20.

those magistrates and politicians were interfering in the interest of the "right" side. Thus it was true, but true on both sides of the controversy, that *Realpolitik* and religion were often indistinguishably intertwined. For it has been well said that "if reassertion of the absoluteness of the monarch's authority on earth did figure as a central issue in Iconoclasm, it could do so only because the emperors of the preceding era had promoted the worship of images as a means of emphasizing their own subordination to a transcendental power."[7]

But it was ever thus. From the shamanism of primitive tribes to the dramatic events being reported out of the Near East or Northern Ireland or Poland on the front pages of today's newspaper, the relation between *Realpolitik* and religion has always been a major source of conflict as well as of ambiguity. It would seem that every system for regulating the coexistence of church and state—all the way across the spectrum, from the notion of "theocracy" through the metaphor of a "wall of separation" to the slogan of "the church of the catacombs" (whatever each of those three mottoes may have meant concretely for either party)—has carried advantages as well as disadvantages both for the state and for the church. As Edward Gibbon put it in one of his best-known epigrams near the beginning of the *Decline and Fall*, "the various modes of worship which prevailed in the Roman world were all considered by the people as equally true; by the philosopher as equally false; and by the magistrate as equally useful."[8] The failure of secularized moderns to pay sufficiently serious attention to the complexity of this problem can lead to a grave misunderstanding not only of religious faith but of political power as well. Whether or not one agrees with Ernst Troeltsch in positing "the dependence of the whole Christian world of thought and dogma on the fundamental sociological conditions, on the idea of fellowship which was dominant at any given time,"[9] it remains true that to understand either political power or religious faith, there are few inquiries more illuminating than a study of the history of church–state relations in various cultures.

Within that history, the relation between church and state in the Byzantine or Later Roman Empire—which Troeltsch, in a work on the history of Christian social teachings that fills more than a thousand pages, felt able to dismiss in just one page, and that under the title "Arrested Development

7. Kitzinger 1954, 128.
8. Gibbon 1896–1900, 1:28.
9. Troeltsch 1960, 2:994.

in the East"[10]—carries special fascination. The Roman papacy has lasted longer than Byzantium did, and it has certainly been both a political and a religious institution. But with that single exception, the Byzantine Empire must probably be regarded as the longest continuous political and religious experiment in the history of Christian civilization.[11] During an evolution of eleven and a quarter centuries from the transplantation of the capital of the Roman Empire to Byzantium by Emperor Constantine I in 330 to the conquest of Constantinople by the Turks in 1453 (a period of time approximately as long as that which separates us from the Carolingian era), the Byzantine style of ordering church and state was unique.[12] That experiment occupies an especially important place in the history of ideas. Far more than their contemporaries in the Latin West, the Greek-speaking Christians of the Eastern Roman Empire possessed in both religion and *Realpolitik* a special measure of self-consciousness and a reflective capacity that made their treatment of these issues not only interesting practically but challenging theoretically. Both in its political theory and in its dogmatics, Byzantine thought was deliberately continuing the philosophical speculation and the theological exposition that had come down to it from its dual heritage, Greek and Christian.

In the administrative structure of the empire, the icon-painting workshops maintained in Constantinople were part of the religious and cultural patronage system of the Byzantine emperor and of the Byzantine nobility. Therefore scholars have, naturally though sometimes mistakenly, tended to attribute to such workshops, or at any rate to "a master who participated in the traditions and in the methods of the school of Constantinople," the origin of almost any icon from any period that appeared to be Byzantine in its style.[13] A recent scholarly description of the patronage system for a later period in the history of the Byzantine Empire, bearing the title *Patronage in 13th Century Constantinople*,[14] would seem to apply in considerable measure to earlier centuries as well. In the exercise of their responsibility as patrons, the autocrats as well as the aristocrats of the Byzantine Empire brought artists to Constantinople from all over the Near East. Like so much of Byzantine politics and culture, this began already with the emperor Constantine.[15] As set forth in his letter to Bishop Macarius, his detailed attention

10. Troeltsch 1960, 1:213–14.
11. Bury 1958, 1:348–88, "Church and State," remains a useful introduction.
12. See Gelzer 1907, 57–141.
13. Berenson 1921–22, 292; Demus 1959.
14. Buchthal and Belting 1978.
15. Conant 1956, 1–48.

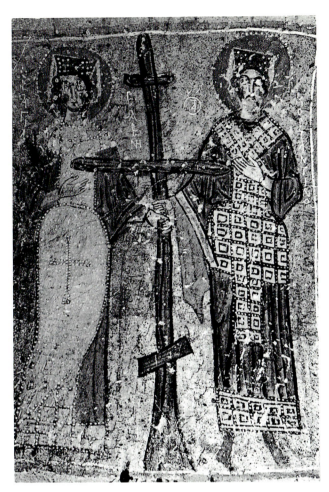

3. Fresco of Saints Constantine and Helena. Nevsehir, Turkey

to the construction of the Church of the Holy Sepulcher (or, as Eusebius of Caesarea called it, "the Church of Our Savior's Resurrection") at Jerusalem, including a provision for "abundant and liberal grants [to] make the work quite extraordinary in size and costliness," indeed "the finest in the world," was to serve as a model for his successors on the throne of New Rome.[16] Therefore the architectural patronage of the emperor Constantine and of his mother, Saint Helena, has received more attention, from their contemporaries and then from modern scholars, than has their support of the less monumental arts.[17] This concentration on architecture and the corresponding neglect of painting and mosaics create a crucial problem in and of themselves, because of the later disputes, both Byzantine and modern, over just when the use of images began in the church and over what role, if any, Constantine and Helena (Fig. 3) may have had in that development.

16. Eusebius *Life of Constantine* III.29–40 (*GCS* 7:91–95; *NPNF*-II 1:528–30; Mango 11–14).
17. See Heisenberg 1908, especially vol. 1, which deals with the patronage of the emperor and empress as it pertained to the Church of the Holy Sepulcher.

It is probably still correct to see "the recognition of Christianity as the state religion under Constantine" as the turning point in the artistic depiction of Christ, who had been the "thing from which men turn away their eyes" of which Isaiah spoke but who became instead the one who "surpass[es] all mankind in beauty" celebrated in the Psalm.[18] But it was in the continuation of Constantine's function as patron of the arts by the greatest of his successors, the emperor Justinian, that "Byzantine art found its definitive formula and at the same time attained its apogee."[19]

The work with which Justinian crowned his continuation of Constantine's patronage was the rebuilt Hagia Sophia at Constantinople, "the supreme achievement not only of Justinianic but of all Byzantine architecture."[20] For this massive undertaking, the emperor, "disregarding all considerations of expense, hastened to begin construction and raised craftsmen from the whole world."[21] Despite their panegyric and "semi-legendary" quality, the contemporary accounts of the project do make it clear that the emperor personally oversaw both the planning and the execution of Hagia Sophia, and did so in great detail.[22] Upon its completion, according to one of these accounts, the emperor could regard himself as the faithful follower not only of the first Christian emperor—who may have begun the edifice known as "the Great Church [*Megalē Ekklēsia*]"—but of an even greater monarch. On the basis of those accounts, Gibbon has, in the fortieth chapter of the *Decline and Fall*, vividly described Justinian's participation and the scene of the dedication of Hagia Sophia:

> [There were] ten thousand workmen, whose payment in pieces of fine silver was never delayed beyond the evening. The emperor himself, clad in a linen tunic, surveyed each day their rapid progress, and encouraged their diligence by his familiarity, his zeal, and his rewards. The new cathedral of St. Sophia was consecrated by the patriarch, five years, eleven months, and ten days from the first foundation; and, in the midst of the solemn festival, Justinian exclaimed with solemn vanity, "Glory be to God who hath thought me worthy to accomplish so great a work; I have vanquished thee, O Solomon [*Nenikēsa se, Solomōn*]!"[23]

18. Dobschütz 1899, 29, quoting Isa. 53:3 and Ps. 45:2.
19. Diehl 1936, 768.
20. C. Mango 1985, 59.
21. Procopius *On Buildings* I.i.23 (*LCL* 7:10; Mango 72).
22. There is a good selection from these accounts, in English translation and with helpful notes, in Mango 72–102.
23. Gibbon 1896–1900, 4:245.

4. Medallion of Saint Bartholomew, detail from *Icon of the Virgin*

5. (following page) Medallion of Saint Matthias, detail from *Icon of the Virgin*

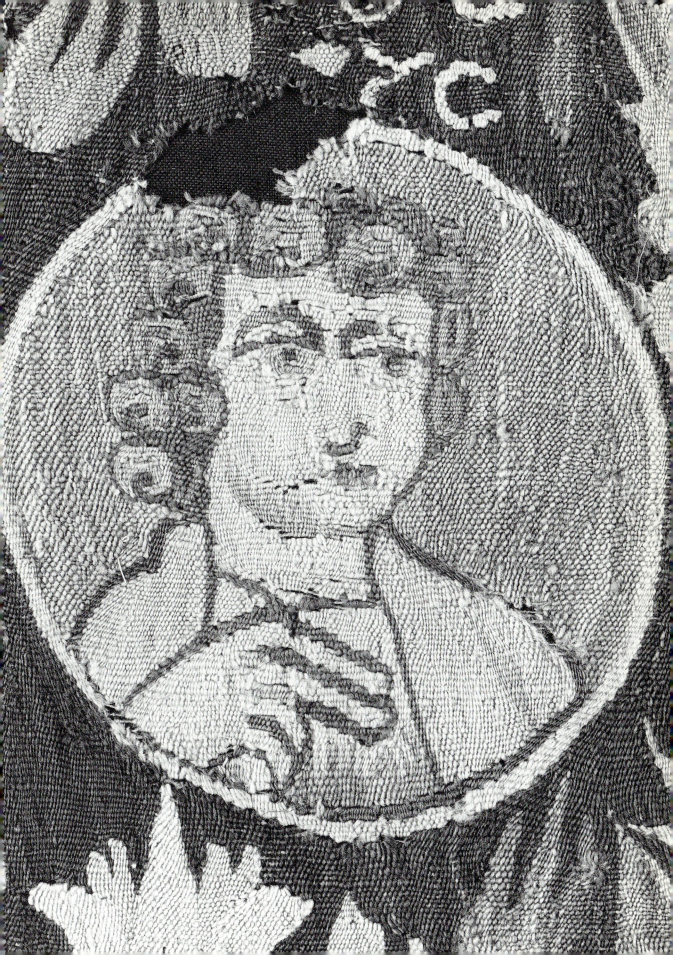

As the controversies we are examining here were to demonstrate forcefully, however, this generous patronage of the Byzantine emperor had a darker obverse side: the vulnerability both of the church and of its Christian art to the exigencies of Byzantine *Realpolitik*.

Our sixth-century tapestry *Icon of the Virgin* was almost certainly produced in Egypt during the Byzantine period, rather than in the workshops of Byzantium itself. This is suggested also by the weaver-artist's evident ignorance of written Greek, seen in his misspellings of the names of various apostles, for example, the printing in mirror reverse of the name "*Andreas* [Andrew]," the writing of "*apostolos*" as "*atostolos*," and the substitution of "*Bareolomaiōs*" for "*Bartholomaios*" and of "*Matheōs*" for "*Maththias*" (Figs. 2, 4–6). Nevertheless, the icon does raise not only the question of the relation between politics and art, but the question of the relation between politics and religion Byzantine style. Even the iconography of the tapestry suggests that question: as the central figure in the upper zone, Christ is seated on a throne (Fig. 7); the *Theotokos* or Mother of God, as the chief figure in the lower zone, is likewise seated on a throne (Fig. 8). As several scholars have suggested, such a view of Christ as the King had carried, from the very beginning of the Christian movement, a polemical message against the cult of the pagan Roman emperor, whose sacred kingship was believed in Roman civic religion to embody both divine and political authority.[24] Christ enthroned in Majesty, as seen by Saint John the Divine in his visions at Patmos, gave Christian artists a worthy theme for making a statement about the absolute lordship of the King of Heaven, by whom the relative lordship of all kings and emperors was to be judged: "The sovereignty of the world has passed to our Lord and his Christ, and he shall reign for ever and ever. . . . We give thee thanks, O Lord God, sovereign over all, who art and who wast, because thou hast taken thy great power into thy hands and entered upon thy reign. The nations raged, but thy day of retribution has come."[25] Those same "theophanies" from the Book of Revelation provided Christian art with themes for the glorification of the sovereign transcendence of God over all other lords and kings, Christian as well as heathen.[26] At the same time, however, it is no less clear that in the Byzantine Empire the figure of the Christian "Roman emperor"—as he was still being called, since the official name of Constantinople as a city was "New Rome"—carried, also liturgically and iconographically, metaphysical connotations that had in one sense been reduced and redefined, but that had

24. Peterson 1951; Wessel 1953.
25. Rev. 11:15–18.
26. Van der Meer 1938.

16

6. (preceding page) Medallion of Saint Paul, detail from *Icon of the Virgin*

7. Christ Enthroned, detail from *Icon of the Virgin*

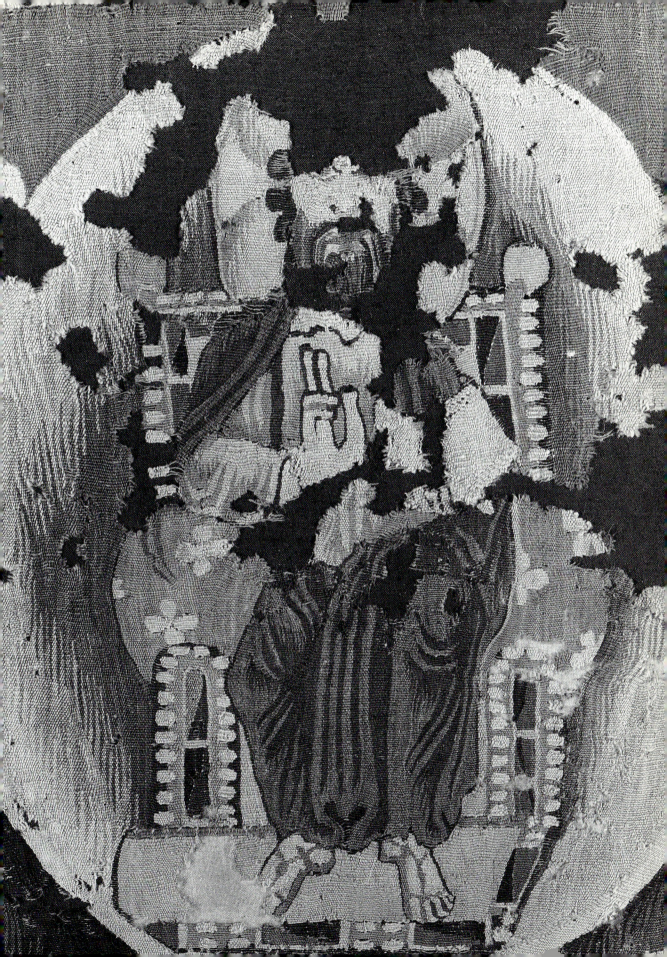

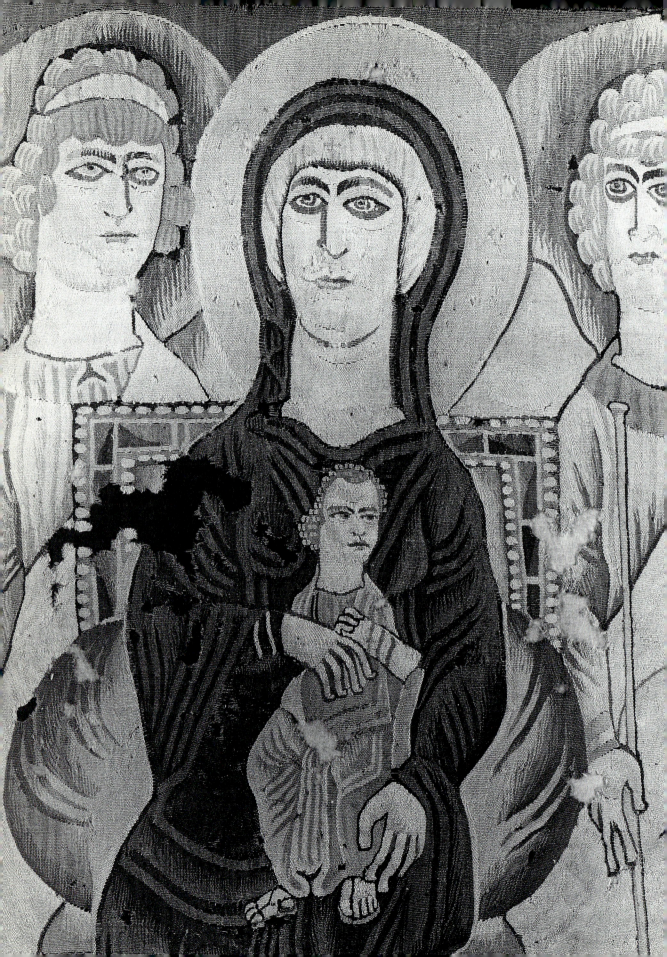

also in another sense been enhanced, by the Christianization of the empire and of the imperial office, as this had been accomplished by Emperor Constantine the Great.[27]

Although there are two enthroned figures on the tapestry, not only one, it is probably correct to conclude that "it was in the service of the cult of the Virgin that our panel was created."[28] For as the relative size of the two zones indicates, the principal subject of this tapestry is Mary in Majesty, and it could well have been entitled *The Theotokos Enthroned*. She was often portrayed that way in Byzantine icons from all periods. For example, she is seated on a throne in an icon of Byzantine origin from the thirteenth century, which Kurt Weitzmann has entitled *Virgin Enthroned* (Fig. 9). Nor is this an exclusively Byzantine motif. The enthronement of the Virgin Mary as herself the "Throne of Wisdom [*Sedes Sapientiae*]" and her coronation by her Son (or sometimes by the entire Holy Trinity) are familiar themes also in the mariological art of the Latin West during the Middle Ages.[29] One of the most splendid of extant examples of this theme also happens to be preserved in the United States (Fig. 10). In the context of our consideration of church-state relations in Byzantium, however, the thrones themselves are of special interest. For while "throne and altar" was a common way of speaking, used also in the political literature of the Church of England during the nineteenth century, about *Realpolitik* and religion,[30] the depictions on this tapestry of Christ enthroned and of Mary enthroned suggest a somewhat different formulation of the question: According to Byzantine theology and Byzantine political theory, what was the relation of these two eternal and heavenly thrones of the *Theotokos* and of her divine Son to the temporal and earthly thrones on which, in Byzantium, both the emperor and the patriarch were seated? And then—though only then, after the eternal and the temporal (which includes both the "secular" temporal and the "ecclesiastical" temporal) have been properly ordered in accordance with Orthodox doctrine—it is possible to ask the further question: What, as a result, was the relation of the throne of the emperor to the throne of the patriarch (together with the thrones of the other bishops and clergy) according to Byzantine theology and Byzantine political theory?[31]

27. A. Grabar 1963.
28. Shepherd 1969, 105.
29. Forsyth 1972.
30. *OED* 11-I:369.
31. On the architectural relation between the throne of the bishop and the throne of the Byzantine emperor, see Kostof 1965, 80–82.

8. Virgin Enthroned, detail from *Icon of the Virgin*

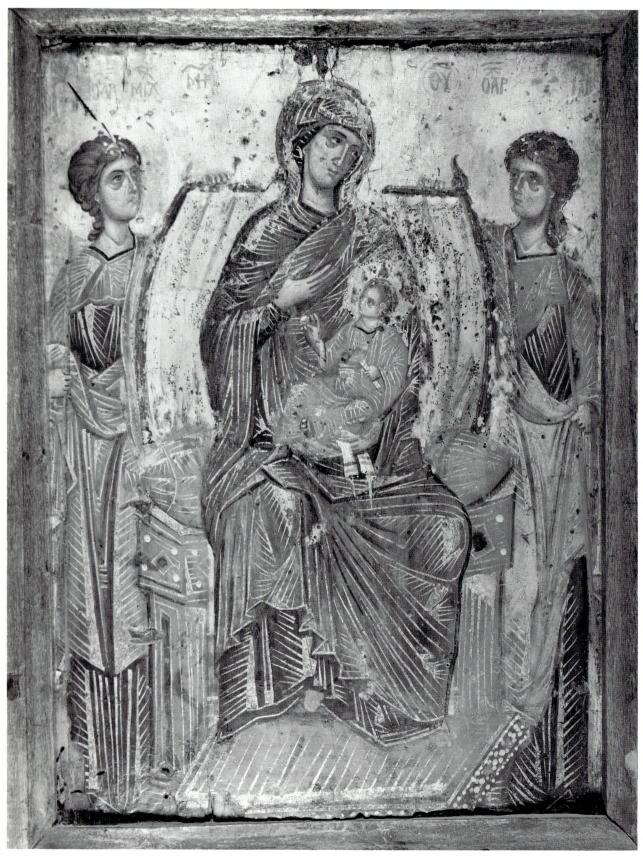

9. *Virgin Enthroned*. Constantinople, 1200–50. Saint Catherine's Monastery, Sinai

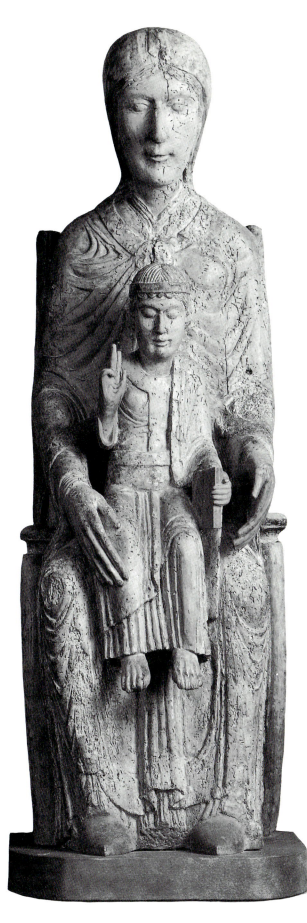

10. Figure of Mary as "Throne of Wisdom [*Sedes Sapientiae*]." Benedictine Abbey of Saint John the Baptist, Collegeville, Minnesota

The central reality in the Byzantine answer to such questions was the Christian throne of empire established by the emperor Constantine I and anchored in Constantinople.[32] The existence of the Constantinian Christian empire made the Eastern understanding of both state and church different both from the theory and from the practice that were to develop in the Latin West during the Middle Ages. That difference had been stated from the very beginning, in the words of Constantine I to his prelates (and it is obvious from his administrative style that he did regard the prelates as "his"): "You are bishops whose jurisdiction is over matters within the church; I also am a bishop [*episkopos*], ordained by God to oversee whatever matters are external to the church."[33] As the Iconoclastic struggles were to make clear, of course, it still remained to be seen concretely just where the boundary line was to be between those "matters within the church," over which the bishops had jurisdiction, and these "matters external to the church," which fell within the purview of the emperor.[34] During the reign of Justinian the Great or perhaps even earlier, a felicitous biblical metaphor for the unique status of the emperor had come into use: he was the new Melchizedek, who, like that shadowy figure in the Book of Genesis, could be said to be both king and priest at the same time.[35] In recognition of the special position of Melchizedek, Abraham, although he was himself the father of all believers, had offered sacrifice to him;[36] that event became a subject for Byzantine art, for example at Ravenna (Fig. 11). So also now, the incumbent of the imperial throne in Byzantium was not thought to be, as was the incumbent of the imperial throne in the Western empire, the recipient of an authority that was conferred by God through Christ on Peter and then transferred by the successors on the throne of Peter to the occupants of the imperial throne. Rather, the authority came directly from the throne of Christ in heaven to the throne of the emperor in New Rome.

The religious responsibility and and the religious power of the emperor have been well formulated in the summary definition of A. A. Vasiliev:

This policy of temporal authority in religious and ecclesiastical affairs, penetrating even the deepest regions of inner religious convictions of individuals, is known in history as Caesaropapism, and Justinian may be con-

32. See the source materials collected and translated in Geanakoplos 17–45, under the headings "The Imperial Image" and "Succession to the Throne."
33. Quoted in Eusebius *Life of Constantine* IV.24 (*GCS* 7:126; *NPNF*-II 1:546).
34. Kraft 1957, 32–42.
35. Gen. 14:18–20.
36. On the history of the early Christian use of the Melchizedek story, see Wuttke 1927.

22

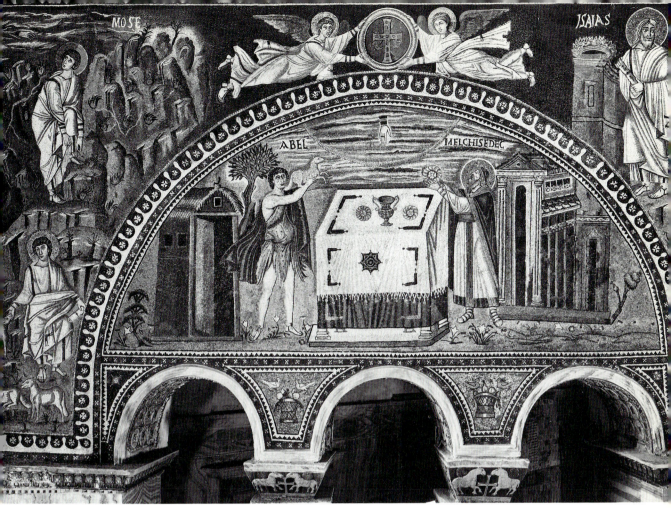

11. Sixth-century mosaic of Melchizedek offering sacrifice to Abraham. San Vitale, Ravenna

sidered one of the most characteristic representatives of the Caesaropapist tendency. In his conception the ruler of the state was to be both Caesar and pope; he was to combine in his person all temporal and spiritual power.[37]

The chain of command is documented not only in the political theories of Byzantine writers, but in the ritual of induction for the emperor and in the formula of faithfulness to orthodoxy by which he assumed his authority.[38] It is not, however, entirely clear just when that ritual first came into use.[39] It should be kept in mind, moreover, that even when, perhaps around the middle of the fifth century, the patriarch of Constantinople began to be the one who crowned a new emperor, that practice "was the regular and desirable mode of coronation, but was never legally indispens-

37. Vasiliev 1958, 1:148.
38. Speck 1978, 399–404.
39. Ensslin 1948.

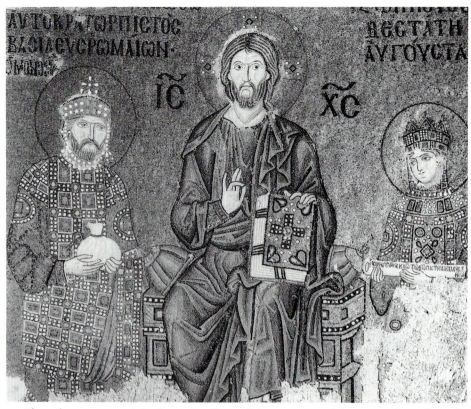

12. Eleventh-century mosaic in the south gallery, of the empress receiving power from Christ the King. Hagia Sophia, Istanbul

able for the autocrat's inauguration. . . . The consent of the Church was not formally necessary to the inauguration of a sovran."[40] There is iconographic evidence as well for the Byzantine understanding of the direct authorization of the emperor by Christ, for example, in the eleventh-century mosaic in the south gallery of Hagia Sophia in Constantinople, which depicts the emperor—or more precisely in this case, the empress—receiving power directly from Christ the King, with no earthly priest or prelate in sight (Fig. 12).

That definition of imperial authority expressed itself in Byzantine jurisprudence, and simultaneously was substantiated by it.[41] As the Eastern critics of Western barbarism never failed to remind the Latin church, the heritage of the Latin Roman law had been definitively codified not by a Latin

40. Bury 1958, 1:11.

41. Alivisatos 1973 deals explicitly with the ecclesiastical legislation of Justinian, but his discussion is also pertinent to that of Justinian's successors.

24

Christian in Old Rome, much less by a pagan Roman, but by a Christian Greek in New Rome: the emperor Justinian. Therefore the later introduction of the Roman law into Latin jurisprudence in the Middle Ages was yet another gift from Constantinople.[42] For our present purposes, the importance of this development lies in the position it assured for civil law as distinct from canon law, and therefore for the "state" as distinct from the "church," in the legal practice and in the political theory of Byzantium.[43] In Byzantium, civil law was not obliged to defend itself against the charge that its pagan provenance had rendered it null and void for Christians, for the civil law of Christian Byzantium interpreted itself as standing in continuity with the civil law of pre-Christian Rome, which had waited to be codified by the Christian emperor Justinian. Nor had Tribonius, Justinian's chosen deputy for this task, exhausted the scholarship of Byzantium in the field. When the University (or "perhaps, more accurately, the 'Higher School'")[44] of Constantinople had been founded by Emperor Theodosius II on 27 February 425, it included two chairs of jurisprudence, so that Byzantine lawyers and statesmen could study the legal system, as initially codified by that same emperor Theodosius II and then by Justinian, and prepare themselves for service in the court system and the bureaucracy of the empire. It was a pattern of higher education in the law that was to be continued, with some interruptions as well as modifications, into the later periods of Byzantine history.[45]

In addition, also beginning already with Constantine and then especially with the *Code of Theodosius*, the Roman law had been modified by Christian additions and revisions in the direction of "godly and righteous legislation," which "took the form either of conceding special privileges to the Church or of revising the law in the light of presumably Christian principles."[46] Theologically the most far-reaching of such additions were the laws regulating Christian doctrine and requiring adherence to the orthodox dogma of the Trinity as a prerequisite for holding office in the new Christian empire. Politically the most influential among these new laws were provisions that guaranteed special rights for the church, including immunity from taxation, and for the clergy, including exemption from military service. And socially

42. On Byzantine law, see H. J. Scheltema in Hussey 1966, 2:55–77, and the extensive bibliography, 408–21.

43. See the thoughtful essay of Ihor Ševčenko 1981, 247–59.

44. Geanakoplos 402.

45. On the university in the period we are examining here, see the careful account of Hussey 1937.

46. Cochrane 1944, 324–36 is a concise and penetrating review of this legislation.

the most important were probably those that proscribed certain ancient Roman practices now deemed immoral and antisocial. Among the most significant for subsequent developments were the Christian laws modifying the *patria potestas*, under which in ancient Rome the father of the family or clan had the right to decide the question of life or death for a newborn child, especially for one that was born deformed. Constantine struck down that provision of the *patria potestas*, thereby helping to initiate the legislation against abortion that was to characterize the legal and moral position of most nations in Christendom, both Eastern and Western, until comparatively modern times, but thereby also making it necessary to invent other forms of care for such unwanted children.[47] All of this was, it should be emphasized, regarded as the proper business of the civil law, because in Byzantium the incumbents of the civil court, like the incumbents of the civil throne, were seen to be competent to determine such issues on grounds that were civil but Christian, and to do so they did not have to seek specific instruction from the clergy or the theologians.

If it is correct to characterize the Byzantine courts by such a term as "civil but Christian," that is also a term even for the Byzantine army and navy, which fought under "the usual imperial standard, that is, the cross with flamethrowers."[48] Because the entire society was fraught with symbols and images celebrating this definition of the Christian empire, the military described itself by its symbols, above all by the cross, as the defender of the holy orthodox faith. As a recent description of Byzantine military campaigns points out, "each day began and ended with prayer and the singing of the *Trisagion*.[49] Clergy accompanied the army and solemn services were even held on the field of battle. . . . Byzantine battle songs from the best periods of the army are really hymns, breathing a proud fighting spirit in which trust in God is combined with sublime self-confidence."[50] As was the case with so many other features of Byzantine life, the precedent for this Byzantine version of "Onward, Christian Soldiers" had come already in the military career of the founder of the city. For after the battle of the Milvian Bridge, Constantine

> . . . immediately commanded that a trophy of the Savior's passion be put in the hand of his own statue. And when he had placed it, with the

47. See Boswell 1988, 69–73, on the legislation of Constantine with regard to the *patria potestas*.
48. Pseudo-Codinus in Geanakoplos 111.
49. "Holy God, Holy and mighty, Holy and immortal, have mercy upon us!" (Brightman 535).
50. W. Ensslin in Hussey 1966, 2:44–45.

saving sign of the cross in its right hand, in the most public place in Rome, he commanded that the following inscription should be engraved upon it in the Roman [Latin] tongue: "By this salutary sign, the true proof of bravery, I have saved and freed your city from the yoke of the tyrant; and moreover, having set at liberty both the senate and the people of Rome, I have restored them to their ancient distinction and splendor."[51]

When Saint Helena, the mother of Constantine, found what she believed to be the true cross in a cave in Jerusalem, and with it the nails that had pierced the hands and feet of Christ, she sent one part of the true cross "to the emperor, who being persuaded that the city would be perfectly secure where that relic should be preserved, privately enclosed it in his own statue, which stands on a large column of porphyry in the forum called Constantine's at Constantinople." She also sent some of the nails to her son, who "took them and had them made into a bridle-bit and a helmet, which he used in his military expeditions."[52] When the true cross disappeared in the seventh century, it was being carried by the armies of the Byzantine Empire into battle against the Persians; and when it disappeared, again and forever, in the twelfth century, it was once more being borne into the battlefield, this time by the bishop of Bethlehem.

Thus the insignia and talisman of the Byzantine armies was what Eusebius had already called "the confession of the victory-bringing cross [*hē tou nikopoiou staurou homologia*]."[53] Above all, of course, this was true of the cross in the transcendent sense, especially cherished by Greek Christianity and celebrated in its art (Figs. 26–27), that the Crucifixion and the Resurrection of Christ had achieved victory over sin and death, the devil and hell, the ancient enemies of the human race. But it was true also in the very immanent sense that the cross of Christ was believed to have enabled the Christian forces of Byzantium to defeat their foes.[54] Most, though by no means all, of the wars in which the Byzantine army was engaged were fought against the avowed enemies not only of the empire but of the Christian faith. As Byzantium learned in such wars and as the West was to discover especially during the Crusades of the twelfth and thirteenth centuries, a war against Islam had to contend with the zeal of an enemy for

51. Eusebius *Ecclesiastical History* IX.11 (*GCS* 9:832; *NPNF*-II 1:364). Our knowledge of the inscription is based solely on the account of Eusebius, apparently without archaeological substantiation thus far.

52. Socrates Scholasticus *Ecclesiastical History* I.17 (*PG* 67:117–21; *NPNF*-II 2:21).

53. Eusebius *Life of Constantine* I.41 (*GCS* 1:26; *NPNF*-II 1:494).

54. Cecchelli 1954.

whom the war was a *jihad*, a holy war.[55] Therefore the need to match such zeal often led to the identification also of Christian warfare against such an enemy as holy war, for which the precedent of the wars of the ancient Israelites seemed to provide ample justification. Here again it was Eusebius who had supplied the Christian Empire with such a precedent.[56] This he had done by his graphic typological description of the victory granted by God to Constantine at the Battle of the Milvian Bridge as a parallel to the victory granted by God to Moses in the battle against the armies of Pharaoh at the Red Sea during the Exodus.[57] The manuals of military science for which Byzantium became famous, also in the Arab world and in the West, blended carefully thought-out theories of strategy with a kind of Christian "divine warfare," in which the icons and other symbols of the Christian empire had an important tactical function.[58]

It should, nevertheless, not be forgotten that within the total political-religious ideology of Byzantium, what the church stood for was believed to be supreme. The throne of any earthly king, including the Byzantine "king [*basileus*]," was subordinate to the throne of Christ the King.[59] As on our tapestry *Icon of the Virgin*, the heavenly throne of Christ was positioned, surrounded by the angels, far above all terrestrial powers, and even above the heavenly throne of his Mother (Fig. 7). The orb in the hand of the archangel Gabriel, moreover, symbolized the universal, indeed cosmic, authority of God and of the Son of God (Fig. 44). But according to the Eastern scheme of things, it did not necessarily follow from this supremacy of the throne of Christ the King that the throne of the Byzantine king or Roman emperor was subordinate to the throne of the patriarch, whether of the patriarch at New Rome or of the one at Old Rome, or to that of any other ecclesiastical dignitary; nor did the institutional structure of the organized church as such have to be supreme.[60] In a manner that Western prelates repeatedly found not merely puzzling but heretical, the Eastern Church, also in its iconographic depictions of the Byzantine emperor, acknowledged the autonomy of the empire as a Christian empire without being obliged to claim that either the authority of the empire as empire or even its right to be called Christian was in any direct and simple way

55. See, in general, Laurent 1946, 71–98, on the similarities and differences between the Byzantine view of Christian warfare and both the Muslim and the Western Christian versions of the idea of "holy war."

56. Berkhof 1939.

57. Eusebius *Ecclesiastical History* IX.9 (*GCS* 9:828–30; *NPNF*-II 1:363–64).

58. Oman 1953.

59. Kollwitz 1947–48, 95–117.

60. Ziegler 1953, 81–97.

dependent on the explicit actions of the church and of its prelates.[61] What the West could not, or would not, understand was that in Eastern eyes this was not, at least in principle, a diminution of the authentic power of the church at all, but on the contrary an elevation of its spiritual authority, providing it with the defense and protection of the emperor and subjecting the authority of earthly kings to the sovereignty of the heavenly King, who was in turn the Lord of the church. By not being obliged to meddle into political affairs in the way that according to the East the Western Church was continually doing, the church was set free to pursue its primary and distinctive mission, a mission that represented the transcendent source and goal of human existence not only in this world but chiefly in that which was to come.

During the centuries in which the Latin West was evolving the monarchical papal polity that was to equip the church for its aggressive political mission throughout medieval Europe, the East remained committed to the earlier, more federative patriarchal polity frequently defined as "pentarchy." The five apostolic patriarchs of Rome, Constantinople, Jerusalem, Alexandria, and Antioch shared the supreme earthly authority in the church, and no one of them had the right to exercise that authority over the universal church on his own. The primacy of Rome was acknowledged, but only within the context of the apostolic college of all five patriarchs.[62] Next in line was Constantinople. Already by the decree of the second ecumenical council in 381, the patriarch of Constantinople was put alongside the patriarch of Rome, "because [Constantinople] is the New Rome [*dia to einai autēn nean Rōmēn*]."[63] Then in 451, at the fourth ecumenical council, which was held in Chalcedon, just outside Constantinople, that prerogative of the see of Constantinople was reaffirmed, by what eventually came to be called the twenty-eighth canon of the Council of Chalcedon:

> Following in all things the decisions of the holy fathers . . . we also do enact and decree the same things concerning the privileges of the most holy church of Constantinople, which is New Rome. For the fathers rightly granted privileges to the throne of Old Rome, because it was the royal city. And the 150 most religious bishops [at the First Council of Constantinople in 381], actuated by the same consideration, gave equal privileges [*ta isa presbeia*] to the most holy throne of New Rome, justly

61. A. Grabar 1936.
62. Dvornik 1958, 39–105, is a careful and highly informative account of the problem.
63. First Council of Constantinople (Alberigo 32; *NPNF*-II 14:178).

judging that the city which is honored with the Sovereignty and the Senate, and enjoys equal privileges with the only imperial Rome, should in ecclesiastical matters also be magnified as she [Old Rome] is, and rank next after her.[64]

This passage from the *Acts* of the Council of Chalcedon is quite remarkable in several respects, at least three of which are immediately pertinent to our present inquiry.

The first is the repeated use of the Greek word "throne" as a way of referring both to the patriarchal see of Old Rome and to that of New Rome—a metaphor that is derived from the ancient Christian practice of having the bishop seated on a throne,[65] but one that also suggests direct connections with the depictions of Christ and of Mary on our tapestry icon. A second item, of some interest or perhaps even of amusement, is the difference of nomenclature between the ways in which the two patriarchal sees are characterized: only the see of Constantinople is called "most holy church" and "most holy throne," while the see of Old Rome is unadorned with such titles. The third point made in the twenty-eighth canon of Chalcedon, and by far the most important, is the historical basis that is cited as the legal ground for the action of ranking Constantinople next to Rome: "The fathers rightly granted privileges to the throne of Old Rome, because it was the royal city." Therefore the ecclesiastical position of Old Rome was derived from its political position as the capital of the Roman Empire. From that it would necessarily follow that Constantinople, as the new "royal city," was now entitled to "equal privileges." The patriarch of Old Rome, eventually if not immediately, rejected these grounds for his "privileges." He claimed instead that the basis for his primacy was not to be found in any secular or political preferment at all, but in the words of Christ to Peter: "You are Peter, the Rock; and on this rock I will build my church, and the gates of hell shall not prevail against it [*Tu es Petrus, et super hanc petram aedificabo ecclesiam meam, et portae inferi non praevalebunt adversus eam*]."[66] The principal doctrinal decree of Chalcedon concerning the relation between the divine nature and the human nature in Christ was in considerable measure the expression of the special theological perspective of the Latin West, as this had been articulated two years earlier in the *Tome* of Pope Leo I to Flavian. The assembled council fathers are said to have recognized this when, upon hearing the *Tome* read out, they declared: "Peter has spoken

64. Council of Chalcedon (Alberigo 99–100; *NPNF*-II 14:287).
65. Stommel 1952, 17–32.
66. Matt. 16:18 (Vulgate).

through the mouth of Leo!" But the twenty-eighth canon of the Council of Chalcedon was never accepted by Rome.[67] When the dramatic events of the seventh century brought three of the five apostolic patriarchates of the pentarchy—Jerusalem and Antioch in 638, Alexandria in 641—under Muslim rule, only Rome in the West and Constantinople in the East remained. The rivalry between Constantinople and Rome was seemingly inevitable whenever, as in the ninth-century missions to the Slavs, border incidents between East and West revealed that they could not accurately be called two parts of a single church any longer, but were in the process of rapidly becoming two competing and then separated churches.[68]

Our tapestry *Icon of the Virgin* seems to embody at least an implicit pictorial affirmation of the Byzantine definition of apostolic authority in the church. The arrangement of the apostle medallions on the icon is, as Shepherd has said, "unusual in a number of ways"; nevertheless, it may not be accurate to characterize it, as she suggests, as "one of the most extreme cases of the Eastern disregard for an orderly hierarchy among the apostles," or even as "chaotic."[69] For the apostle whose medallion appears at top right—which would seem to be the preeminent position of honor—is the disciple Andrew, with Matthew, Paul, and Luke pictured below him (Fig. 2). The apostle Peter, to whom the first place as position of honor is accorded in most lists of the twelve apostles, including all four lists that appear in the New Testament,[70] is shown in the column on the left side (Fig. 13), and then below even the apostle Bartholomew. There may or may not be some specific church-political implication to this demotion of Peter by the artist (or perhaps by an even earlier icon that he was copying); for the allegation of such a demotion of the bishop of Old Rome was a point that appeared in Byzantine anti-Roman polemics only much later.[71] But in any case, the promotion of Andrew is hard to dismiss as an instance of "the Eastern disregard for an orderly hierarchy among the apostles." For in the East, Andrew did come to occupy a special position in that orderly hierarchy. He was, according to the New Testament, the brother of Simon Peter, in fact the older brother of Peter; and it was he who, after having himself become a follower of Jesus, found his brother and "brought Simon to Jesus."[72] Thus

67. This entire history is the subject of three essays (all of them, however, written from a Western Latin perspective), in Grillmeier–Bacht 1951–54, 2:433–562.

68. See above all Dvornik 1970.

69. Shepherd 1969, 101–03.

70. Matt. 10:2–4; Mark 3:16–19; Luke 6:14–16; Acts 1:13.

71. Dvornik 1970, 125.

72. John 1:40–42.

Peter was, also according to Byzantine theologians like Theodore the Studite,[73] identified as "the occupant of the first throne [*prōtothronos*]" in the church. But Andrew was, according to standard Byzantine usage, known as "the first one to be called [*prōtoklētos*]."[74] According to a tradition repeated by Eusebius from Origen's *Commentary on Genesis*, Andrew had carried on his missionary work in "Scythia," the region north of the Black Sea.[75] Thus, while Peter was the founder of the church at Old Rome, Andrew was the one who brought the faith to Byzantium, which nearly three centuries later would become New Rome.[76]

For the understanding of the Iconoclastic controversies, however, our interest is not chiefly in the relation between the authority of the patriarch of Rome and that of the patriarch of Constantinople, but in the authority of the patriarch of Constantinople within his own church, as that authority was seen to be at stake in these controversies, and especially in the traditional alliance between the patriarch and the monks, which so often proved to be the decisive factor in resisting Iconoclasm. One of the chief differences between Western and Eastern bishops, including Eastern patriarchs, resulted from the gradual development in the Western Church of the rule requiring celibacy also for parish clergy, not only for bishops. There had been married bishops in the early church, as for example Socrates Scholasticus acknowledged in his *Ecclesiastical History*.[77] The New Testament had even included among the requirements for a bishop that he be "the husband of one wife" and one who "wins obedience from his children."[78] It had also described Peter, the prince of the apostles and according to tradition the first bishop of Rome, as having a mother-in-law and as traveling with his wife.[79] This practice of permitting married bishops had, however, gradually yielded to the rule in both East and West that a bishop must be celibate—and, though only in the West, to the rule that a priest must also. A consequence of this was that in the West any diocesan or regular priest could, at least in principle, become a bishop or pope. In the East, on the other hand, the practice continued to be that although a priest, once ordained, could not marry, a married man could be ordained and remain married. As a result it gradually became standard procedure that "bishops are drawn exclusively from the

73. Theodore the Studite *Epistles* II.86 (PG 99:1332).
74. Lampe 1200; Sophocles 958.
75. Eusebius *Ecclesiastical History* III.1 (GCS 9:188; NPNF-II 1:132).
76. Dvornik 1958, 138–299.
77. Socrates Scholasticus *Ecclesiastical History* V.22 (PG 67:637; NPNF-II 2:132).
78. 1 Tim. 3:2–4; Titus 1:6.
79. Matt. 8:14; 1 Cor. 9:5.

13. Medallion of Saint Peter, detail from *Icon of the Virgin*

monastic clergy, although a widower can be made a bishop if he takes monastic vows."[80] Over and over in the history of the Byzantine church, these fraternal ties between the bishop or patriarch and the monastic community were to assert themselves, and in the battle to restore the images the monks were to function as the shock troops. Conversely, Iconoclastic hostility to icons and to Iconodule patriarchs also took out its revenge on the monastic community.[81] It is known even to those Western readers whose only acquaintance with Eastern Orthodoxy comes from the novels of F. M. Dostoevsky that the monastic father confessor (or *starec* in Russian) could sometimes carry a far greater moral and spiritual authority than did the local parish priest.[82]

In this Christian empire and this imperial church, the emperor who stood in the succession of Constantine and the patriarch who stood in the succession of the apostle Andrew were expected to live in harmony. Each was divinely charged with responsibility for the welfare of the other, but the emperor was thought to provide for the church with special care. When this arrangement worked, it worked well. But repeatedly, and long before the Iconoclastic controversies, the two divine institutions in the Eastern Roman Empire had collided, not only over issues of political authority as such but over questions of doctrine and of morals. Within a few years after celebrating the victory of orthodox trinitarianism at the Council of Nicaea in 325, the champions of orthodoxy were to discover that the same imperial sovereignty which had enforced the formula of the Creed of Nicaea could be dogmatically fickle, endorsing the opposite of Nicaea and enforcing this with the same sanctions of punishment and exile that had been invoked against the Arian heretics; and they could have grimly applied to the emperor the words of Job: "The Lord gives and the Lord takes away; blessed be the name of the Lord."[83] For his loyalty to the Nicene doctrine and his defiance of imperial edicts against it, Athanasius, bishop of Alexandria (whom Theodore the Studite, borrowing an epithet once used for Heracles, called "the one of many labors [*polyathlos*]"),[84] went into exile in 336, and again in 339, was deposed again in 356, and yet again in 362, and one more time in 365. As Gibbon put it, with grudging but unmistakable admiration,

80. Ware 1969, 298.
81. Nicephorus *Refutation* III.64 (*PG* 100:493).
82. Holl 1898 is a brilliant analysis of the significance of this monastic tradition for penitential practice and mystical piety in Byzantine spirituality.
83. Job 1:21.
84. Theodore the Studite *Refutation* II.18 (*PG* 99:361; Roth 53).

Five times was Athanasius expelled from his throne; twenty years he passed as an exile or a fugitive; and almost every province of the Roman empire was successively witness to his merit, and his sufferings in the cause of the Homoousion, which he considered as the sole pleasure and business, as the duty, and as the glory, of his life. Amidst the storms of persecution, the archbishop of Alexandria was patient of labor, jealous of fame, careless of safety; and although his mind was tainted by the contagion of fanaticism, Athanasius displayed a superiority of character and abilities, which would have qualified him, far better than the degenerate sons of Constantine, for the government of a great monarchy.[85]

It does seem paradoxical, at any rate from a modern perspective, that despite occasional complaints that the emperor was overstepping his bounds by interfering in questions of faith and doctrine[86]—some of the most vigorous of these, however, coming from spokesmen for the West and for Rome[87]— the erstwhile victims of such persecution, including Athanasius himself, were quite willing, upon being restored by an orthodox emperor, to invoke his power against their theological opponents, thus vindicating the very system that had worked against them and against the orthodox church.

That same paradox manifested itself during the eighth and ninth centuries in the political conflicts over images. In 725 or 726, Emperor Leo III, usually (though perhaps incorrectly) surnamed "the Isaurian," issued an edict forbidding their continued use; and when Patriarch Germanus of Constantinople refused to approve the action of a church synod supporting the emperor's action, he was deposed. Under Leo's son and successor, Emperor Constantine V, the campaign against icons was intensified, with the emperor not only leading the political and military campaign for their abolition but himself articulating the theological and philosophical arguments in support of that campaign. As one scholar has noted, "there is scarcely any other monument that gives us the opportunity to penetrate so deeply into the essence of the Iconoclastic heresy and that so clearly sets forth its philosophical-theological foundations as do these writings of the emperor."[88] And in 754 he convoked a synod, which eventually was relocated in Constantinople and which issued a decree, generally identified by its Greek title as *Horos*, against images:

85. Gibbon 1896–1900, 2:362.
86. Athanasius *History of the Arians* 52 (PG 25:756–57; *NPNF*-II 4:289).
87. See the letter of Ossius of Cordova to the emperor Constantius, as quoted by Athanasius *History of the Arians* 44 (PG 25:745–48; *NPNF*-II 4:285–86).
88. Ostrogorsky 1929, 2–3.

Supported by the Holy Scriptures and the fathers, we declare unanimously in the name of the Holy Trinity, that there shall be rejected and removed and cursed out of the Christian Church every likeness which is made out of any material whatever by the evil art of painters. Whoever in the future dares to make such a thing or venerate it, or set it up in a church or in a private house, or possesses it in secret, shall, if bishop, priest, or deacon, be deposed, if monk or layman anathematized and become liable to be tried by the secular laws as an adversary of God and an enemy of the doctrines handed down by the fathers.[89]

The dogmatic decree was followed by a pledge of political allegiance to the Byzantine emperor: "It is through you that the church in the entire world has been pacified. You are the splendor of orthodoxy. . . . Long live the new Constantine, the most pious king! . . . You have abolished every idolatry. You have triumphed over the teachers of this error."[90]

Yet the Second Council of Nicaea, which met to condemn the Iconoclast Synod and to whose excerpts from the synod's decrees we owe practically everything we know about what had happened in 754, opened its own Definition by calling itself "the holy, great, and Ecumenical Council—convened by the grace of God and by the sanction of our pious kings, those lovers of Christ, Constantine [VI] and his mother Irene."[91] As for those who opposed its decree restoring the images, "if they are bishops or clergymen, we direct that they be unfrocked; if monks or laymen of the society, that they be excommunicated."[92] It acknowledged that the salutations addressed by the Iconoclast synod to Leo III and Constantine V had "addressed the kings as is the custom," but it did go on to criticize the closing language of the *Horos*, which gave the emperor credit for having abolished idolatry and triumphed over the teachers of error: "If, as they say, it was the council of bishops and presbyters *and the power of kings* which delivered us from the error of idols, then the human race has been deceived about the truth, since one Person has saved it but someone else has boasted that he did."[93] As it stands, this condemnation takes the credit away from bishops and clergy as well as from "the power of kings." But it must be

89. I have followed here the translation given in Vasiliev 1958, 1:260, rather than, as I usually have, that of Sahas.
90. Iconoclast Synod of Constantinople, quoted by Second Council of Nicaea (Mansi 13:353; Sahas 166).
91. Second Council of Nicaea (Mansi 13:373; Sahas 176).
92. Second Council of Nicaea (Mansi 13:380; Sahas 180).
93. Second Council of Nicaea (Mansi 13:3564; Sahas 167 [italics added]).

seen in the context of a decree which, while giving the glory to God alone, and not to any human power, affirmed that God had "through his good will brought us, the leaders of the priesthood, together from all parts, through the divine zeal and inspiration of Constantine [VI] and Irene, our most faithful kings, so that the divine tradition of the catholic church may regain its authority by a common vote."[94] The tradition of the church had "regained its authority," but it had done so when God had inspired Empress Irene and her son Constantine VI with "divine zeal." Therefore the defenders of the icons against the emperor's usurpation continued to celebrate "Constantine [I] the Great" as "the head and summit of religion [koryphē kai akropolis eusebeias]."[95]

Thus at one level the paradox of something resembling Caesaropapism was retained; for on both sides the conflict over the icons was a political struggle, and imperial authority was at stake. At another level, however, a fundamental difference emerged between the two sides in their estimate of that authority. The Iconoclastic *Horos* of 754 located the Byzantine emperors in the apostolic succession:

> For this reason, therefore, Jesus, the author and agent of our salvation, as in the past he had sent forth his most wise disciples and apostles with the power of the most Holy Spirit in order to eliminate completely all such things [as idolatry], so also now he raised his devotees, our faithful kings—the ones comparable to the apostles, who have become wise by the power of the same Spirit—in order to equip and teach us, as well as to abolish the demonic fortifications which resist the knowledge of God, and to refute diabolic cunnings and error.[96]

The Second Council of Nicaea dismissed this as "flatteries for the rulers."[97] But John of Damascus pressed the political point considerably further. He was, as his Iconoclastic opponents pointed out, writing under the protection of Muslim rulers, who, while uncompromising in their hostility to the use of images in the worship of the true God, were tolerant of a Christian theologian who defended the church's use of icons; therefore the Iconoclast Synod of 754 called him, among other epithets, "Mansur, the one with a vile-sounding name and of Saracen opinions, the worshiper of icons and writer

94. Second Council of Nicaea (Mansi 13:376; Sahas 177).
95. Nicephorus *Refutation* III.78 (*PG* 100:517).
96. Iconoclast Synod of Constantinople, as quoted by Second Council of Nicaea (Mansi 13:225; Sahas 65).
97. Second Council of Nicaea (Mansi 13:228; Sahas 67).

of falsities."[98] "Kings," John of Damascus declared, "do not possess the authority to legislate for the church [*ou basileōn esti nomothetein tēi ekklēsiai*]." The apostle Paul had listed those whom God had ordained with authority in the church: "in the first place apostles, in the second place prophets, thirdly teachers."[99] "He did not say: 'kings,'" John Damascene added. For "the business of kings is political administration; ecclesiastical governance pertains to pastors and teachers."[100] Paraphrasing the words of the apostle Paul to the Galatians,[101] he asserted: "If anyone, an angel from heaven *or a king*, should preach a gospel at variance with the gospel we preached to you, close your ears to him."[102] Therefore it does seem valid in many ways to conclude that "with the end of Iconoclasm caesaropapism was replaced by a dyarchy of emperor and patriarch."[103]

Nothing more strikingly illustrates the subtle connection between theological and political motifs in the Iconoclastic controversy than the use of images of the Roman and Byzantine emperor as the argument for making a theological point. Athanasius had put that argument to effective use in proving that the Father and the Son were one in the Trinity:

> The likeness of the emperor in the image is exact, so that a person who looks at the image sees in it the emperor; and he again who sees the emperor recognizes that it is he who is in the image. And from the likeness not differing, to one who after the image wished to view the emperor, the image might say, "I and the emperor are one; for I am in him, and he in me." . . . Accordingly, he who worships the image, in it worships the emperor also; for the image is his form and appearance.[104]

A similar method of proof was employed again by Basil of Caesarea.[105] Also with reference to a royal image, Basil had declared that "honor which is paid to an image pertains to its prototype."[106] Although neither of these church fathers was referring to Christian images of the eternal King, but to pagan images of a temporal king, the defenders of icons felt able to quote these and other passages from Athanasius and Basil in support of Christian

98. Iconoclast Synod of Constantinople, as quoted by Second Council of Nicaea (Mansi 13:356; Sahas 168–69).
99. 1 Cor. 12:28.
100. John of Damascus *Orations on the Holy Icons* II.12 (PG 94:1296).
101. Gal. 1:8.
102. John of Damascus *Orations on the Holy Icons* II.6 (PG 94:1288); italics added.
103. Ladner 1940, 142.
104. Athanasius *Orations against the Arians* III.5 (PG 25:332; *NPNF*-II 4:396).
105. Basil *Homilies* xxiv.4 (PG 31:608).
106. Basil *On the Holy Spirit* xviii.45 (PG 32:149; *NPNF*-II 8:28).

images.[107] Because the "image" in these quotations was Christ as the image of the Father, not an image of Christ, the proof was not a direct one; but because the argument on the basis of the person of Christ came to be the clinching proof in the Iconodule apologia, it was fitting that these passages be introduced as an argument "*a fortiori* from the laws and customs governing the worship of the portrait of the basileus" to the legitimacy of the worship of icons.[108] Therefore the saying of Christ in the Gospel about the image of the emperor applied here as well.[109] To "render to Caesar what was Caesar's" meant rendering to Caesar the icon of Caesar on the coin, and to "render to God what was God's" meant rendering to God the icon of God in the church.[110]

The interrelation of "religion and *Realpolitik* Byzantine style," then, can never be far from the mind of anyone seeking to make sense either of the Byzantine attack on the icons or of the Byzantine apologia for the icons.[111] It will not be far from this exposition, but it will not be permitted to set the rules for it. Only political reductionism and social determinism of the most naive sort can interpret "ancient heresies" as "disguised social movements" as though they were nothing more.[112] For at the very least, if doctrine did not determine the grand strategy of the opposing forces in this battle, it did provide most of the ammunition on both sides. The history of warfare would not make sense without the history of ordnance, nor would the history of politics without the history of political rhetoric. Therefore it behooves even a modern historian, in interpreting this chapter in the political history of art, to look beyond the politics to the rhetoric, including the theological rhetoric. Byzantium was famous for its weaponry, especially for "Greek fire," a secret chemical formula for its most frightening naval armament.[113] It was no less famous for its theological weaponry. This is a study of the Byzantine theological arsenal.

107. Athanasius is quoted in Theodore the Studite *Refutation* II.13 (*PG* 99:360; Roth 49); Basil in John of Damascus *Orations on the Holy Icons* I.21 (*PG* 94:1252–53).

108. Kitzinger 1954, 124.

109. Matt. 20:21.

110. John of Jerusalem *Against Constantine V* 5 (*PG* 95:321).

111. Lipšic 1961, 227–28, discusses the significance of "class" for the struggle over icons; her general discussion (170–212) is a helpful analysis from that particular philosophical and historiographical perspective.

112. Jones 1966 is a brief but incisive refutation of such simplistic interpretations.

113. See the comments of J. B. Bury, in an appendix to his edition of Gibbon 1896–1900, 6:539–40.

GRAVEN IMAGES
The Ambiguity of the Iconographic Tradition

The problem of tradition—and of the ambiguity of tradition—is in some ways the most fundamental problem of all in the theology of icons. It was so for the Iconoclastic debates of the eighth and ninth century themselves, and it is so for our effort today to understand the theological issues believed by all sides to be at stake in those controversies. Each side appealed to the authority of tradition, and each claimed to be defending what it took to have been the traditional view of images against the "novelty-mongering [*kainotomia* or *neōteropoiïa*]"[1] being furtively introduced by its opponents, in this case by the opponents or by the defenders of icons. The authority of the first five centuries or so of Christian history—it came to be called in post-Reformation debates the *consensus quinquesaecularis*—was to cast the deciding vote in this or any other controversy: on that principle there was agreement between those who were opposing the icons and those who were defending them, both of whom regarded that traditionary authority as clear and simple.

Upon closer examination of the evidence from the preceding centuries, however, it becomes clear that the witness of the authoritative tradition in this area (and not only in this area) was neither clear nor simple. That judgment applies to all the several classes of such traditionary evidence, whether written or iconographic. The interrelation between the written

1. Basil of Caesarea warned that "it is enough for us to confess those names which we have received from Holy Scripture, and to shun all innovation [*kainotomia*] about them," *Epistles* 175 (*PG* 32:652–53). The well-known opening words of the *Ecclesiastical History* of Eusebius of Caesarea contrast the "continuity [*diadochē*]" of the true church and doctrine with the "innovation [*neōteropoiïa*]" of the heretics (*GCS* 9:6; *NPNF*-II 1:81).

41

14. Medallion of the apostle and evangelist John, detail from *Icon of the Virgin*

documents of the tradition and its artistic monuments is itself complex enough to call for close attention. As will become evident repeatedly in the later discussion, the documents and the monuments were bound together thematically. The individuals represented in the icons were also the subjects of saints' lives and of edifying memorial discourses, whose biographical data help to explain some details of the iconography that might otherwise be obscure. For example, the figure of the apostle and evangelist John on the Cleveland *Icon of the Virgin* is that of a beardless young man (Fig. 14), as compared with portraits of John at San Vitale in Ravenna (Fig. 15) and in an icon from Sinai (Fig. 16). The explanation for this way of portraying John is to be found in the development of the hagiographic literature about him. The Gospel story of John and Mary at the foot of the cross seemed to carry the implication that John was younger than Jesus.[2] That implication was confirmed in the tradition transmitted by Jerome that John lived for sixty-eight years after the death of Christ,[3] which was an elaboration on the tradition transmitted especially by Eusebius, on the basis of Irenaeus and Origen, that John had lived to a great old age and died at Ephesus.[4] Since it was widely believed, on the basis of the harmony of the Gospels, that Jesus was at least thirty-three when he died (and even, at any rate according to Irenaeus, that he had reached the age of fifty),[5] John would therefore have had to live well beyond the age of one hundred if he had been Christ's exact contemporary.

Because of the interrelation between document and monument, moreover, the scholarly determination of iconographic provenance has a close analogy in the treatment of written sources, an analogy close enough to make metaphors drawn from the visual arts the obvious ones in which to express the nature of the literary material. The preoccupation with tradition was responsible, apparently from the end of the fourth century onward,[6] for the development in Byzantium of a genre of scholarly literature in law, in philosophy, and above all in theology, consisting of judiciously selected excerpts from the great authorities of the past. It was to become a genre in which "the theological literature of the Byzantines was extraordinarily rich."[7] In English these compilations are usually called

2. John 19:25–27.
3. Jerome *Lives of Illustrious Men* 9 (PL 23:623–25; *NPNF*-II 3:364–65).
4. Irenaeus *Against Heresies* III.i.1, III.iii.4 (Harvey 2:6, 2:13; *ANF* 1:414, 1:416). Eusebius *Ecclesiastical History* III.1 (GCS 9:188; *NPNF*-II 1:132–33).
5. Irenaeus *Against Heresies* II.xxii.5 (Harvey 1:331; *ANF* 1:392).
6. So Marcel Richard in Grillmeier–Bacht 1951–54, 1:721.
7. Krumbacher 1897, 206.

15. Sixth-century mosaic of the apostle and evangelist John. San Vitale, Ravenna

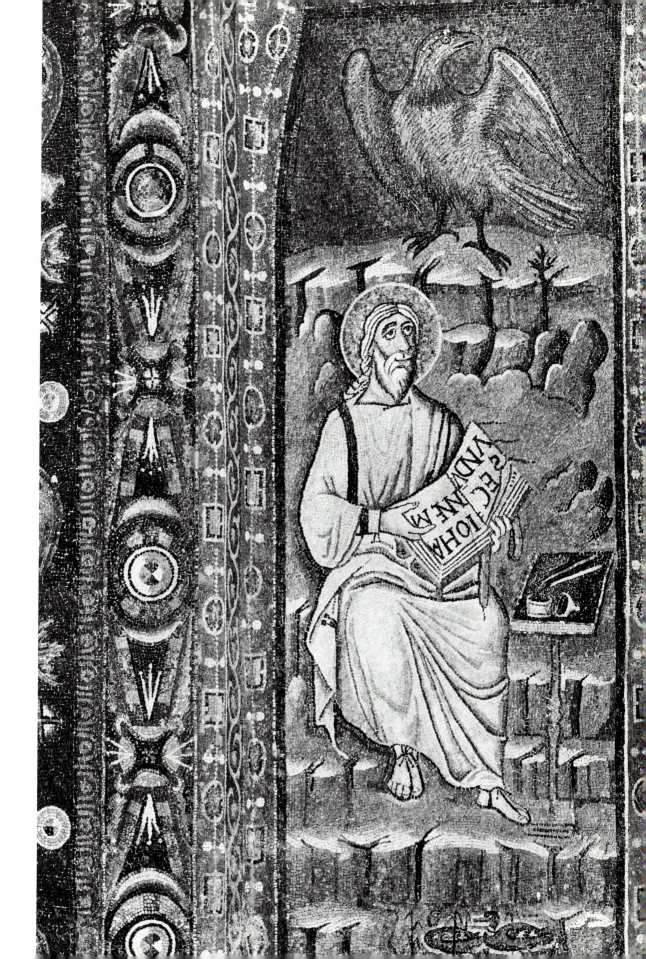

by the Neo-Latin name *florilegium*, which is a literal rendering of the Greek *anthologia*, "a selection of flowers."[8] One extremely valuable anonymous Byzantine florilegium from the debates over the relation between the divine and the human nature in the person of Christ, which Hans-Georg Beck has called "one of our most important mines of information about early theologians,"[9] bears the title *The Doctrine of the Fathers on the Incarnation of the Logos* [*Doctrina patrum de incarnatione Verbi*].[10] To such literary materials it would be possible to apply a metaphor drawn from Byzantine art that Edward Gibbon utilized to characterize the codification of the Roman law, at nearly the same time as the *Doctrina patrum*, by the emperor Justinian: "Instead of a statue cast in a simple mould by the hand of an artist," Gibbon suggested, "the works of Justinian represent a tesselated pavement of antique and costly, but too often of incoherent, fragments."[11] Hence it is an act of scholarly reciprocity to use the Byzantine theological tradition as a heuristic device for analyzing the backgrounds of the Byzantine iconographic tradition. Except for the special case of such an icon as that which allegedly "Christ himself made, which is called 'not with hands' [*eikona tēn legomenēn acheiropoiēton*],"[12] or of the icons attributed to Luke (Fig. 22), the Byzantines did not regard it as important or even interesting to know when or by whom either a florilegium or an icon had been crafted: it was part of the tradition.

The florilegia indicate that it was an identifying characteristic of Byzantine theological method, and one that throughout the Iconoclastic controversy was to be shared by the theologians on both sides, to appeal to the authority of the fathers as the changeless truth set down in the norms of traditional doctrine. First among those norms—for Eastern Orthodox Christians, as for all other Christians, as well as for Jews and Muslims—was the written word of Holy Scripture, howsoever its canon may have been defined. The habit of Byzantine theologians of seeming to intermingle proof texts from the Bible indiscriminately with quotations from later centuries has led some Western, especially Protestant, interpreters into the error of attributing to them a doctrine of homogenized and unstratified authority. Thus Harnack spoke about a Byzantine traditionalism "which regarded any participation by theology in the work of the present-day church with

8. *OED* 4-I:344, s.v. "florilegium."
9. Beck 1959, 446.
10. Diekamp 1907.
11. Gibbon 1896–1900, 4:463.
12. John of Jerusalem *Against Constantine V* 4 (PG 95:320).

45

suspicion, which put authority in the place of scholarship, and which elevated some ancient teachers to heaven as saints while it banished others to hell as heretics."[13] But Byzantine theology affirmed unequivocally the primary position of Scripture in the schema of authority. For example, "the most prominent Orthodox theologian and philosopher of the eighth century"[14] and the most universally influential among the systematic theologians of the Eastern tradition, John of Damascus, in the chapter of *The Orthodox Faith* immediately following his summary presentation of the doctrine of images, took up the authority of Scripture as "the purest of waters" imbued with "inexhaustible grace." This he set into sharp contrast with whatever could be derived "from outside sources [*para tōn exōthen*]."[15] By this phrase he was evidently referring in the first instance to the Greek philosophers and other non-Christian writers, despite his repeatedly demonstrated willingness to make use of their insights when it suited his theological or dialectical purpose; but it would not do violence to his language, and above all to his usage, to extend the supreme authority of the Bible over all other sources also to its supremacy over other sources that were Christian.

Nevertheless, it is essential to recognize that this celebration of biblical authority did come just after a paragraph in which the Damascene had explicitly refused to confine authority to the Bible:

> Moreover, that the apostles handed down by tradition much that was not written down [*agraphōs paradedōkasi*],[16] Paul, the apostle of the Gentiles, tells us in these words: "Stand firm, then, brothers, and hold fast to the traditions which you have learned from us by word or by letter."[17] And to the Corinthians[18] he writes: "I commend you for always keeping me in mind, and maintaining the traditions I handed on to you [*kathōs paredōka hymin, tas paradoseis katechete*]."[19]

For the controversy over images, in the context of which John of Damascus was making this point, and for the understanding of Byzantine theology generally, it is essential to note that this "handing down by tradition of

13. Harnack 1931, 2:28.
14. Ostrogorsky 1927, 40.
15. John of Damascus *The Orthodox Faith* IV.17 (PG 94:1176–77; NPNF-II 9:89).
16. This could also mean, but probably does not: much that was not contained in Scripture, though it might have been written down somewhere else.
17. 2 Thess. 2:15.
18. 1 Cor. 11:2; because the plural in the Greek original of the passage is basic to the argument of John of Damascus, I have changed the rendering "tradition" in *The New English Bible* to "traditions."
19. John of Damascus *The Orthodox Faith* IV.16 (PG 94:1173–76; NPNF-II 9:88).

much that was not in Scripture" was said to have come from the original apostles of Jesus Christ, who had in turn received it from Christ and from the Holy Spirit. It was not believed to have been the subject of new and additional revelations given to the church after the apostolic era.

At the same time the Byzantines insisted that the Holy Spirit who had inspired the apostolic Scriptures was present and active in the post-apostolic church as well, in keeping with the promise of Christ to the apostles, and through them to the church of every time and every place: "When he comes who is the Spirit of truth, he will guide you into all the truth."[20] Therefore the portentous formula of the so-called apostolic council described in the fifteenth chapter of the Acts of the Apostles, "It is the decision of the Holy Spirit, and our decision,"[21] could become the justification also for later church councils to claim to be expressing "the decision of the Holy Spirit, and our decision," without making any clear disjunction between these forms of decision. The fifth ecumenical council, held at Constantinople in 553, quoted this formula from the Book of Acts, as confirming "the great examples left us by the apostles, and the traditions of the fathers":

> Although the grace of the Holy Spirit abounded in each one of the apostles, so that no one of them needed the counsel of another in the execution of his work, yet they were not willing to define on the question then raised concerning the circumcision of the Gentiles until being gathered together they had confirmed their own several sayings by the testimony of the divine Scriptures. And thus they arrived unanimously at this sentence, which they wrote to the Gentiles: "It is the decision of the Holy Spirit, and our decision."[22]

Obedience to the decree of a council was obedience to the Holy Spirit—though only if the council was deemed, according to whatever criteria, to have been truly ecumenical and truly orthodox, as became evident in the controversy over the synod held at Ephesus in 449 (the so-called "robber synod of Ephesus [*latrocinium Ephesinum*]"); this synod was overriden and superseded by the Council of Chalcedon in 451, which now counts as the fourth ecumenical council.

Whatever may have been the difficulties created by the authority of the tradition for Byzantine thought (and on both sides of the debate) when it confronted the new and yet ancient issue of the place of images in the

20. John 16:13.
21. Acts 15:28.
22. Second Council of Constantinople (Alberigo 108; *NPNF*-II 14:306).

worship of the one invisible God, our historiographical difficulties in seeking after more than a millennium to reconstruct that tradition (and on both sides of the debate) are in some ways at least as great.[23] For these historiographical difficulties, moreover, we have both sides to thank. In what must be, for any historically minded person, the most chilling of all of George Orwell's pictures of the totalitarian state, "day by day and almost minute by minute the past was brought up to date" in conformity with the newest party line, when in libraries and archives "the original copy [was] destroyed, and the corrected copy placed on the files in its stead," until a document "rewritten a dozen times still stood on the files bearing its original date, and no other copy existed to contradict it."[24] Without having at its disposal the technological capacity of the Ministry of Truth described in *1984*, the Byzantine alliance of "religion and *Realpolitik*" did match it in thoroughness. When the edict against images had been issued by Emperor Leo III, squads were dispatched not only to government buildings, churches, and monasteries, but to private homes, to extirpate the abomination of the idolatrous pictures that had desecrated the holy city of Byzantium. Even if one does not credit all the details of the atrocity stories that were circulated by the partisans of images,[25] we must conclude that the police did their job effectively. Just how effectively can be judged by the scarcity today of pre-Iconoclastic icons. Therefore the opening sentences of an essay by Kurt Weitzmann on "The Icons of Constantinople" summarize very well the historian's predicament: "Iconoclasm, Venetian looting in 1204, and the sack by the Turks in 1453 are the main reasons why only very few icons have survived in Constantinople proper. It may seem daring, therefore, to write an entire chapter on the icons of the capital."[26] Most such studies of pre-Iconoclastic icons must deal with other centers than Constantinople, above all, of course, the Monastery of Saint Catherine on Mount Sinai,[27] whose treasure trove includes a familiar sixth-century encaustic icon of Christ. As a consequence of the thoroughness with which the early icons were eliminated, it is extremely difficult for the art historian to assemble the surviving iconographic evidence into a connected narrative account of "the icons before Iconoclasm."[28]

23. On the historiographical problems, see Uspenskij 1950–51, as amplified and corrected by Ostrogorsky 1969, 147–52.

24. Orwell 1949, 40–41.

25. Theodore the Studite *Orations* IX.12 (PG 99:788); Nicephorus *Refutation* II.5 (PG 100:344).

26. Weitzmann 1982, 11.

27. See Galey 1980, especially the chapters by George Forsyth, "The Monastery of St. Catherine at Mount Sinai: The Church and the Fortress of Justinian," and by Kurt Weitzmann, "The Arts."

28. Baynes 1951, 93–106.

It is, however, almost as difficult for the intellectual historian to put together the bits and pieces of the writings of the Iconoclasts that have outlived their enemies.[29] Although there were several substantial theological treatises directed against images, including the works of the theologian-emperor Constantine V, these have not come down to us intact. They fell victim to the zeal of the eventual victors in the Iconoclastic controversies, who pursued them as relentlessly as the Iconoclasts had hunted down the icons themselves. Fortunately for the historian, the conventions of philosophical and theological polemics before the invention of printing required that a reader who may not have seen the treatise being refuted be supplied with at least enough of an excerpt from it to make sense of the critique. It is to this convention that we owe many of the fragments of the pre-Socratics edited by Hermann Diels,[30] as well as the works against Christianity by such leading exponents of Greco-Roman paganism as the philosopher Celsus and the emperor Julian "the Apostate." Until the discovery of the Coptic library at Nag Hammadi, scholars were likewise dependent on the writings of the orthodox church fathers for most of their knowledge of Christian Gnosticism,[31] and to a considerable extent they still are. But the detective work of attempting to read such excerpts within their own system of belief when they have always been selected—and have sometimes been distorted—on behalf of an opposing system of belief presents a formidable methodological challenge to the present-day historian. The challenge becomes all the more disturbing when the issue for which the historian is probing the material is the issue of tradition itself, since it was the purpose of the orthodox refutation to deny the legitimacy of the appeal to tradition by the heretics.

The tradition dealing with the use of images, like the tradition of monotheism to which it had stood in a corollary position ever since the giving of the Law to Moses on Mount Sinai, was of course far older than Christianity, and it had an ancestry in paganism as well as in Jewish monotheism.[32] The ambiguity of the tradition was far older as well.[33] Both groups of Christians in the Iconoclastic controversy denounced Judaism and dissociated themselves from the Jews, who had "introduced an absence

29. The problem of the sources has been thoroughly dealt with in Gero 1973, to which I am deeply indebted.
30. Jaeger 1947, 1–17.
31. Van den Eynde 1933.
32. Geffcken 1916–19.
33. Barnard 1974, 80–103.

[*penia*] of divinity."[34] Nevertheless, both of them also acknowledged the bearing of the biblical and post-biblical Jewish tradition on the question of the place of the icons in the worship of the one God. The crucial text was the commandment in the Decalogue against "graven images," or as the Septuagint had it, against "an idol or any likeness whatsoever [*eidōlos oude pantos homoiōma*]."[35] Regardless of whether this prohibition was punctuated in such a way as to form a part of the First Commandment, "You shall have no other god to set against me," as the Roman Catholic (and then the Lutheran) system of numbering the Ten Commandments was to take it, following the precedent of Augustine, or in such a way as to become the Second Commandment on its own, as the Eastern Orthodox (and then the Calvinist and Anglican) system was to count it, following the Jewish tradition documented in Philo and Josephus—it was believed to form a nonnegotiable foundation of the repugnance with which, on the basis of the Jewish Scriptures, the faith of the people of Israel had always regarded all artistic representations of the Holy, from the golden calf in the wilderness to the icons in the Christian churches.

We may put to one side for later consideration the arguments between the defenders and the opponents of icons over such artistic representations within the Old Testament itself as the cherubim on the Tabernacle, which were described as commanded by God in a later chapter of the same Book of Exodus that contained the prohibition of images;[36] such representations were continued on our tapestry icon with the figures of the angels (Figs. 42, 44, 50). But there is some striking evidence, uncovered by twentieth-century archaeology of the synagogue at Dura-Europos, for the ambiguity also of the post-biblical Jewish tradition on representation. Scholars have drawn several lines of connection between the art of the Dura synagogue and the art of the Christian Church. For example, the "analogy" of the figure of the apostle Paul in Christian art has been used in order to explain how the Jewish artists, in their treatment of Ezekiel, had introduced the prophet at the center of a narrative composition in which he was prominent.[37] Again, the form in which Joshua appears in one of the Dura panels provides an illuminating contrast with the figure in the mosaics at Santa Maria Maggiore.[38] Christians had used the name "Joshua" as a type of the name "Jesus," as can be seen already in the use of the name *Iēsous* for Joshua

34. Second Council of Nicaea (Mansi 13:276; Sahas 102).
35. Ex. 20:4 (LXX).
36. Ex. 36:8, 35.
37. Kraeling 1979, 194b.
38. Kraeling 1979, 231a.

50

17. Moses receiving the tablet of the law in the shape of a scroll. Sixth-century mosaic above the apse in the Church of Saint Mary. Saint Catherine's Monastery, Sinai

as well as for Jesus in the New Testament.[39] Therefore this particular contrast might conceivably have been carried even further.[40] For behind the Christian images of Joshua lay a typology of Joshua and Jesus: Moses stretching out his hands in battle was an anticipation of the cross, and Israel prevailed in that battle "because, while one who bore the name of Jesus was in the forefront of the battle, [Moses] himself made the sign of the cross."[41]

These and other references to Christian parallels with Jewish iconography, interesting and important though they are, scarcely prepare the reader of the authoritative monograph on the synagogue at Dura for the bold hypothesis that "the paintings of Dura can properly be called forerunners of Byzantine art."[42] There was, for example, the depiction by Byzantine artists of the very scene of Moses at Sinai receiving the law, including the prohibition of images (Fig. 17). This depiction, as one scholar has noted, "has a long tradition, reaching back into Jewish times," when it was "to be found above the Torah niche in the 3rd century synagogue of Dura Europos (now in the museum of Damascus)."[43] At the hands of Christian exegetes, and then of Christian artists, this scene at Sinai formed part of a far more elaborate typology of "the mystical Exodus" which "sees in the march of the Jews from the Red Sea to Sinai through the desert a type of the journey of the Christian soul to God."[44] And Moses himself, who had been regularly cited by the Iconoclasts as their ultimate authority against icons, became for the Iconodules "the hierophant."[45] In view of the efforts by John of Damascus and other defenders of Iconodule orthodoxy to validate the Byzantine reverence for images on the basis of early usage, the evidence provided by Dura may at least in part make up for the absence of more artistic remains from the early centuries of Christian history—although it also adds to the ambiguity of the argumentation from tradition.

As applied to the prohibition of graven images in the Second Commandment, the argumentation from tradition was burdened with the further ambiguity that attended all early Christian appeals to the authority of the Mosaic law. In the earliest exemplar of Christian *adversus Judaeos* literature, the *Dialogue with Trypho* of Justin Martyr—purportedly, though of course

39. Acts 7:45; Heb. 4:8.
40. Daniélou 1960, 231–34.
41. Justin Martyr *Dialogue with Trypho* 90 (*PG* 9:689–92; *ANF* 1:244).
42. Kraeling 1979, 384b.
43. Weitzmann in Galey 1980, 85.
44. Daniélou 1960, 226.
45. Theodore the Studite *Refutation* I.5 (*PG* 99:333; Roth 24).

not actually, the verbatim transcript of a real encounter—the Christian apologist laid claim to the Jewish Bible not as a property that the Christians shared with the Jews but as the property that the Christians now had all to themselves.[46] But to explain how Christians were making use of this property, he went on in a later chapter to posit a distinction between "what in the law of Moses is naturally good, and pious, and righteous, and has been prescribed to be done by those who obey it" and "what was appointed to be performed by reason of the hardness of the people's hearts." It was the former provisions in the law, "that which is universally, naturally, and eternally good," as distinguished from that which had been specifically and temporarily commanded as positive ceremonial and political law only for Israel, that remained binding on Christian believers.[47] This was, to be sure, a distinction difficult to make precise on the basis of the usage in the Old Testament itself, where, within the Ten Commandments, moral imperatives that Judaism shared with the universal natural law, such as the prohibition of murder, were intermingled with specifically Jewish commandments of a ceremonial or political kind, such as the law of the Sabbath.

From the Pauline Epistles and the Acts of the Apostles it is evident that the enforcement of the requirement of circumcision upon Gentile converts to Christianity was a principal source of disputes over the permanent validity of the ceremonial law,[48] and that the requirement of eating kosher food was another.[49] But these requirements were not a part of the Decalogue itself. Within the Decalogue, as is clear from the New Testament,[50] it was the law of the Sabbath that was the focus for such disputes, since it was the explicit requirement of the Fourth (or Third) Commandment and was by far the longest and most detailed of the Ten Commandments.[51] It based the observance of the Sabbath, moreover, on a truth that was in the fullest sense of the word "universal" (that is, a truth pertaining to the whole universe), the creation of heaven and earth in six days, not merely on the Exodus or some other historical presupposition that pertained only to Israel. Yet, apparently in the first century,[52] the Christians had taken it upon themselves to move their own observance of the Sabbath from Saturday to

46. Justin Martyr *Dialogue with Trypho 29 (PG 6:537; ANF 1:209)*.
47. Justin Martyr *Dialogue with Trypho 45 (PG 6:572; ANF 1:217)*.
48. For the cases of Timothy and of Titus, compare Acts 16:3 with Gal. 2:3.
49. Acts 9:9–16, 15:29.
50. See the discussion in John of Damascus *The Orthodox Faith IV.23 (PG 94:1201–05; NPNF-II 9:95–96)*.
51. Ex. 20:8–11.
52. So it seems necessary to conclude from 1 Cor. 16:2 and Rev. 1:10.

Sunday, although they retained the Jewish practice of observing one day in seven. Thus the ambiguity in applying the prohibition against graven images to the icons in the church lay in the question: Was this prohibition of "graven images" part of what Christians could dismiss as the temporary ceremonial and political law obligatory only for the people of Israel (as the commandments requiring observance of Saturday as the Sabbath, kosher food, and circumcision were taken to be)? Or was the injunction against images meant in the Decalogue as part of the universal, natural law (as were the commandments prohibiting adultery, murder, and theft, recited also by Paul),[53] and thus permanently binding not only upon the Jewish community under the old dispensation, but no less binding upon the Christian community even after it had been set free from the authority of the law of Moses as a whole—in fact permanently binding upon the entire human community simply by virtue of its being human and created?

At least initially, it would seem that the Iconoclasts were the ones who were more entitled to appeal to the authority of tradition. Their opponents appeared to be acknowledging as much when they said in exasperation that after all forms of argumentation and rhetoric had failed, the Iconoclasts would as a last resort always "take refuge in tradition."[54] Georges Florovsky has described the state of the question this way:

> What was the main authority of the Iconoclasts? It was an appeal to antiquity, and this was possibly the strongest point both of their attack and of their self-defense. It was a double appeal to Scripture and Tradition. It is usual, in modern interpretation, to give priority to their scriptural proof. Their patristic references were rather neglected. They seemed to be less instructive and convincing. But in the eighth and ninth centuries the patristic proofs would carry full weight. It seems to me, we should have given more attention to these references, not to pass a judgment on the fight, but to ascertain the reasons and aims of the contending parties.[55]

In their attack on the icons, the Iconoclasts were able to call upon an almost unbroken succession of church fathers and apologists for Christianity who had seen one of the principal differences between false, heathen worship and the worship of the one true God precisely in this: that for Christianity,

53. Rom. 13:9; it would certainly be pressing the language too far to put emphasis on the words following the recital, "and any other commandment there may be," as though they indicated an indifference to specific provisions and specific commandments.
54. Nicephorus *Refutation* III.1 (PG 100:376).
55. Florovsky 1972, 2:105.

in the words of Origen, "image" in the good sense of the word was to be understood of "the inward man,"[56] a human dignity whose perfection had been reserved for the consummation of all things,[57] but whose potential was present now in "the rational soul which has a capacity for virtue."[58] Paganism, by contrast, was accused of having permitted and even prescribed bowing down before external images wrought by human hands. For example, Athenagoras of Athens in the second century, who has been described by a modern patristic scholar as "unquestionably the most eloquent of the early Christian apologists" and "the first to attempt to prove monotheism scientifically,"[59] denounced artistic representations of the divine as a recent invention and as nothing but "earth, stone, wood, and a misapplied skill."[60]

In fact, "of the pre-Nicene Fathers, Clement of Alexandria was the only one to have any feeling at all for art and beauty; but even he acknowledged no such thing as 'Christian' art, and saw the true love of beauty as reaching out beyond the things of sense towards its end in God, the primal source of all spiritual beauty."[61] Clement, who counted the prohibition of images as the Second Commandment, saw the object of its denunciation as the practice of paying divine honor, which should be reserved for "the One who is," to "things created, and vain, which human artificers have made."[62] But, he insisted, "nothing among created things can be a likeness of God," and "none of those images which they worship can be similitudes."[63] Nor was it only the immorality and licentiousness of pagan art that Clement found objectionable:

> Art is powerful, but it cannot deceive reason, nor those who live in accordance with reason. . . . It is with a different kind of spell that art deludes you, if, though it does not lead you to the indulgence of amorous affections, it does lead you to pay religious honor and worship to images and pictures. The picture is a faithful resemblance, you say. Well and good! Let art receive its share of praise, but let it not deceive man by passing itself off for truth. . . . While you bestow the greatest pains that the image may be fashioned with the most exquisite beauty possible, you

56. Origen *Against Celsus* VI.63 (*GCS* 3:133–34; Chadwick 378–79).
57. Origen *On First Principles* III.vi.1 (*GCS* 22:280; *ANF* 4:344).
58. Origen *Against Celsus* VII.66 (*GCS* 3:216; Chadwick 450).
59. Quasten 1951–86, 1:229, 232.
60. Athenagoras *Embassy for the Christians* 17 (*PG* 6:925; *ACW* 23:47–48).
61. Campenhausen 1968, 175.
62. Clement of Alexandria *Stromata* VI.16 (*GCS* 15:501; *ANF* 2:512).
63. Clement of Alexandria *Stromata* VI.18 (*GCS* 15:516; *ANF* 2:519).

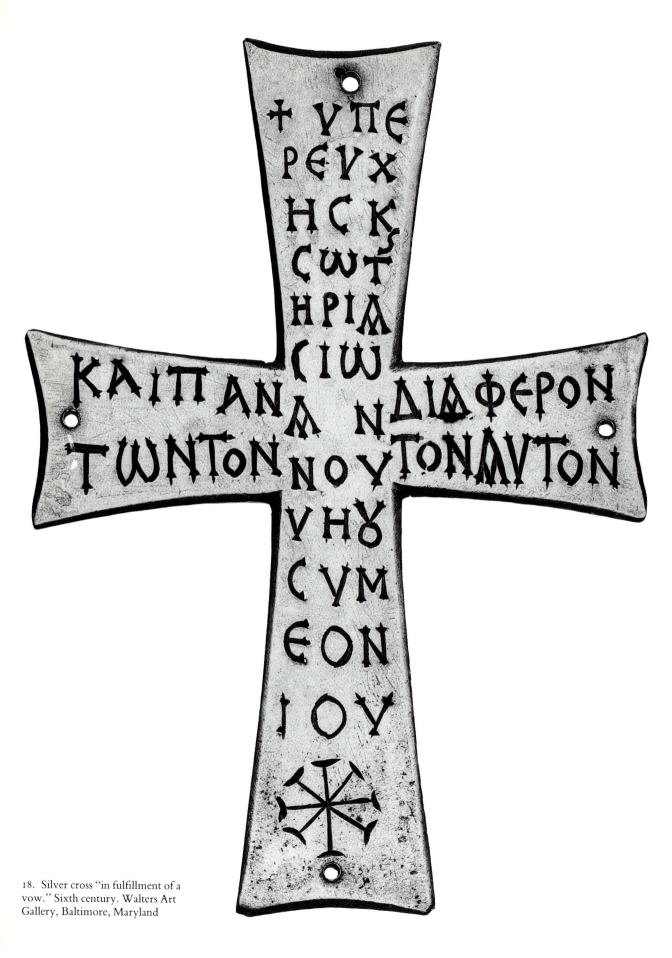

18. Silver cross "in fulfillment of a vow." Sixth century. Walters Art Gallery, Baltimore, Maryland

exercise no care to guard against your becoming like images for stupidity.[64]

Such polemics against Greek practice, both idolatrous and artistic, which could be multiplied almost at will from the Christian writers of the first several centuries, would seem hypocritical, to say the least, if these spokesmen for Christianity themselves had at the same time been paying worshipful homage to icons—or even perhaps if they had only been making them without actually worshiping them.

By contrast with this negative treatment of the icons in the tradition, the cross was in the position of being able to claim universal support.[65] One example from approximately the same period as our tapestry icon is a small cross bearing an inscription in Greek that shows it to have been created "in fulfillment of a vow [*hyper euchēs*]" (Fig. 18). On the basis of this universal Christian reverence for the cross, the Iconoclasts could ask, "Where is there anything written about the icon comparable to what is written about the cross?"[66] Saint Paul had called the cross "the power of God."[67] He had also exclaimed: "God forbid that I should boast of anything but the cross of our Lord Jesus Christ, through which the world is crucified to me and I to the world!"[68] Nevertheless, the evidence for this aspect of the tradition, whether literary or iconographic, is also surrounded by ambiguity. At the end of the second century Tertullian testified that Christians "trace upon the forehead the sign" of the cross many times a day.[69] In the fourth century the emperor Julian singled out this practice, together with "hissing at demons," as evidence that Christians were no less superstitious than the crudest of the pagans.[70] But we know from the *Apology* of Tertullian—which was written in A.D. 197 and, as Eusebius of Caesarea attests,[71] had been translated into Greek in the third or fourth century and may therefore be assumed to have been available in Constantinople in the eighth century—that the Christians were being criticized in the second century for "rendering superstitious adoration to the cross."[72] Such language in Tertullian does sound as though he were speaking of crosses as real physi-

64. Clement of Alexandria *Exhortation to the Heathen* iv.57–62 (*GCS* 12:45–48; *ANF* 2:188–89).

65. Bernardakis 1901, 193–202, 257–64.

66. Quoted in Theodore of Studios *Refutation* I.8 (*PG* 99:337; Roth 27–28); see also *Refutation* I.15 (*PG* 99:345; Roth 35).

67. 1 Cor. 1:18.

68. Gal. 6:14.

69. Tertullian *On the Chaplet* iii.4 (*CCSL* 2:1043; *ANF* 3:94–95).

70. Julian *Epistles* 19 (*LCL* 3:52).

71. Eusebius *Ecclesiastical History* II.2 (*GCS* 9:110–12; *NPNF*-II 1:106).

72. Tertullian *Apology* xvi.6 (*CCSL* 1:115–16; *ANF* 3:31).

cal objects, not only of the practice of making the sign of the cross on the forehead or the breast. Excavations have not, however, turned up as much corroboration for this as might have been expected. As a recent summary of the archaeological data has put it,

> In the early Christian centuries the cross appears above all in the art of sepulchers and in miniatures; therefore a precise dating is rarely possible for the period before Constantine. The cross on the wall of a house in Herculaeneum (before A.D. 79), since it does not face the East, is not unanimously regarded as Christian. A cross in the form [of a Chi] contained in an inscription at Palmyra from the year 134 has been shown to be non-Christian. There are several forms of the cross found on shards of pottery in Dura-Europos (before A.D. 256).[73]

In any case, however, the Iconoclasts, as their enemies testified,[74] believed that they were following authentic tradition when, while treating the cross with reverence, they drew a sharp distinction between it and the icons.

Also on the basis of the tradition, they drew an even sharper distinction between the icons and the Sacrament of the Eucharist, and they made that distinction a fundamental component of their attack upon the icons. In the formula of Emperor Constantine V, "the bread that we receive is an icon [*eikōn*] of his body, presenting the form [*morphazōn*] of his flesh, as that which has become the figure [*typos*] of his body."[75] Or, as another and unidentified Iconoclast put it,

> Yes, it *is* legitimate for Christ to be iconized [*eikonizesthai ton Christon*]— but only as the sacred formula handed down by tradition from God himself specified: "This do in remembrance of me."[76] Obviously, then, it is not legitimate for him to be iconized in any other way, nor to be held in remembrance in any other way. For only this way of his being represented in an icon is authentic [*alēthes*], and only this way of iconizing him is sacred.[77]

The tradition of celebrating the Eucharist as the true presence of Christ in his body and blood was taken to be altogether unambiguous, as the defenders of the icons were of course also ready to grant. The Iconoclasts quoted from the Byzantine liturgical tradition, which they shared with their

73. *LTK* 6:610.
74. Nicephorus *Refutation* III.34 (*PG* 100:425).
75. Constantine V, quoted in Nicephorus *Refutation* II.3 (*PG* 100:337).
76. 1 Cor. 11:24.
77. Quoted in Theodore the Studite *Refutation* II.10 (*PG* 99:340; Roth 29).

opponents, to identify the Eucharist as the only icon that was not a deceptive representation of reality; for "there was no other kind or form under the sun selected by him which could depict the Incarnation."[78] This tradition had been conveyed by Christ himself "to his holy disciples and apostles," and his words meant that what was received in the Eucharist was "exactly and authentically [*kyriōs kai alēthōs*] his body."[79] No other so-called icon was "exactly and authentically" what it purported to depict: the sign and what the sign represented, *signum* and *signatum*, were identical here—but nowhere else. Only the Eucharist could be "the icon that has been proven to be the true icon of the incarnate dispensation of Christ our God, . . . and it is the one which the true Creator of the life of the world has handed down to us with his own words."[80]

As was to be expected, the defenders of icons not only refuted the Iconoclasts' appeal to tradition, but developed their own forms of that appeal. The basic principle, for Iconodule no less than for Iconoclast, was that "what has been handed down to the catholic church is subject to neither addition nor reduction."[81] For the repetition in the Book of Deuteronomy of the prohibition against the image as "the handiwork of a craftsman [*ergon cheirōn technitou*]" was followed immediately, at any rate in the Septuagint, by a curse upon anyone who "dishonors his father or mother" or who "removes the landmarks [*horia*] of his neighbor," which could then be conflated into: "Cursed is he that removes his father's landmarks."[82] Although the destruction of the icons has made it difficult for us to piece together a connected narrative of the art history, the very existence of icons, some of them obviously of great antiquity, was to the Iconodules an apodictic proof of their standing as part of the tradition. The Second Council of Nicaea in 787 described the period between the time of Christ and the time of Emperor Constantine I, the very period when Christians were "standing up against idols," as the time when the icons had arisen:

> Moved with divine zeal in building churches, some of them in the name of Christ and others in honor of saints, [they] painted in them scenes related to the Incarnation of our God, as well as other stories related to the contests of the martyrs. Others, who wanted to preserve the memory

78. Iconoclast Synod of Constantinople, quoted by Second Council of Nicaea (Mansi 13:264; Sahas 93).

79. Constantine V, quoted in Nicephorus *Refutation* II.2 (PG 100:333).

80. Iconoclast Synod of Constantinople, quoted by Second Council of Nicaea (Mansi 13:264; Sahas 94).

81. Second Council of Nicaea (Mansi 13:328; Sahas 145).

82. Deut. 27:15–17 (LXX).

of them forever, painted on boards the icon either of their desired martyr or even of Christ himself. Icons were also reproduced by our holy fathers and pious men on holy veils and utensils which they used to perform bloodless sacrifices [of the body and blood of Christ in the Eucharist]. All these are clearly preserved up to our own time and will remain forever.[83]

And yet, although six ecumenical councils, beginning with the First Council of Nicaea in 325 and continuing until the Third Council of Constantinople in 680/81, had had the opportunity to condemn these icons, none of them had done so until the Iconoclasts came along.[84] In a way this was an argument from silence, with all the well-known logical hazards attending such a form of argumentation.

In addition, however, it was a method of argumentation from tradition and from "the vertical dimension of ecumenism."[85] For the preceding ecumenical councils, far from having dealt only with the issues of christological dogma by which they are usually identified, had addressed a great variety of practical questions in the life of the church. In particular they had been explicit and detailed in their condemnation of both moral and liturgical abuses as these arose. And above all they had given repeated attention to whatever remnants of idolatrous and immoral pagan practice seemed to be evident among the lay people and especially among the clergy. The First Council of Nicaea in 325, for example, had devoted its second canon to the danger that could arise if "men just converted from heathenism to the faith and who have been instructed in the catechism but a little while [*en oligōi chronōi katēchēthentas*]" were to be ordained without a proper interval having elapsed.[86] In its ninth canon the same council had gone on to deal with the related problem of "presbyters [who] have been advanced without examination or [who] upon examination have made confession of crime."[87] As the authoritative nineteenth-century commentary on the history of church councils pointed out, "idolatry, sorcery, and the like" were among the principal such "crimes" for which presbyters and bishops were to be tried.[88] With such legislation of the First Council of Nicaea in mind, the Second Council of Nicaea argued that if the Christian use

83. Second Council of Nicaea (Mansi 13:220; Sahas 60).
84. John of Jerusalem *Against Constantine V* 5 (PG 95:320).
85. Dumeige 1978, 195.
86. First Council of Nicaea (Alberigo 6; *NPNF*-II 14:10).
87. First Council of Nicaea (Alberigo 10; *NPNF*-II 14:23).
88. Hefele 1855–60, 1:396.

of images had been the idolatrous practice that the Iconoclasts had charged it with being, it would have been singled out by one or another council during all those centuries while it was becoming standard Christian practice. The tradition being cited as authority, then, was tradition in the concrete, the very icons against which the Iconoclasts had—without precedent, it was argued—launched their campaign. The campaign provided inadvertent proof for the presence of the icons in the tradition.

Yet the sheer preponderance of the patristic attacks on images or any other kind of representation, of which the Iconoclasts had been able to take such advantage, made it necessary for the defenders of icons to turn away from a preoccupation solely with the literary deposit that had come down to them from the first Christian centuries. Because of the apologetic situation of the church under a pagan government and in a pagan culture, Christian writers seem to have dealt explicitly only with an image worship that was idolatrous, but not with a legitimate Christian use of images. Therefore it appeared that if the surviving collection of written works were to be taken as exhaustive of the entire tradition of the church, the argument from tradition would support the Iconoclasts, as they insisted that it did. But in the form it had been taking since the second century,[89] the traditionary method of proof had come to recognize that tradition in its fullest and deepest sense, as the ongoing and living voice of an ongoing and living Christian community, could never be simplistically confined to those *ipsissima verba* of the church fathers that had been preserved in the libraries of the church. If tradition were to be used to address new and unprecedented issues that arose within Christian life and teaching, such as the issue of icons, the reliance on texts needed to be amplified—not negated, but amplified— by the introduction of two additional and more subtle methods of invoking the authority of tradition: the appeal to unwritten tradition, and the argument from analogy within tradition. Both of these refinements of the conventional argument from tradition could be construed in such a way as to work to the advantage of the Iconodule position. At the same time, both of these methods could present themselves as "traditional" in the fullest sense, by being able to lay claim to traditional authorization of the very highest sort, as documented, for example, in the writings of the celebrated Basil "the Great," fourth-century bishop of Caesarea.[90]

89. That development has been well described in van den Eynde 1933 and Flesseman–Van Leer 1954.

90. See the lengthy excerpt from Gregory of Nyssa *Funeral Oration on Basil* (PG 46:796) in the Acts of the Second Council of Nicaea (Mansi 13:224; Sahas 63–64). Basil was, as the council said, Gregory's "own brother in flesh and spirit."

As it happened, the formal authority of the argument from unwritten tradition was itself an interesting illustration of the inadequacy of invoking only the *ipsissima verba* of the church fathers to document apostolic tradition. The first important spokesman for the authority of tradition had been Irenaeus of Lyons.[91] His most detailed consideration of the question of unwritten tradition, however, had come in the course of his reply to Gnostic heretics, who, "when they are confuted from the Scriptures, turn around and accuse these same Scriptures of being neither correct nor authoritative." The written words of Scripture, according to them, were "ambiguous"; as a result, they argued, "the truth cannot be extracted from them by those who are ignorant of tradition." And the Gnostics maintained that this traditionary "truth was not delivered by means of written documents [*per literas traditam*], but *viva voce*."[92] A superficial reading of such patristic testimony could lead to the conclusion that the antithesis lay in an opposition between the heretics, who invoked some sort of vague unwritten tradition, and the orthodox, who relied solely upon the written word of the Scriptures. But Irenaeus himself appeared to be going beyond such a superficial reading of the antithesis when, in the very next paragraph, he appealed, against the Gnostic heretics, to "that tradition which originates from the apostles [and] which is preserved by means of the successions of presbyters in the churches," and to "the tradition of the apostles manifested throughout the whole world."[93] It would be difficult to interpret such an appeal to a universal apostolic tradition, handed down from the apostles by "temporal succession [*diadochē*]," as nothing more than Irenaeus's way of asserting the sole and sufficient authority of the New Testament.

Whatever may have been the position of Irenaeus, later church fathers had, in their writings, sometimes affirmed the authority of an unwritten apostolic tradition in addition to—or alongside—the written apostolic tradition. In going beyond the written deposit of the fathers to cite the unwritten tradition, then, the Iconodules could claim that they were simply being faithful to the written tradition, which itself had also done so. The most striking instance of a patristic reliance on unwritten tradition had come in the treatise *On the Holy Spirit* of Basil of Caesarea, written in 374. When the First Council of Nicaea had determined that the Son of God, as the Second Person of the Trinity, was "one in being [*homoousios*] with the

91. See Outler 1965.
92. Irenaeus *Against Heresies* III.ii.1 (Harvey 2:7; *ANF* 1:415).
93. Irenaeus *Against Heresies* III.ii.2, III.iii.1 (Harvey 2:7–8; *ANF* 1:415).

Father," the status of the Holy Spirit, as the Third Person of the Trinity, was left unclear. Having specified in considerable detail how the Son was related to the Father, Nicaea had simply added: "And [we believe] in the Holy Spirit," with no similar specification at all.[94] During the fifty years after Nicaea, that lack of specification had precipitated fierce controversy, in which the theological methods of argumentation employed for the doctrine of Christ proved inadequate as a means of dealing with the doctrine of the Holy Spirit. Recognizing this inadequacy, Basil had been faced with the embarrassment of having little or no explicit biblical or patristic support for the doctrine that the Holy Spirit should be confessed alongside the Father and the Son as a coequal in the Godhead.

Much of his case was based on liturgical practice. At issue was the propriety of a form of the doxology that read, "To God the Father and the Son our Lord Jesus Christ, with [*syn*] the Holy Spirit, glory and might for ever and ever. Amen,"[95] for which there was not explicit warrant in the New Testament. On the other hand, there was a liturgical practice that did of course have unanimous biblical and patristic support, that of baptizing "in [*eis*, into] the name of the Father and of the Son *and of the Holy Spirit*," as Christ had commanded his apostles before his ascension.[96] It was necessary to "preserve, both in the confession of faith and in the doxology, the doctrine taught at baptism."[97] The Holy Spirit was clearly coordinated with the Father and the Son in the New Testament formula, rather than being subordinated to the Father; and if the coordination of the Son with the Father meant what the Council of Nicaea had declared it to mean, then the implication seemed to be that the third "person," also being a member of the divine Triad in whose sacred name the candidate was being baptized, was to be accorded equal honor. Here Basil was following the precedent set in the earlier debates over the relation between the Son and the Father, where Athanasius had argued that baptism "into [*eis*] the Father and into the Son" was "not into the Creator and a creature," as the opponents of Nicene orthodoxy maintained, but into the Creator, who was both Father and Son.[98] Basil was now insisting, by extension, that if baptism was, as the formula prescribed by Christ required, also "into the Holy Spirit," it could not be into the Creator (the Father) and the Creator (the Son) and

94. First Council of Nicaea (Alberigo 5; *NPNF*-II 14:3).
95. Basil *On the Holy Spirit* xxix.72 (*PG* 32:201–02; *NPNF*-II 8:45).
96. Matt. 28:19–20; italics added.
97. Basil *On the Holy Spirit* x.24–26 (*PG* 32:109–13; *NPNF*-II 8:16–17).
98. Athanasius *On the Councils of Ariminum and Seleucia* 36 (*PG* 26:756–57; *NPNF*-II 4:470).

a creature (the Holy Spirit), but had to be only into the Creator, who was Father and Son and Holy Spirit.

Basil maintained that his position on the doctrine of the coequality of the Holy Spirit with the Father and the Son was vindicated both by the written evidence of the Scriptures and by the traditionary evidence of church custom.[99] Therefore, after he had extracted from the line of reasoning on the basis of liturgical and biblical tradition its full contribution to trinitarian doctrine, he went on to assert the existence of unwritten tradition, and to affirm its authority:

> Of the beliefs and practices whether generally accepted or publicly enjoined which are preserved in the church, some we possess derived from written teaching [*tōn en tēi ekklēsiai pephylagmenōn dogmatōn kai kērygmatōn ta men ek tēs eggraphou didaskalias*]; others we have received delivered to us "in a mystery"[100] by the tradition of the apostles [*ek tēs tōn apostolōn paradoseōs*]; and both of these in relation to true religion have the same force. And these no one will gainsay—no one, at all events, who is even moderately versed in the institutions of the church. For were we to attempt to reject such customs as have no written authority [*ta agrapha tōn ethōn*], on the ground that the importance they possess is small, we should unintentionally injure the gospel in its very vitals; or, rather, we should make our public definition a mere phrase and nothing more.[101]

He then enumerated several such "unwritten traditions."

These included: the use of the sign of the cross, prayer facing toward the east, the recitation of the words of institution at the celebration of the Eucharist, the blessing of water for baptism and of oil for chrism, and trine immersion at baptism. All of these practices had a standing in the church that was unquestioned, but none of them could be documented from the explicit injunctions of the New Testament. For example, the appearance of the words of institution in all three of the synoptic Gospels and in 1 Corinthians, albeit with noteworthy variations in wording, is usually taken as evidence that these words were indeed being recited from earliest times as the warrant for the Lord's Supper.[102] Even the omission of them from one of the most complete of patristic discussions of the sacraments, that of Cyril of Jerusalem, does not count against such evidence.[103] Cyril does

99. Basil *On the Holy Spirit* xxv.58 (*PG* 32:173–76; *NPNF*-II 8:37).
100. 1 Cor. 2:7.
101. Basil *On the Holy Spirit* xxvii.66 (*PG* 32:188; *NPNF*-II 8:40–41).
102. See Jeremias 1955.
103. See the comments in *NPNF*-II 7:xxvii–xxviii.

state that the Holy Spirit "makes the bread the body of Christ, and the wine the blood of Christ."[104] This suggests the Eastern rather than the Western doctrine of how the eucharistic miracle took place, viz., by the prayer for the descent of the Holy Spirit on the elements, the so-called Epiclesis, rather than by the recitation of the words of institution; but it does not prove that the words were not being recited in the liturgical observance being described by Cyril.

Significantly, all of these unwritten traditions pertained directly to the liturgical and sacramental life of the church, and in placing their authority alongside that of the written tradition in Scripture and the fathers Basil was applying the principle that "the rule of prayer should determine the rule of faith [*lex orandi lex credendi*]." In addition to those teachings that had been written down by the apostles and by their successors in the books of the tradition, they had instituted liturgical practices, in which, no less than in the written teachings, the one authentic apostolic tradition was available. So authoritative did Basil's case for unwritten tradition become, even in the Western Church, that it was included among the twelfth-century collection of quotations in Gratian's compilation of the canon law and, perhaps chiefly from that source, was regularly cited in support of the idea of a normative extrascriptural tradition, both for canon law and for church doctrine. In the East, moreover, the passage from Basil's *On the Holy Spirit* just quoted appeared verbatim in the first of the *Apologetic Orations against Those Who Are Expelling the Holy Icons* of John of Damascus, as well as in the *Refutation of the Iconoclasts* by Patriarch Nicephorus of Constantinople.[105]

Basil was likewise the source, along with other Greek fathers who were quoted in support of him, for an analogy invoked in the conciliar decree of 787, which contained a method of argumentation that was to prove decisive dogmatically as well as intriguing theologically:

Who does not know that when an icon is dishonored the insult applies to the person who is depicted on the icon? The truth knows this to be so and the nature of things teaches so. The fathers also agree with this: for example, Basil, who says: "The honor of the icon is conveyed to the prototype."[106] [There follow similar statements by Athanasius and John Chrysostom.] . . . These fathers clearly followed what is natural.[107]

104. Cyril of Jerusalem *Catechetical Lectures* XXIII.7 (PG 33:1113–16; *NPNF*-II 7:154).
105. John of Damascus *Orations on the Holy Icons* I.23 (PG 94:1256); Nicephorus *Refutation* III.8 (PG 100:389).
106. Basil *On the Holy Spirit* xviii.45 (PG 32:149; *NPNF*-II 8:28).
107. Second Council of Nicaea (Mansi 13:325; Sahas 145).

In the specific context of the words being quoted, Basil was not speaking about Christian icons, but was making the point that just as paying respect to the image of Caesar as well as to Caesar himself did not imply a divided loyalty, since there was only one Caesar whether in person or in the image, so also it was mistaken to charge the worship of the Son and of the Holy Spirit with dividing the unity of the Godhead. But by connecting this statement with various other *obiter dicta* quoted from Basil about icons,[108] the council felt justified in applying it specifically to Christian icons. Honor paid to the icon of Christ was in fact being addressed to Christ himself, not to the icon as such.

Yet this argument on the basis of tradition went beyond the simple multiplication of proof texts from Scripture and the fathers. For if, according to the council fathers in 787, all of this was true because "the nature of things teaches so" and if Basil, Athanasius, and others had "clearly followed what is natural," the principle of a correlation between the icon and the iconized evidently was not only a Christian teaching, but belonged to what must be labelled the "natural theology" of the fourth-century Greek fathers.[109] To an extent that has often gone unnoticed even in standard treatments of their thought, these thinkers felt free to fall back upon arguments from natural theology in the very midst of making a point about Christian revelation. Thus in his earliest work, *Against the Heathen*, Athanasius had found the idea that God the Creator as simple Being was superior to the composite beings of creation to be "a principle of natural philosophy [*logos physikos*],"[110] which it was assumed that any rational heathen should be able to acknowledge. He had also argued on the basis of the absoluteness and self-sufficiency of God as "an admitted truth about God [*peri theou logos*]."[111] Clearly this appeal to "natural theology" was for Athanasius a method of thinking that had a legitimate place in the exposition also of "revealed theology"; both were part of the tradition. Nevertheless, it had been in defense of revealed theology that the Greek fathers like Athanasius and Basil had resorted to this method, specifically in defense of their doctrines of the Trinity and the Incarnation, and therefore it was fitting that those doctrines should play the decisive role in shaping the aesthetic theology of icons in the thought of their Byzantine descendants.

108. Second Council of Nicaea (Mansi 13:268; Sahas 98).
109. The best brief introductions to this theme are Ivánka 1948 and Otis 1958, 95–124.
110. Athanasius *Against the Heathen* xxxix.4 (PG 25:77; NPNF-II 4:25).
111. Athanasius *Against the Heathen* xxviii.1 (PG 25:56; NPNF-II 4:18).

DIVINITY MADE HUMAN
Aesthetic Implications of the Incarnation

The Iconoclastic controversy was the first thoroughgoing debate in the history of the church about the nature and function of religious art and the possibility of a Christian aesthetics. In fact, as one historian has suggested, "during the entire Middle Ages there did not take place in the West any theoretical discussion of the relations between religion and art nearly so vigorous as that put forward by the Greek theologians."[1] That characterization is accurate in its description of the Western response to the Byzantine controversy.[2] It would also apply to both sides in the Byzantine controversy, to the Iconoclasts as well as to the Iconodules. By contrast with earlier opposition to images based on "spirituality of worship, adherence to Old Testament law, and revulsion against the cult practices of the pagan masses," the eighth-century Iconoclast position "was based firmly on doctrinal arguments."[3] And whether or not there was as much development in the Iconoclast position after 815 as some scholars have suggested,[4] the firm reliance on doctrinal arguments continued to mark both the Iconoclasts and the Iconodules. Among the latter, "perhaps the most penetrating"[5] was Theodore the Studite, who died in 826. This evaluation of Theodore holds despite the characterization of his thought by one scholar as "an iconosophy compounded of superstition, magic, and scholasticism."[6] The same scholar

1. Ladner 1931, 14.
2. Although Bastgen 1911–12 must be revised in the light of more recent research, it does remain a useful summary of Western reactions.
3. Kitzinger 1954, 133.
4. See the discussion in Beck 1959, 303.
5. Krumbacher 1897, 150.
6. Harnack 1931, 2:490.

also manifested the depth of his hostility not only to "iconosophy" but to icons as such when he described their development in Christian art and worship as an idolatrous practice that was carried on in the Eastern Church "just as it had been in paganism, only the sense of beauty had been corrupted."[7] The full depth of the doctrinal arguments can be understood only if we examine what happened when the theoretical justification of icons moved from the arguments over tradition described in the preceding chapter to proofs on the basis of Christology, and from these to what has been called a "scholastic" method of argumentation.[8]

In the early stages of the contention between Iconoclasts and Iconodules over the authority of tradition, the sheer mass of the explicit evidence from the early centuries of Christian thought and teaching clearly appeared to be weighted on the side of the Iconoclasts. The patristic defenses of the Christian faith, first those directed against Judaism and then those addressed to Hellenism, had consistently emphasized the fundamental divergence between Christian worship as paid to the invisible God and every form of idolatry as paid to visible representations of Deity. Moreover, they had done so in such a way that their polemical language now seemed, at least upon an unprejudiced initial reading, to apply even more severely to any Christian use of representative art in worship than it had to pagan practice. If that genre of patristic apologetic literature were to be taken as the only admissible evidence from the testimony of the fathers of the church, the Iconoclasts would seem to have been right in claiming that it was their uncompromising stance against images, and not the "novelty-mongering" of the spokesmen for image worship, that faithfully represented the continuing voice of the authentic and orthodox Christian tradition.

But before long it became obvious to all parties that the controversy could not be confined to that class of traditionary evidence, because the apologetic attacks on pagan image worship were not all there was to early Christian literature. For, as Florovsky has observed, "Iconoclasm was not just an indiscriminate rejection of any art," whether religious or secular. "It was rather," he continued, "a resistance to one special kind of religious art, . . . and its distinctive mark was, as Louis Bréhier put it recently, 'la recherche naïve de la vérité historique'—a special emphasis on the historic truth," especially as it pertained to the person of Christ.[9] When the fathers of the church were differentiating so sharply between the authentic worship of the invis-

7. Harnack 1931, 2:480.
8. Alexander 1958, 189.
9. Florovsky 1972, 2:115.

ible true God and the inauthentic worship of the visible false gods, they were doing so in the name of worship that was addressed also to the person of Jesus Christ. Already in the second and third centuries, and then *ex professo* from the fourth century onwards, the central preoccupation of Christian thought had been with the legitimacy of that specific form of worship. The fundamental question was, as a modern scholar has phrased it: "Is the Divine that has appeared on earth and reunited man with God identical with the supreme Divine, which rules heaven and earth, or is it a demigod?"[10] Eventually, the development of Christian art had also come to correspond with this theological development. That becomes clear from both zones of our tapestry *Icon of the Virgin*, for the glorification of divinity made human in Christ is the ultimate object of both zones. The damage to the textile cannot obscure the obvious conclusion that the theme of the upper zone of the icon is the familiar one of Christ in Majesty, seated on a throne and flanked by the two archangels Gabriel and Michael (Fig. 7); and although it is less massive in size than the lower zone, it is also still more exalted in theme. It has been suggested that the angels are bearing Christ aloft, and that "the iconography is undoubtedly derived from" earlier artistic representations of the Ascension of Christ, even though, strictly speaking, the icon itself "does not represent an Ascension." More specifically, it appears to have been adapted from one or another of the representations of the Ascension that were popular in Palestine, and probably elsewhere, around the time this icon was woven.[11]

But also in the lower zone of this *Icon of the Virgin* the most important figure is not the Virgin Mary as *Theotokos* or Mother of God, but her infant Son, even though the panel was inspired by devotion to Mary. The image of the Virgin is subordinate to the image of Christ in another sense as well; for it was on the question of the legitimacy or illegitimacy of the portrayal of Christ as confined and "circumscribed [*perigraptos*]" within an image, be he infant or adult, that the issue in the Iconoclastic controversy was perceived to depend, including for that matter the dispute over the justification for making Christian images of the Virgin Mary herself.[12] Here in our tapestry icon, Mary is holding him forward and presenting him to the world as its infant Sovereign. The angels Michael and Gabriel on either side likewise bear witness to him (Figs. 44 and 50), with the globe as a sign

10. Harnack 1905, 192.
11. Shepherd 1969, 98.
12. John of Jerusalem *Against Constantine* V 4 (PG 95:317).

of Christ's power and authority. But meanwhile the infant Christ himself is serenely looking out—with what Bernard Berenson, in commenting on a much later icon dealing with the same theme (though one that he believed to be Byzantine in provenance), once called his "*tranquilla sovranità*"[13]—at the world, of which already as a child he is the "All-sovereign [*Pantokrātōr*]" and the King. Important though the orthodox doctrine about the person of the Virgin Mary was to the theological apologia for icons, that doctrine, like every other orthodox doctrine in Byzantine Christianity, was ultimately a corollary of the two fundamental dogmas of the church, as these had been affirmed by the orthodox tradition and formulated by the ancient creeds and councils of the ecumenical church: the dogma of the Trinity and the closely related dogma of the Incarnation. When it came to a decision about icons, therefore, it seems at least by hindsight to have been unavoidable that the orthodox doctrine of the Incarnation would have to be for the theologians of the Byzantine church on both sides of the question the basic principle from which any such decision would proceed.

The Incarnation of the divine and eternal Logos in the historical person of Jesus Christ, which was unanimously taken by orthodox theologians and church councils to require the inseparable union between the divine nature and the human nature in him even here as a child, was, according to Byzantine liturgical spirituality and liturgical art and therefore according to Byzantine learned theology—and therefore according to Byzantine theological and philosophical aesthetics—the manifestation within the scheme of reality, including all of cosmic reality, of nothing less than New Being, divinity made human. Coming as it did after more than half a millennium of almost uninterrupted discussion about the various aspects of the doctrine of the Incarnation as New Being, the Iconoclastic controversy could have been expected at the very least to make use of some of the refinements of technical theological and philosophical vocabulary that had been evolved especially in the Greek-speaking Eastern section of the church during that discussion. But its use of the christological development went much further and deeper than mere vocabulary, for each of the major dogmatic themes of that development was to make a decisive contribution to the Byzantine apologia for the icons: both the true divinity and the true humanity of the Incarnate One were indispensable not only to the Byzantine understanding of the meaning of salvation but specifically to the defense of the use of images in orthodox Christian worship. To understand the apologia,

13. Berenson 1921–22, 289.

therefore, it is essential to understand historically the conclusions to which the christological dogma had led, and to see in those conclusions the implications that were drawn from the doctrine of New Being for all of human thought, and in particular for a Christian aesthetics.

"When anyone is united to Christ," the apostle Paul had written to the Corinthians, "there is a new world [*kainē ktisis*, new creation]; the old order has gone, and a new order has already begun."[14] This new order was perceived as having affected all of human life and thought, also every branch of metaphysics, including not only ethics but aesthetics. Commenting on these words of Paul about the "new order" of reality, the fourth-century Cappadocian church father Gregory of Nyssa—who was, as the Second Council of Nicaea would declare in its reaffirmation of icons, "universally celebrated as 'the father of the fathers'"[15] (universally celebrated, it should perhaps be added, by the Iconoclasts no less than by the Iconodules)—had distinguished "a twofold order of our nature, the first that whereby we were made [originally], the second that whereby we were made anew" through Christ. As a consequence of human disobedience and sin, "the first order had grown old and vanished away, and it was needful that there should be a new order in Christ." This was what the New Testament had meant by the admonition: "Discard the old nature which is deluded by its deeds and lusts, and put on the new nature of God's creating [according to the image of the one who created, *kat' eikona tou ktisantos*]."[16] Against every kind of heretical dualism, whether Marcionite or Gnostic or Manichean, Gregory of Nyssa always insisted that these two orders of creation and of salvation were the same as to their divine origin and that they had not been produced by two distinct deities.[17] But here he was insisting no less strenuously on the other pole of the orthodox dialectic, the teaching that the two orders were nonetheless drastically different as to their metaphysical—and aesthetic—outcomes:

> The first time, [God the Logos] took dust from the earth and formed man; this time, he took dust from the Virgin and did not merely form man, but formed man around himself. The first time, he created; this time, he *was* created. The first time, the Logos made the flesh; this time, the Logos was made flesh, so that he might change our flesh to spirit,

14. 2 Cor. 5:17.
15. Second Council of Nicaea (Mansi 13:293; Sahas 119).
16. A conflation of Col. 3:9–10 and Eph. 4:24.
17. Gregory of Nyssa *On the Making of Man* xxiii.4–5 (*PG* 44:212; *NPNF*-II 5:413–14).

by being made partaker with us in flesh and blood. Of this new order in Christ, therefore, which he himself began, he is called the first-born.[18]

Not only because this new order of creation was, as the New Testament said, "according to the icon [*kat' eikona*]" of Christ,[19] but because the Incarnation simultaneously figured forth and accomplished the New Being, it seems difficult to imagine that the Iconodules in the controversy could long have ignored its bearing upon the theological aesthetics of the icons.

Curiously, however, the introduction of the doctrine of the Incarnation into the controversy seems to have been initially a rhetorical and polemical tactic of the Iconoclasts instead. This they did by invoking an analytical tool known in Classical logic and Classical rhetoric as the "disjunctive [*diazeuktikos*] syllogism." For the question of images, this disjunctive syllogism had been formulated already in the fourth century by "the father of church history," Eusebius of Caesarea, who was therefore in some ways entitled to be called "the father of Iconoclasm" as well. In a letter that has since been lost, the recently converted sister of the emperor Constantine I, Queen Constantia, had apparently written to Eusebius to request an icon of Christ. The letter of response from Eusebius to Constantia has not been transmitted in the manuscripts of his complete works either, but has been preserved for later centuries only because of its use by the Iconoclasts in the controversy of the eighth century and because of the orthodox refutation of it.[20] In it Eusebius formulated the disjunctive syllogism.[21] "Which icon of Christ do you mean?" he asked. "That which is true and unchangeable and which bears the characteristics of his [divine] nature, or that which he assumed for us, the figure, that is, that he took in 'the form of a slave'?"[22] Whichever choice the queen would have made in this disjunction between possible images of Christ would have been wrong. The first, an icon of the divine nature of Christ as the Logos, was of course impossible by any definition, whether that of Judaism or of Christianity or for that matter of pagan Greek philosophy; for that nature was not knowable to the human mind, much less susceptible of portrayal in a picture made by human hands. It could not be iconized. Yet if she was asking for a picture of the human nature of Jesus as a man, she had to recognize that "even this has been mingled with the glory of the divinity." Therefore it was no more possible,

18. Gregory of Nyssa *Against Eunomius* IV.3 (*PG* 45:637; *NPNF*-II 5:158); italics added.
19. Col. 3:10.
20. See Quasten 1951–86, 3:345.
21. Eusebius *Letter to Constantia the Queen* (*PG* 20:1545–48; Sahas 134–35).
22. Phil. 2:7.

by means of "dead and inanimate colors [*nekrois kai apsychois chrōmasi*]" to do justice to the glorified human nature of Christ, with its "glittering and sparkling scintillations [*apastraptousas marmarygas*]," than it was to iconize his divine nature as such. As Georges Florovsky puts it, "the main point of this Eusebian argument is clear and obvious. Christians do not need any artificial image of Christ, [for] Christ's 'historical' image, the 'form' of his humiliation, has already been superseded by his Divine splendor, in which he now abides."[23]

On the basis of the intervening decisions of two successive fifth-century ecumenical councils against the Nestorian heresy, which was condemned for dividing the human nature from the divine nature, the Iconoclasts of the eighth century felt in a position to refine the fourth-century disjunctive syllogism by charging that those who iconized Christ fell into a twofold error: either they claimed to have portrayed the divine nature by the icon (which was impossible) or they did not (which was heretical).[24] The Council of Ephesus in 431 had branded Nestorianism a heresy, making its own the fourth of the *Anathematisms* of Cyril of Alexandria against Nestorius:

> If anyone shall divide between two persons or subsistences [*prosōpois dysin ē goun hypostasesin*] those expressions which are contained in the Gospels and Epistles, or which have been said concerning Christ by the saints, or by himself, and shall apply some to him as a man separate from the Logos of God, and shall apply others only to the Logos of God the Father [separate from the man], on the ground that they are appropriate [only] to be predicated of God: let him be anathema.[25]

According to the Council of Ephesus of 431, then, it was a dogmatic error to classify the sayings of the New Testament and of subsequent tradition into those that applied only to the divine nature and those that applied only to the human nature, for if they were properly understood, all those sayings applied to the single and entire divine-human person of the incarnate Logos.

Twenty years later, the Council of Chalcedon of 451 had embedded that anathema against separating the man Jesus from the Logos of God in a comprehensive and carefully balanced formula, which employed four Greek adverbs (rendered in English here by adverbial phrases) to declare that Christ was to be "acknowledged in two natures without confusion, without change, without division, without separation [*en duo physesin asynchytōs,*

23. Florovsky 1972, 2:108–09.
24. Quoted by Nicephorus *Refutation* I.41 (*PG* 100:308).
25. Council of Ephesus (Alberigo 59; *NPNF-II* 14:211).

atreptōs, adiairetōs, achōristōs]."[26] The Iconoclasts invoked this language of the Council of Chalcedon, insisting that because an image had to be derived from some prototype, the dogma calling Christ a single divine-human person "without confusion [*asynchyton*]" implied that he was "double in one person" and hence could not be accurately iconized.[27] But because he was, also according to the Chalcedonian dogma, "without separation [*achōristos*]," that necessarily implied as well that Christ could not be depicted in an icon, since any such portrayal, to be orthodox, would have had to be a depiction of him simultaneously in both natures, distinctly and yet together.[28] The defenders of the icons were, of course, no less committed to the Christology of the Councils of Ephesus and Chalcedon than were the Iconoclasts.[29] They found that the formula "without confusion [*asynchyton*]" could be turned against the Iconoclastic position by a *reductio ad absurdum*: If being uncircumscribed, an attribute of the divine nature, applied now to the human nature as well, as the Iconoclasts contended, would this attribute of being without confusion apply to each nature as well (which was ridiculous)?[30] But on the basis of the same councils, the Iconoclasts were now in a position to charge not only, as Eusebius had asserted and as everyone had to agree, that an icon of the divine nature alone would be impossible, but also that an icon of the human nature alone would be Nestorian and heretical, because it would be tantamount to a separation of the two natures.[31] The conclusion was, therefore, that images of the person of Jesus Christ had to be both superfluous and blasphemous; for, in the words of Emperor Constantine V, "anyone who makes an icon of Christ has failed to penetrate to the depths of the dogma of the inseparable union of the two natures of Christ."[32]

Although the entire orthodox church had long regarded Eusebius as suspect because of the equivocal position he had taken in the Arian controversy[33] and although the defenders of the icons condemned him as well for his stand on images, they should probably have been grateful to Eusebius and to his latter-day champions for having introduced the christological

26. Council of Chalcedon (Alberigo 86; *NPNF*-II 14:264–65).
27. Constantine V, quoted by Nicephorus *Refutation* I.9 (*PG* 100:216).
28. Iconoclast Synod of Constantinople, quoted by Second Council of Nicaea (Mansi 13:257; Sahas 89, though without a reference to Chalcedon in the notes).
29. See, for example, the definition of the Second Council of Nicaea (Mansi 13:377; Sahas 178).
30. Nicephorus *Refutation* I.20 (*PG* 100:240).
31. Quoted by Nicephorus *Refutation* I.42 (*PG* 100:308).
32. Constantine V, quoted by Nicephorus *Refutation* II.1 (*PG* 100:329).
33. Kelly 1950, 213–30.

question into the Iconoclastic debate, and that for several reasons. It provided them with a potent argument against the entire Iconoclast case to be able to focus on Eusebius. The Iconoclasts' use of the passage from his letter to Queen Constantia proved to the Iconodules that although the opponents of icons had been ransacking all the literary remains of the preceding centuries since the New Testament, the most explicit patristic testimony they had been able to come up with that was directed specifically against Christian icons, as distinct from the ongoing apologetic argument against the pagan use of images, did not belong to the mainstream of Christian orthodoxy but had come from a theologian who was tainted with heresy precisely on trinitarian-christological grounds. The Iconodules could remind their opponents that Eusebius had been guilty of heresy on the very doctrine of the person of Christ and of his relation to the Father.[34] Punning on his name, they suggested that he deserved to be called "*dyssebēs* [irreligious]" instead of "*eusebēs* [religious]."[35] He was in fact "the coryphaeus of atheism."[36] But before the Iconoclastic controversy was over, they had gone far beyond such ploys of rhetorical polemics, to wrest this new weapon of christological doctrine from their opponents' hands and turn it against them. By its very emphasis on the New Testament's message that "a new order has already begun,"[37] the orthodox dogma of the person of Christ was to become the doctrinal heart of the Byzantine apologia for the icons: there was a "new order" even and especially in the Christian attitude toward representational art.

An advantage that was less obvious, at any rate to them, was that the dogma of the person of Christ also happened to be the doctrinal question that had gone through a longer history of continuous development than any other Christian teaching. By the time the Iconoclasts invoked it to prove the illegitimacy of the icons, there had been more than six centuries of uninterrupted study, speculation, and debate over the correct doctrinal answer to the question in the Gospel: "What think ye of Christ?"[38] The First Council of Nicaea in 325,[39] the First Council of Constantinople in 381, the Council of Ephesus in 431, the Council of Chalcedon in 451, the Second Council of Constantinople in 553, and the Third Council of Constantinople

34. Nicephorus *Shorter Apologia for the Icons* 11 (PG 100:848).
35. Nicephorus *Apologia for the Icons* 12 (PG 100:561).
36. Nicephorus *Refutation* III.30 (PG 100:421).
37. 2 Cor. 5:17.
38. Matt. 22:42.
39. On the reasons for the selection of Nicaea as the site also for the Second Council of Nicaea as the seventh council, see Speck 1978, 562.

in 680/81—each of the six ecumenical councils of the church that had been held until that time had been obliged to put one or another version of that question at the top of its theological agenda. And each time that one of these six ecumenical councils had responded to the latest controversy with an additional formulation about the relation of the divine nature in Christ to the divine nature in the Father (Nicaea I), or about the relation of the divine nature in Christ to the divine nature in the Holy Spirit (Constantinople I), or about the relation of the divine nature in Christ to the human nature in Christ (Ephesus, Chalcedon, and Constantinople II), or about the relation of the divine will in Christ to the human will in Christ (Constantinople III), it had insisted in the most unequivocal of terms that it was not adding anything to the doctrine that had been believed, taught, and confessed by the orthodox church, as the celebrated Latin formula of Vincent of Lérins put it, "*quod ubique, quod semper, quod ad omnibus creditum est* [what has been believed everywhere, always, by all]."[40] For example, the fourth of the ecumenical councils, the Council of Chalcedon in 451, incorporated into its own decree the texts of the creeds adopted by "the 318 fathers" of the first ecumenical council at Nicaea in 325 and by "the 150 holy fathers" of the second ecumenical council at Constantinople in 381. Having affirmed those creeds, it then went on to introduce its own creedal formulation, not as though it were thereby presenting an innovation, but as "following the holy fathers [*hepomenoi tois hagiois patrasin*]."[41] Proceeding by a similar method, the sixth of the ecumenical councils, the Third Council of Constantinople in 680/81, which was the last council to have been held before the Iconoclastic controversy broke out and which was to figure as an authority during the Iconoclastic controversy,[42] had led into its dogmatic promulgation by reciting the creeds of Nicaea from 325 and of Constantinople from 381. Only then had it proceeded to introduce its own decree, doing so with the declaration: "This holy and ecumenical council, rejecting the error of irreligion [*tēs dyssebeias planēn*] that has for some time been propounded by some, and following without guile the right path of the holy and orthodox fathers, has been in complete harmony [*synephōnēse*] with the five holy and ecumenical councils" that had preceded it. There followed a list of those five councils, with the specific christological heresy that had been condemned by each.[43] Yet the methodology employed

40. Vincent of Lérins *Commonitorium* 2 (*PL* 50:640; *NPNF*-II 11:132).
41. Council of Chalcedon (Alberigo 83–87; *NPNF*-II 14:262–64).
42. Nicephorus *Refutation* II.38, III.30 (*PG* 100:377, 421).
43. Third Council of Constantinople (Alberigo 124–30; *NPNF*-II 14:344–46).

by each of these councils in affirming its continuity with the previous councils had been to recite their decrees and then to extrapolate from those decrees to meet the new challenge that it was now confronting.

That is to say, invoking the paradox of John Henry Newman, that the doctrine had developed, "chang[ing] . . . in order to remain the same."[44] This quality of having developed, which according to Newman has been characteristic of every Christian doctrine, indeed of every "great idea" throughout history whether that idea was Christian or not, had been manifested the most dramatically of all in the history of the doctrine of the person of Christ; and now the same quality would make this doctrine ideally suited to the newest and in many ways the most complex challenge to which it would ever be addressed. For the Byzantine apologia on behalf of icons, the figure of Jesus Christ was the indispensable key to the meaning of the icons, and that in three fundamental respects: in his person, in his life, and in his Passion and Resurrection. The dogma of the person of Jesus Christ, as this had been codified by the ecumenical councils and the creeds, was to supply the fundamental justification for the Christian icons in the church. At the same time, the life of Jesus Christ, narrated and described in the Gospels, supplied the most important themes for the Christian icons in the church. And the Passion and Resurrection of Jesus Christ, celebrated in the liturgy, supplied the interpretation of the Christian icons in the church, as emblems of Christ the Victor and Christ the Savior. Thus the Incarnation of Christ as divinity made human did make it possible for Byzantine theology to affirm the validity of aesthetics and of representational religious art, but in the process it also transformed both art and aesthetics into something they had never quite been before.

It was a universal presupposition of all Christian theologians on all sides of this or of any other question that the nature of God could not be encompassed by anything spatial or temporal; in the word used by the fifth-century pagan Neoplatonic philosopher Proclus, it was "uncircumscribed [*aperigraphos*]."[45] That Greek word and its cognate *aperigraptos* had not only been used by pagan philosophers like Proclus, but had become a standard part of the theological and philosophical vocabulary of the Greek church fathers, specifically of Gregory Nazianzus and Gregory of Nyssa in the second half of the fourth century, in speaking about the essence of God.[46] In speaking about the person of Christ and his two natures, however, they

44. Newman 1949, 38.
45. Liddell–Scott–Jones 186.
46. See Lampe 183.

77

had used dialectical language, explaining, in the formula of Gregory Nazianzus, that because of the Incarnation the Logos was "passible in his flesh, impassible in his Godhead; circumscribed in the body, uncircumscribed in the spirit; at once earthly and heavenly, tangible and intangible, comprehensible and incomprehensible"[47]—and, he might easily have added, "visible and invisible" and therefore "circumscribed and uncircumscribed," hence also "portrayable and unportrayable." At least as the Iconoclasts were quoted by the Iconodules—which is the only evidence we have about them—the Iconoclasts seem to have emphasized one polarity of this dialectic of the Incarnation at the expense of the other: "Christ," they said, "is uncircumscribed and incomprehensible and impassible and immeasurable."[48] Once again, the disjunctive syllogism stated their case: "Along with describing created flesh, [the Iconodule] has either circumscribed the uncircumscribable character of the Godhead, according to what has seemed good to his own worthlessness, or he has confused that unconfused union, falling into the iniquity of confusion."[49] If they were being quoted accurately by their opponents, the Iconoclasts were not interested primarily in the "flesh" of Christ "as it was seen upon earth" at all, but in its transformation after the Resurrection and Ascension of Christ, when it had become incorruptible and immortal.[50] According to them, therefore, "the dogma of the inseparable union of the two natures of Christ"[51] implied not only that the divine nature of Christ was uncircumscribed and would ever remain uncircumscribable, as everyone who accepted the orthodox faith was obliged to agree that it was and had been from eternity to eternity, but that through its glorification in union with the divine nature his human nature, too, had now become uncircumscribable and hence unportrayable as well.[52]

In attempting to find common ground with the Iconoclasts before going on to attack them, the Iconodules posited an agreement between them in their acceptance of the orthodox confession "concerning the person and the hypostasis" of Christ.[53] Responding to the argument of the Iconoclasts that Christ was "uncircumscribed," therefore, an Iconodule had to reply

47. Gregory Nazianzus *Epistles* 101 (*PG* 37:177; *NPNF*-II 7:439).
48. Quoted by John of Jerusalem *Against Constantine V* 4 (*PG* 94:317).
49. Iconoclast Synod of Constantinople, quoted by Second Council of Nicaea (Mansi 13:252; Sahas 83).
50. Quoted by Nicephorus *Refutation* III.38 (*PG* 100:437).
51. Constantine V, quoted by Nicephorus *Refutation* II.1 (*PG* 100:329).
52. Quoted by Nicephorus *Refutation* III.38 (*PG* 100:437).
53. Nicephorus *Refutation* I.20 (*PG* 100:237).

78

that when it came to the divine nature, of course "I confess the same"; but as to the human nature, "the flesh was circumscribed, as it was seen upon earth" during the years of Christ's life on earth,[54] and therefore it was legitimate to iconize it now. Yet when that was done and the human nature was being iconized, what was actually being iconized was not the human nature alone—since it never was alone, nor had it ever been alone, nor must it ever be considered alone—but the total divine-human person of Christ. To make this affirmation, the Iconodules could employ a host of technical theological formulas that had come into use in the course of the development of the doctrines of the Trinity and of the person of Christ.[55] Therefore it is instructive to examine, in some historical and theological detail, at least two of these orthodox christological formulas that could now be pressed into service for the purpose of validating the icons: the phrase "in two natures," and the attribute of "having an existence as a person [*enhypostatos*]."[56]

In the text of the dogmatic decree of the Council of Chalcedon of 451 there was an ancient and well-known variant reading between its Greek version and its Latin version. The Greek text, as transmitted in manuscripts and quotations and as eventually published in the standard (Western) eighteenth-century edition of the church councils by Giovanni Domenico Mansi, said that "one and the same Christ" was to be "acknowledged as *from* two natures [*ek dyo physeōn*]"; but the received Latin text, apparently reflecting a very old translation from the Greek, read *in duabus naturis*, "*in* two natures," indicating that the original Greek reading would probably have been *en dyo physesin* instead. This textual variant, *en dyo physesin*, is now generally recognized to be the correct reading, and it has been incorporated in the new critical edition of the *Acta Conciliorum Oecumenicorum*.[57] This is also the reading that appears in the current editions of the two standard collections of the conciliar decrees.[58] Each of the two readings is susceptible of an orthodox interpretation; and although the entire matter could be dismissed as merely a difference between two Greek prepositions—or even as little more than a difference between two Greek consonants, calling to mind Gibbon's remark about "the furious contests which the difference

54. John of Jerusalem *Against Constantine V* 4 (PG 94:317).

55. Prestige 1956 remains one of the most learned and balanced discussions of this history of terminology.

56. Evans 1970, 132–46.

57. Ignacio Ortiz de Urbina in Grillmeier–Bacht 1951–54, 1:390–91, with references to primary and secondary sources.

58. Denzinger 302 (with an explanatory footnote); Alberigo 86.

of a single diphthong excited between the Homoousians and the Homoiousians" after the First Council of Nicaea[59]—the distinction could, if it were pressed, have far-reaching consequences for theology, and also beyond theology. When it was applied to the issue of icons, the better attested reading meant that also after the Incarnation and even after the Resurrection, it still remained accurate to speak of the one person or hypostasis of Jesus Christ as continuing "*in* two natures" rather than as composite "*from* two natures." The two natures of the one Christ could not be separated, but neither had they been amalgamated: as the Chalcedonian formula went on to say after inditing the four celebrated adverbs, "the distinction between the natures has not at all been abolished, but rather the peculiar property of each nature has been preserved [*oudamou tēs tōn physeōn diaphoras anēirmenēs dia tēn henōsin, sōizomenēs de mallon tēs idiotētos hekateras physeōs*]."[60] To the Iconodules it seemed to follow as a necessary consequence, therefore, that the human nature could be iconized, but that when it was, the icon of Christ that was produced was a depiction of the total divine-human person of Christ and not only of the human nature in isolation from the total person.

Another technical christological concept of great relevance to the Iconoclastic controversy was the teaching that the human nature of Christ had never possessed a separate or preexistent personhood [*hypostasis*] of its own, but that it had from the moment of its inception been inseparably joined with the divine nature of the Logos, the eternal "Second Person [*hypostasis*]" of the Trinity; the humanity of Jesus Christ was, therefore, and always had been "devoid of any individual personhood of its own [*anhypostatos*]."[61] But for orthodoxy, this had as its counterpart and corollary, on the basis of the language of the Council of Chalcedon, a formula that declared: "Each of his natures [*ousiai*] since the Incarnation is one that possesses personhood in [*enhypostatos*]" the single person of the incarnate Logos.[62] In and of itself, the concept of the human nature of Christ as possessing personhood in the person of Christ was one that the Iconoclasts were also obliged to accept.[63] But as a necessary implication following from this formula and from the definition of the Council of Chalcedon that the person of Christ was still "in two natures" after the Incarnation, the defenders of

59. Gibbon 1896–1900, 2:352.
60. Council of Chalcedon (Alberigo 86; *NPNF*-II 14:265).
61. See the passages collected in Lampe 164.
62. John of Damascus *Against the Jacobites* 12 (PG 94:1441).
63. Quoted by Theodore the Studite *Refutation* III.i.15 (PG 99:396; Roth 82–83).

the icons affirmed the continuing integrity, also after the Incarnation, of that nature of the one Christ which was human and therefore both circumscribed and circumscribable—and therefore picturable. It is significant that the formula just quoted comes from one of the writings of John of Damascus dealing specifically with the orthodox doctrine of the person of Christ.[64]

For it was also John of Damascus who, in his writings against the Iconoclasts, provided the first substantial Iconodule argumentation that proceeded from the doctrine of Christ to the doctrine of icons.[65] Taking up the Iconoclasts' use of the Second Commandment, which prohibited the making not only of any idol but even of any "similitude [*homoiōma*],"[66] he declared that Moses "the lawgiver interprets this himself."[67] Moses the lawgiver had provided such an interpretation of the Second Commandment when he gave his reminder elsewhere to the people of Israel that "when the Lord spoke to you out of the fire on Horeb, you saw no similitude [*homoiōma*] of any kind."[68] The difference between the true God of Israel and the false gods of the heathen peoples lay precisely in this absence of any "similitude," which had been forbidden by the law given on Sinai. But that law, like every law of Moses, was, according to the Pauline formula,[69] intended to serve as a "tutor [*paidagōgos*] to lead us to Christ." Its prohibition of false images, consequently, was at the same time a "foreshadowing of the real image [*procharagma eikonos*]" that was to come.[70] Before the Incarnation an icon of the Logos would have been outlandish and wicked.[71] But Christ, as the eternal Logos, had in these latter days become incarnate in human flesh, and he had thereby presented humanity, for the first and only time in its entire history, with a genuine and accurate "similitude" of God, one that could be seen and hence one that could be iconized.[72] In the usage of the apostle Paul, the term "similitude [*homoiōma*]," which appeared five times altogether in his Epistles, four of them in the Epistle to the Romans, usually referred specifically to the humanity of Christ.[73] As the Cappadocian fathers had insisted, however, in that context it did not connote a mere "semblance" or "some delusive

64. See also his explanation in *On Composite Nature* 6 (PG 95:120).
65. Ostrogorsky 1927, 35–48.
66. Ex. 20:4 (LXX).
67. John of Damascus *Orations on the Holy Icons* III.7 (PG 94:1325).
68. Deut. 4:15 (LXX).
69. Gal. 3:24–25.
70. John of Damascus *Orations on the Holy Icons* I.15 (PG 94:1245).
71. Theodore the Studite *Refutation of the Poems of the Iconoclasts* 13 (PG 99:457).
72. John of Damascus *Orations on the Holy Icons* III.8 (PG 94:1328).
73. Rom. 1:23; 5:14; 6:5; 8:3; Phil. 2:7.

phantom and appearance [*phantasia kai dokēsis*]," but reality.[74] And since, both in the language of the New Testament[75] and in the official language of the church—most succinctly perhaps in the definition of the Council of Chalcedon that Christ was "one in being [*homoousios*] with the Father according to his deity and one in being with us according to his humanity"[76]—there was a parallelism between the reality of this "similitude [*homoiōma*]" or "form [*morphē*]" of the humanity of Christ and the reality of the "form" or "similitude" of the divinity of Christ, the Cappadocians insisted as well that it referred in both instances to his two essential natures, the one which he shared eternally with the Father and the Holy Spirit in the Trinity and the one which as a consequence of the Incarnation he now shared with the human race.[77]

On the basis of the patristic tradition, John of Damascus maintained that while it would of course be a sin, as it always had been, to presume to make an image of the invisible and "uncircumscribable [*aperigraptos*]" divine nature of the Holy Trinity (and hence of the divine nature of the Second Person of the Trinity, the Son of God), or to make images of human beings and to call them gods, a "new order" had been established also here: now that the invisible God had become human through the Incarnation of the Logos, he had in Christ also become "circumscribable [*perigraptos*]" in an icon.[78] In that sense God himself had suspended his own commandment by "violating" it—or, to put it not only more reverently but also more precisely, by fulfilling it[79]—when he provided a genuine icon of himself in the history of Christ, an icon of which it was now legitimate to make an icon in turn. If Christ had a genuine human body, Patriarch Nicephorus of Constantinople went on to argue a half-century or so after John of Damascus, that body had occupied space and time, and therefore it had been circumscribed.[80] "Christ our God, who took upon himself our poverty . . . and our body—why should he not be pictured or circumscribed?" Nicephorus asked.[81] And taking up the question of "possession of person-hood in some person [*enhypostasia*]," he declared it to be inconceivable that a genuine human nature, which truly possessed personhood but only

74. Gregory of Nazianzus *Epistles* 102 (*PG* 37:200; *NPNF*-II 7:444).
75. Phil. 2:6–7.
76. Council of Chalcedon (Alberigo 86; *NPNF*-II 14:264).
77. Gregory of Nyssa *Against Eunomius* IV.8 (*PG* 45:672; *NPNF*-II 5:169).
78. John of Damascus *Orations on the Holy Icons* II.5 (*PG* 94:1288).
79. John of Damascus *Orations on the Holy Icons* I.15 (*PG* 94:1245).
80. Nicephorus *Refutation* I.20 (*PG* 100:241).
81. Nicephorus *Apologia for the Icons* 71 (*PG* 100:781).

through its having been "enhypostasized" in the person of Christ, could not be pictured.[82] Theodore, abbot of the monastery of Studios and contemporary of Patriarch Nicephorus, also addressed the issue of "possession of personhood": he took it to mean that what Christ had assumed in the Incarnation was "the total or universal nature [*tēn katholou physin*]" of humanity.[83] As the New Testament taught, Christ was the Second Adam.[84] "Man," Theodore concluded, "has no characteristic more basic than this, that he can be iconized; that which cannot be iconized is not a human being, but an abortion."[85]

What was at stake in the Iconoclastic controversy, according to this apologia, was nothing less than the true humanity of Christ as Second Adam described in the creed of the church, and therefore the genuine history of Christ described in the Gospels. When, in the narrative of the twelve-year-old Jesus in the temple recounted in the second chapter of the Gospel according to Luke, he was described as having been in the temple of Jerusalem in Judea, he was truly in Judea and was not at the same time "physically [*sōmatikōs*]" in Galilee. This was so in spite of the fact that, as the New Testament asserted,[86] "it is in Christ that the complete being of the Godhead dwells embodied [*sōmatikōs*]": as Son of God he "filled all things" in heaven and on earth including both Judea and Galilee, was "as God above all things," and therefore remained "uncircumscribed [*aperigraptos*]" in his divine nature.[87] In an icon devoted to this incident, consequently, it would be proper to depict the single divine-human person of the incarnate Logos, at one particular geographical place and at one particular historical time, as (in the words of the Gospel) "sitting in the temple surrounded by the teachers, listening to them and putting questions."[88] So it was with all the scenes in the Gospels: they had actually taken place at particular places and times, and therefore they could (and should) be iconized.

In the course of his defense of the case for icons of Christ, John of Damascus enumerated some of these Gospel scenes of specific events from the earthly life of Christ:

[The Son of God], who existed in "the form of God"[89] and who by

82. Nicephorus *Refutation* II.17 (*PG* 100:365).
83. Theodore the Studite *Refutation* III.i.17 (*PG* 99:397; Roth 83–84).
84. Rom. 5:15–21; 1 Cor. 15:45–49.
85. Theodore the Studite *Refutation of the Poems of the Iconoclasts* 3 (*PG* 99:444–45).
86. Col. 2:9.
87. Nicephorus *Refutation* II.18 (*PG* 100:367).
88. Luke 2:46.
89. Phil. 2:6.

the superiority of his nature transcended quantity and quality and size, has taken upon himself "the form of a servant," and by this drawing together [*tautēi systolēi*] he has accommodated himself to quantity and quality, and he has assumed the express image [*charaktēr*] of the body. Therefore go ahead and image [*charatte*] him in icons and present him for viewing, as one who wanted to be viewed:

His ineffable Incarnation and descent into the flesh [*synkatabasis*];

his Nativity from the Virgin;

his Baptism in the Jordan;

his Transfiguration on Mount Tabor;

the Passion and sufferings that have given us exemption from suffering [*tēs apatheias proxena*];

his miracles as signs [*symbola*] of his divine nature and activity [*energeia*], accomplished through the activity of his flesh;

the salvation-bearing Burial of the Savior;

his Ascension into heaven

—go ahead and describe [*graphe*] all of these, both in words and in colors, both in books and in pictures![90]

Similarly, Theodore the Studite listed scenes from the Gospels, chiefly from the Gospel of John:[91] Christ seated at the well, walking on the water, and visiting Capernaum.[92] And John of Jerusalem enumerated other such scenes, from the Annunciation to the kiss of Judas.[93] In view of the repeated parallels that they themselves drew between the icons and the text of the Gospels,[94] it is tempting to hypothesize that as these defenders of icons were itemizing the incidents from the Gospels, they may have had before them, or at any rate in their mind's eye, a series of particular icons in which such Gospel scenes had been depicted.

Another possible explanation would be the existence of medallions or other illustrations of these events, directly adorning manuscript texts of the Gospels, to which John of Damascus, John of Jerusalem, and Theodore of Studios could have been referring. That is, however, an explanation that is difficult either to prove or to disprove. André Grabar has examined, with his characteristic thoroughness of research and brilliance of presentation,

90. John of Damascus *Orations on the Holy Icons* III.8 (PG 94:1328–29).

91. John 4:6; 6:19; 2:12.

92. Theodore the Studite *Refutation of the Poems of the Iconoclast* 1 (PG 99:441–44).

93. John of Jerusalem *Against Constantine* V 3 (PG 95:313–16).

94. Nicephorus *Refutation* I.37 (PG 100:292); John of Jerusalem *Against Constantine* V 3 (PG 95:316).

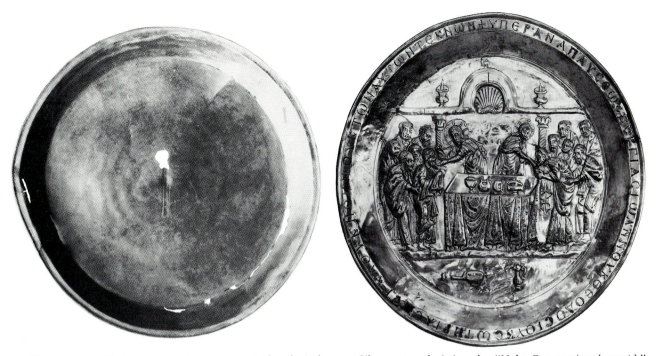

19. Silver paten. Sixth to seventh century. Archaeological Museum, Istanbul

20. Silver paten depicting the "Holy Communion [*synaxis*]." Dumbarton Oaks Collection, Washington, D.C.

the evidence pro and con for what he calls such "narrative illustrations innocent of interventions from other sources of inspiration than the texts of the Evangelists," that is, not dependent on icons and other portrayals. Although Grabar finds the evidence for such narrative illustrations inconclusive, he does go on to suggest that just because these narrative illustrations do not appear on surviving manuscripts of the Gospels, that should not be permitted to obscure the demonstrable fact that "subjects from the Gospels were frequently represented on mosaics, ivories, textiles, goldwork, icons on wood, and other kinds of objects in the fifth and particularly in the sixth century,"[95] especially in the liturgical and devotional art of Byzantium. There are, for example, two striking examples of such representation on early Byzantine silver patens that have been preserved, one in Istanbul and one in Washington, depicting the "Holy Communion [*synaxis*]."[96]

Whether or not it is pressing the language of the passages just quoted too far to see in the sequences described there Greek *catalogues raisonnés* of

95. A. Grabar 1968, 97. The entire chapter, "The Historical Scene," pp. 87–106, is a useful introduction to the history of this genre in early Christian art.

96. Figs. 19 and 20, together with the commentary of M. Mango 1986, 159–70.

actual eighth- and ninth-century icons available to these writers, the earliest of whom was a Greek-speaking Christian writing in Muslim Damascus, there is additional evidence, both liturgical and iconographic, to document the practice of preparing such sequences. Although the "semi-legendary" *Narration about Saint Sophia*, which seems to have been written in the eighth or ninth century, describes the practice of "the Twelve Feasts" as one that was in force during the age of Justinian,[97] it was probably not earlier than the tenth century, and quite possibly even later, that the Byzantine church officially adopted such a cycle for the church year. These were identified according to the Gospel events commemorated on those holidays.[98] On one early artistic depiction of this cycle the following twelve feasts are represented (Fig. 21):

The Annunciation [*Euangelismos*] of the angel Gabriel to the Virgin Mary, recorded in Luke 1:26–38

The Visitation of the Virgin Mary to Elizabeth, mother of John the Baptist, recorded in Luke 1:39–56

The Nativity of Christ, recorded in Luke 2:1–20

The Presentation of the Infant Jesus in the temple, recorded in Luke 2:21–40

The Baptism of Jesus by John the Baptist, recorded in Luke 3:21–22 (as well as in all three of the other Gospels)

The Transfiguration [*Metamorphōsis*] of Christ, recorded in Luke 9:28–36 (as well as in Matthew and Mark)

The Triumphal Entry into Jerusalem, recorded in Luke 19:29–40 (as well as in Matthew and Mark)

The Crucifixion, recorded in Luke 23:33 (as well as in Matthew, Mark, and John)

The Resurrection of Christ, recorded in Luke 24:1–12 (and in the other Gospels)

The Theophany of Christ to Mary and the assembled disciples after the Resurrection, recorded in Luke 24:33

Pentecost, the coming of the Holy Spirit, recorded by Luke in Acts 2:1–13

This series appears on an ivory diptych which scholars date at Constantinople from about the year 1000.

In the light of the long-standing interest, going back to the controversy

97. *Narration about Saint Sophia* 23 (Preger 99–101; Mango 100).
98. Still the best guide to all of these holidays is probably Nilles 1896.

86

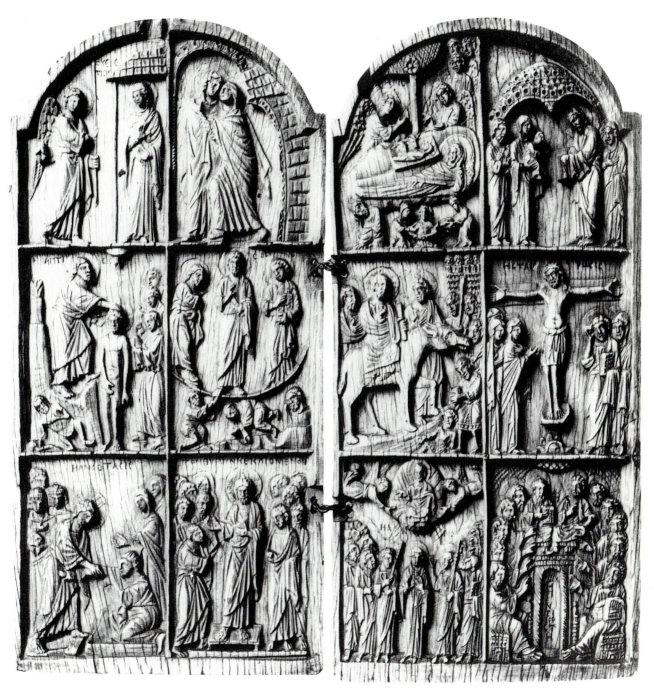

21. Ivory diptych of the Twelve Feasts. Constantinople, ca. 1000. Hermitage, Leningrad

with Marcion in the second and third centuries, in the distinctive elements of the Third Gospel,[99] it is difficult to attribute it to mere chance that every one of these twelve feasts was based on an event reported by the evangelist Luke either in his Gospel or in the Acts of the Apostles (although some of the events, to be sure, appeared also in one or more of the other Gospels). Perhaps on the basis of their chronological order, they were, moreover, portrayed in the same sequence in which they appeared in the Gospel of Luke and in the Book of Acts. At least since the sixth century, it was the evangelist Luke who had also been identified as the originator of icon-painting, having executed the earliest icons of the Virgin Mary.[100] This identification appeared in icons as well as in legends; it is not clear just when the first such icon of Luke painting Mary appeared, but one of the best-known is the one preserved from the seventeenth century at the Monastery of Morača in Montenegro, Yugoslavia (Fig. 22). One of the reasons for attributing icons of the Virgin to Luke was probably that his had been the only Gospel to record—as it was supposed, from her own memoirs, since he stated in the prologue to his Gospel that in his narrative he was "following the traditions handed down to us by the original eyewitnesses,"[101] among whom she was the first—the Magnificat (sung at the morning office in the Eastern Church) and the Nunc Dimittis (sung at Vespers in the East).[102] In a considerably later iconographic version of the Twelve Feasts, on a mosaic diptych dated at Constantinople from the fourteenth century,[103] the Visitation of Elizabeth by Mary and the post-Resurrection Theophany to Mary and the disciples have been replaced by the Raising of Lazarus, recorded in John 11:1–46 (and only there), and by the "Dormition of the Mother of God [*Koimēsis tēs Theotokou*]," which comes from tradition and which became the subject of countless Byzantine and Slavic icons (Figs. 39–41). A twentieth-century list of the Twelve Great Feasts in the Eastern Orthodox Church of Russia, as given in an authoritative and semi-official encyclopedic dictionary of theology, moreover, diverges somewhat from both of those;[104] and there were still other versions of the Twelve Great Feasts as well.

Several of the iconized Gospel events listed by John of Damascus, Theodore the Studite, and John of Jerusalem and celebrated in the Twelve

99. Irenaeus *Against Heresies* III.xiv.3 (Harvey 2:76–78; *ANF* 1:438–39).
100. Henze 1948.
101. Luke 1:2.
102. Mearns 1914 is a review of these and other canticles.
103. See Fig. 23, and Weitzmann 1982, 14.
104. *Prav. Slov.* 1:713.

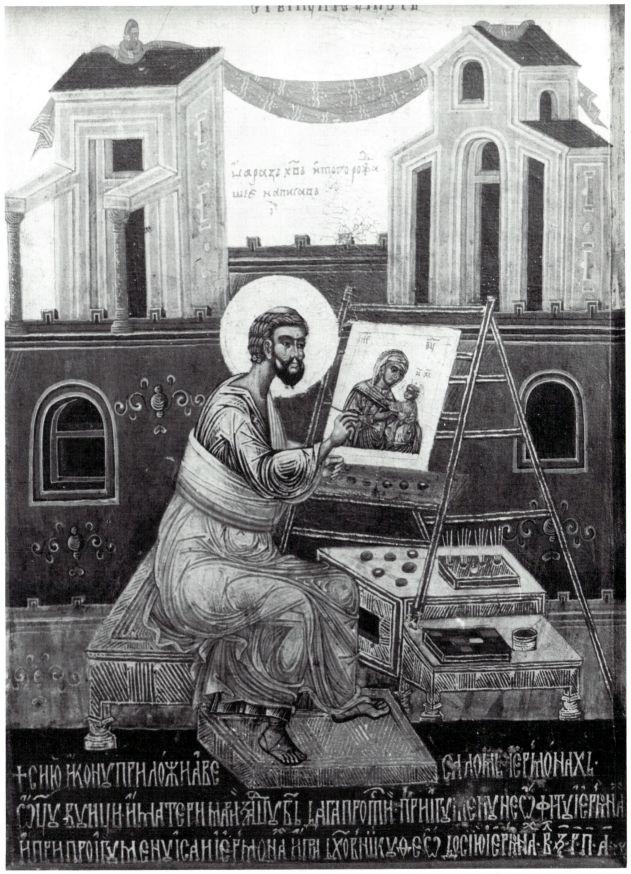

22. Saint Luke painting an icon of the Virgin. Detail from *Saint Luke with Scenes from His Life*, ca. 1672. Monastery of Morača, Montenegro, Yugoslavia

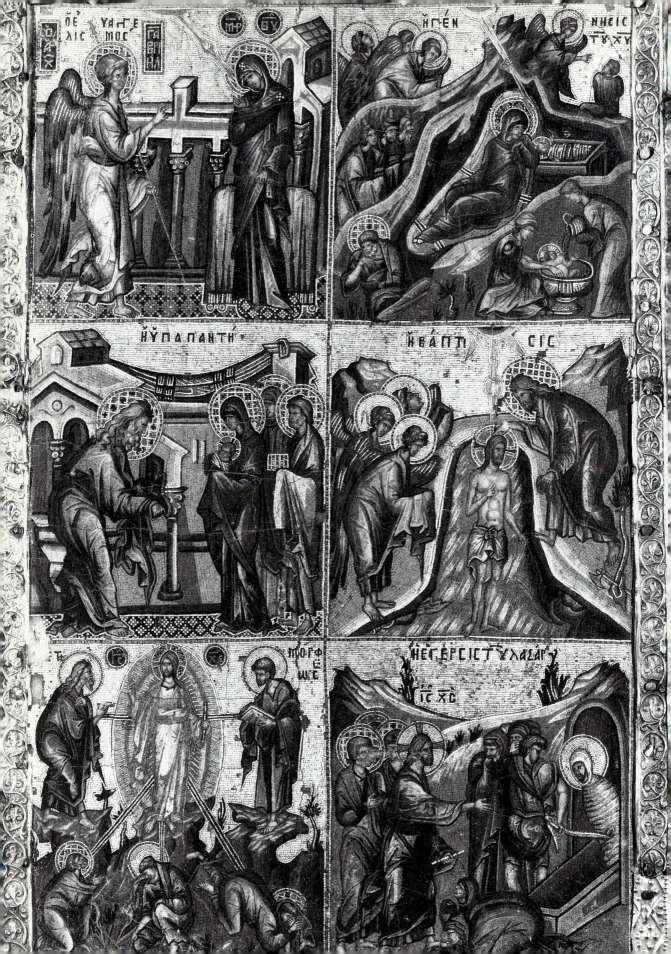

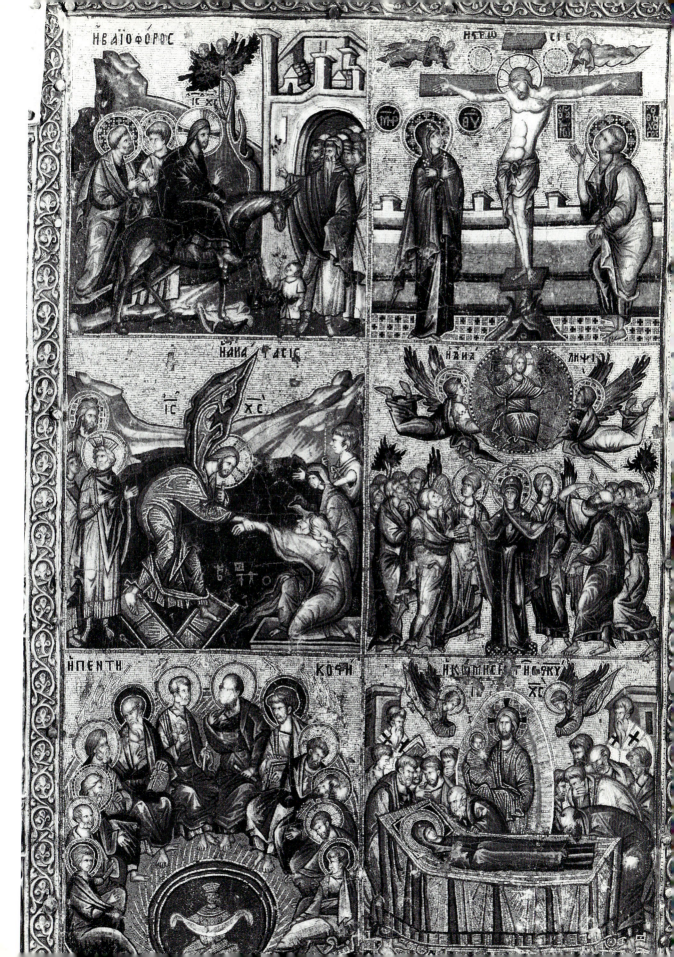

Great Feasts were particularly relevant to the christological apologia for representative art, for example, the Theophany to Mary and the disciples after the Resurrection.[105] Both in the account of Luke and in that of John, this event was intended to demonstrate to the disciples (and thus to later readers) that "no ghost has flesh and bones as you can see that I have."[106] After the Resurrection, therefore, the body of Christ, though changed in such a way that it could pass through doors,[107] was still a real body—one that could be iconized. The apologists for icons could argue that if it was possible for doubting Thomas to put his finger into the pierced hands and to thrust his hand into the wounded side of the resurrected Christ,[108] it ought to be possible to portray the scene between Christ and Thomas in an icon (Fig. 23). Nevertheless, one event deserves to be singled out above the others, both because of its singular importance in the history of Byzantine piety and theology and because of its special significance for the doctrinal justification of icons: the Transfiguration of Christ (known in Greek as *hē Metamorphōsis*). The earliest known representation of it is a sixth-century mosaic in the Church of Saint Mary at Mount Sinai (Fig. 24). "The aureole of light," André Grabar says of this mosaic, "surrounds Christ, who is transfigured and thus manifests his divinity, while the three apostles who are present at this theophany are represented as visionaries, falling to their knees or thrown back by the mysterious light."[109] The same quality persisted in icons and mosaics of the Transfiguration produced at Constantinople centuries later (Fig. 25).

It is not clear whether or not there was such an icon behind the Homily on the Transfiguration attributed by the distinguished French Dominican "Hellenist" François Combefis[110] to John of Damascus.[111] In the conclusion to the homily, the Damascene spoke of "carrying in your heart the beauty [*hōraiotēta*][112] of this divine reality," which could be taken as a reference to an icon.[113] He also emphasized that the Transfiguration was not an ontological change in the person of Christ, but a disclosure to the eyes of the disciples of what had been there all along.[114] But earlier he had warned

105. Theodore the Studite *Refutation* III.i.16 (PG 99:397; Roth 83).
106. Luke 24:39.
107. John 20:19, 26.
108. John 20:27.
109. A. Grabar 1968, 117.
110. *DTC* 3:385–87.
111. John of Damascus *Homily on the Transfiguration of the Lord* (PG 96:545–76).
112. This term seems to come from Isa. 44:13 (LXX).
113. John of Damascus *Homily on the Transfiguration of the Lord* 20 (PG 96:573).
114. John of Damascus *Homily on the Transfiguration of the Lord* 12 (PG 96:564).

23. (preceding pages) Mosaic diptych of the Twelve Feasts. Constantinople, fourteenth century. Museo dell'Opera del Duomo, Florence

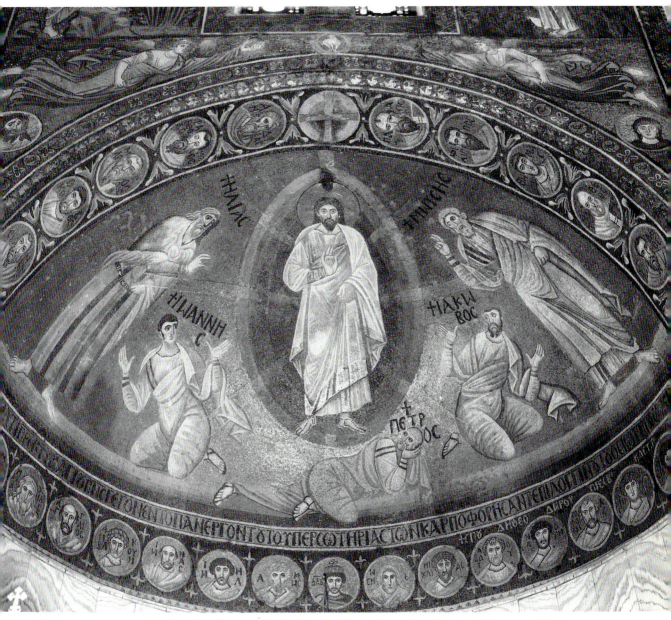

24. Sixth-century apse mosaic of the Transfiguration in the Church of Saint Mary. Saint Catherine's Monastery, Sinai

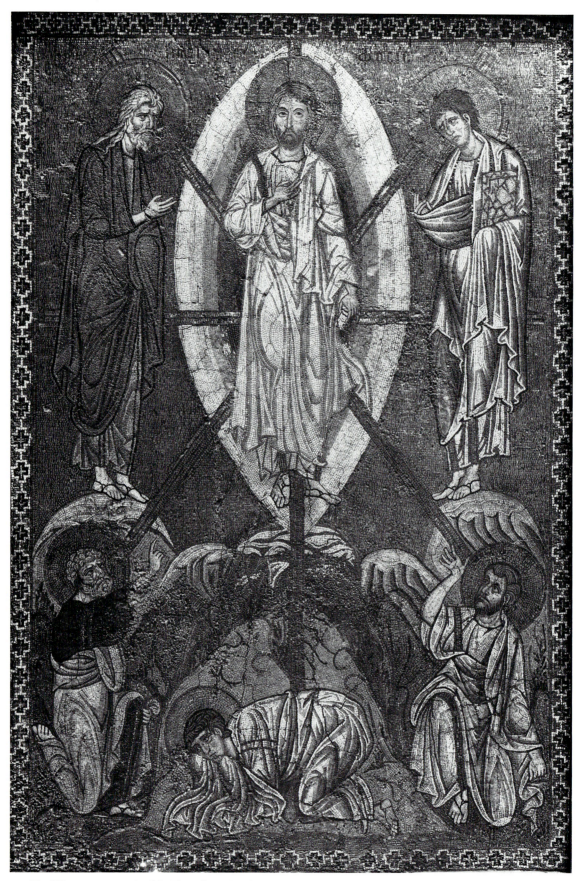

25. Twelfth-century mosaic of the Transfiguration from Constantinople. Musée du Louvre, Paris

about the impossibility of "using a creature to iconize that which is uncreated" and had spoken of the Deity as "uncircumscribed."[115] He had also described the creation of man in "the image and likeness" of God, and had identified the Incarnation of the Logos as the assumption of that "image."[116] Although it may seem rather unlikely, then, that he was speaking in this homily about a specific icon of the Transfiguration, he clearly was setting forth the principal components of his defense of the icons. Among all the Gospel events enumerated by John of Damascus and represented in the Twelve Feasts and their diptychs, the Transfiguration was eminently useful for that defense; for its theological meaning affirmed, against the interest of the Iconoclasts in the post-Resurrection form of Christ's body, that what the disciples had seen on Mount Tabor as a consequence of the Transfiguration was a circumscribed manifestation of the uncircumscribed reality of the divine nature—what the Iconoclasts referred to as the "flesh" of Christ "as it was seen upon earth," not after the Resurrection but even before the Crucifixion.[117] The Transfiguration proved that "the invisible one had an appearance or likeness, the formless one had a form, and the measureless one came encompassed within a measure."[118] This was the flesh that was, and that could be, pictured in an icon, not only in an icon of the Transfiguration but in any icon of any event in the entire life of Christ as narrated in the Gospels.

Because of the theory elaborated by Gregory Palamas, a monk at Mount Athos in the fourteenth century, and formally adopted by synods of the Eastern Orthodox Church, according to which the light that appeared to the disciples on Mount Tabor in the Transfiguration was "uncreated" and therefore was an "action [*energeia*]" of God distinct from the "essence [*ousia*]" of God, the Byzantine view of the Transfiguration became the source for one of the official doctrinal differences between the Eastern and the Western Churches. But in the present context it is more important to note that the distinctive Eastern doctrine of the Transfiguration also helps to account theologically for the quality that art historians have emphasized in Byzantine icons of Christ when they have spoken about an inner majesty shining through the historical form. That, as an eminent Eastern Orthodox theologian has put it, "also gives a quasi-sacramental role to iconography."[119] For, in the words of Theodore the Studite, "the fact that man

115. John of Damascus *Homily on the Transfiguration of the Lord* 13 (PG 96:565).
116. John of Damascus *Homily on the Transfiguration of the Lord* 4 (PG 96:552).
117. Quoted by Nicephorus *Refutation* III.38 (PG 100:437).
118. Theodore the Studite *Refutation* III.i.53 (PG 99:413; Roth 97).
119. Meyendorff 1969, 146.

is made in the image and likeness of God shows that the work of iconography is a divine action."[120] And the fact that God had remade the "image and likeness" in the Incarnation provided an entire new justification for the theory and practice of aesthetics. The Byzantine emphasis on re-creation in the image of God as well as on creation in the image of God made itself evident not only in the iconographic treatment of the Incarnation and the Transfiguration as "divinity made human," but almost as dramatically in the corollary iconographic treatment of "humanity made divine." This was disclosed in a special degree and manner in the person of Mary the Mother of God, but it was eventually to be conferred on everyone who would participate in salvation as "deification [*theōsis*]."

Another difference between the two churches, a difference that was unofficial but that was nevertheless far more important doctrinally as well as iconographically than the doctrine of uncreated light, was visible in the distinctive emphasis of Byzantine theology, and of its antecedents in the Greek church fathers, on the combination of the Passion and the Resurrection of Christ as the event by which God in Christ had brought about salvation. The difference was not, in the strict sense, a dogmatic difference between East and West.[121] For example, the two settings of the Passion story by Johann Sebastian Bach also reflected the difference, with the *Saint Matthew Passion* expressing the medieval Western emphasis and the *Saint John Passion* the characteristic Eastern interpretation (which was present as well in the theology of Martin Luther). Moreover, both churches, of course, affirmed both of these Gospel events as historically true, and they both celebrated them liturgically as solemn festivals of the church year. Yet in the West it was—and is—the Passion and Crucifixion that was seen as having achieved the reconciliation between God and fallen humanity, with the Resurrection seen as the divine attestation that the Atonement achieved on the cross had been accepted by God the Father and that divine justice had been satisfied. Iconographically, that emphasis led to the almost universal distribution of the crucifix in the medieval Latin Church as the distinctive symbol of the Atonement.[122] Theologically, it led to the most representative Western formulation of the doctrine of the Atonement, the treatise *Why God Became Man* [*Cur deus homo*] of Anselm of Canterbury, in which the Passion and Crucifixion of Christ the God-man was seen as the means through which satisfaction was rendered to the violated justice of God by the only one

120. Theodore the Studite *Refutation* III.ii.5 (*PG* 99:420; Roth 101).
121. Borella 1939a and 1939b.
122. Thoby 1959.

96

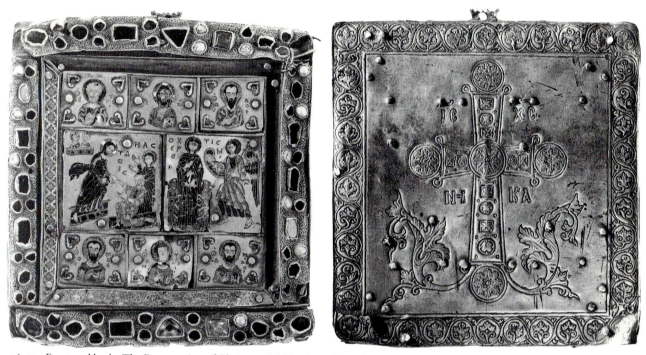

26–27. Front and back: The Resurrection of Christ as *nikē*. Tenth or eleventh century. Arts Museum of the Georgian SSR, Tbilisi

whose death could avail because he was human and could avail for all because he was divine. Atonement by vicarious satisfaction through the Passion and Crucifixion of Christ was a theory that would survive the Reformation and enjoy at least as much support in Protestantism as it had in medieval Catholicism (although much of Protestantism abolished the use of the crucifix, replacing it with a bare cross).

According to the liturgical theology of the East, by contrast, the action of the Atonement was addressed not "upward," from humanity through Christ to the justice of God, but "downward," from God through Christ to sin and death, Hades and the devil, as the enemies of humanity who had held it in thrall since the fall of Adam and Eve and whom Christ now vanquished through his Crucifixion and Resurrection. As (in the phraseology of Gustaf Aulén) the "dramatic" theory of the Atonement, this metaphor of Christ as Victor lent itself fittingly to both liturgical presentation and iconographic representation (Figs. 26–27). Also in his Crucifixion, no less than in his Nativity or in his Resurrection, Christ was "our Lord and God," who had "accomplished victory over death" by his three days' stay in death and by his rising from the dead.[123] In the course of defending the icons against the Iconoclasts, Patriarch Nicephorus made the icons an occasion for an extended discussion of Crucifixion and Resurrection

123. Nicephorus *Apologia for the Icons* 27 (PG 100:608).

as the conquest of the enemies by Christ: "For he has bound the strong man[124] and has as a Victor despoiled the tyrant. He has snatched, and has carried off as booty from the stripped enemy, those whom the enemy had held in thrall. As his first choice of booty [from the enemy] he selected thieves, harlots, and publicans, so that they might no longer remain bound to the yoke of the enemy."[125] Or, in the formula of another Iconodule apologist, "Christ has arisen from the dead, and the whole cosmos has cause for rejoicing. By his life-giving death he has killed death, and all those who were in the bonds of Hades have been set free."[126]

This threefold use of the figure of the incarnate Christ—of his person as the fundamental justification for the Christian icons in the church, of the events of his life as the most important concrete themes for the Christian icons in the church, and of his work of victory and salvation as the content of the celebration by the Orthodox liturgy and the Christian icons in the church—was predicated on one of the most basic of all distinctions in the Eastern method of treating Christian doctrine: the distinction between "theology," as comprising the doctrines, above all the doctrine of the Trinity, dealing with the reality of God as such; and "economy," as comprising the doctrines, above all the doctrine of the Incarnation, dealing with the dispensation of God in history in relation to all of creation and particularly in relation to the human race and most particularly in relation to the church. It was a distinction that, according to the East, had been ignored in the Western development of the doctrine of *Filioque*, the teaching that the Holy Spirit proceeded from the Father and the Son and not only from the Father. What was at stake in the conflict over the icons, according to the Iconodule apologia, was likewise the necessity of keeping "theology" and "economy" clear and distinct.[127] According to "theology" there could not be any idea of finding an appropriate "resemblance or perception of a likeness [*emphereia ē katanoēsis homoiōseōs*]" of God, but according to "economy" that was precisely what the Incarnation had accomplished.[128] As a modern scholar has summarized the entire case, therefore: "As perfect man, Christ not only can but must be represented and worshipped in images: let this be denied, and Christ's *oikonomia*, the economy of salvation, is virtually destroyed."[129]

124. Luke 11:21–22.
125. Nicephorus *Apologia for the Icons* 36 (PG 100:628).
126. Theodore the Studite *Orations* IV.1 (PG 99:693).
127. Theodore the Studite *Refutation* III.iii.15 (PG 99:428; Roth 108).
128. Theodore the Studite *Refutation* II.4 (PG 99:253; Roth 45).
129. Ladner 1940, 145.

THE SENSES SANCTIFIED
The Rehabilitation of the Visual

In articulating the orthodox case for the use of icons in the church, Iconodule thought exploited the implications of the doctrine of the Incarnation not only in order to set forth a new Christian metaphysics and aesthetics but thereby also to formulate a new Christian epistemology. Just as the coming of Christ the Logos and Word of God in the flesh had drastically revised, or even repealed, the meaning of the prohibition against the making of any "likeness [*homoiōma*]," now that God himself had sent an ontologically exact likeness of himself into the world, of which in turn it was possible and permissible to fashion a likeness; so the coming of the Word made flesh carried the clear implication that in addition to hearing the voice of the spoken word of God, as faithful believers had done throughout the Old Testament, New Testament believers were in a position to see the flesh of the incarnate Word of God. The ancient priority of hearing in biblical thought, therefore, had now been forced to yield to the priority of seeing, as a consequence of the Incarnation. For according to the prologue of the Gospel of John, Christ was not only the "Word [*Logos*]" of God; he was also "the real light which enlightens every man."[1] As Word, he was still there to be heard and obeyed; but as Light, he was now there to be seen as well—and therefore to be visualized, also in the form of an icon. Through the Incarnation, then, the visual had finally been rehabilitated, rescued from the service of idols, and restored to the worship of one who was, in the words of the Niceno-Constantinopolitan Creed, "Light from Light, true God from true God."[2]

1. John 1:1, 9.
2. First Council of Constantinople (Alberigo 24; *NPNF*-II 14:163).

In a number of fascinating ways, our tapestry *Icon of the Virgin* reflects such Classical as well as Christian theories about sense-perception, about the primacy of sight among the senses, and about a world view that must be called, and without hyperbole, the metaphysics of light.[3] The figure of Christ in the upper zone of the icon is adorned with the nimbus (Fig. 7). So is the figure of the Virgin in the lower zone (Fig. 8). There is no nimbus on the figure of the Christ Child in the lower zone, by an "omission" that is "rare but by no means unique" (Fig. 28).[4] A nimbus also appears on the heads of the archangel Gabriel and of the archangel Michael (Figs. 44 and 50). The nimbus had been, already in pre-Christian Greek and Roman art, a way of representing preternatural light and glory;[5] and a symbol very much like the nimbus also appears—though apparently without any historical connection in either direction to the Western tradition—in the Buddhist art of India. The nimbus acquired a particular association with the portrayals of the Transfiguration of Christ (Figs. 24–25), in which the symbol came to be identified with the uncreated light on Mount Tabor, where Christ appeared before his inner circle of disciples with Moses and Elijah and "his face shone like the sun, and his clothes became white as the light."[6] So it was that a nimbus was used, for example, in the earliest known depiction of the Transfiguration, the mosaic from about 565 in the Monastery of Saint Catherine on Mount Sinai (Fig. 24). It is a mosaic whose iconography can be positively related to the theological thought of Maximus Confessor, who was nearly its contemporary.[7] In this mosaic, it has been said, "the aureole of light surrounds Christ, who is transfigured and thus manifests his divinity."[8] In this way the symbolism of the golden nimbus was a continuation and an elaboration of the more general symbolism of the crown with which Christ was adorned as Son of God. The words of the Psalm, "crowning him with glory and honor," originally spoken about the preeminent position of humanity in the cosmos, came to be applied, already in the New Testament, to the glorification of Christ.[9] And in some early Christian art the crown bestowed on Christ was in turn a continuation and an adaptation of the *aurum coronarium* or *aurum oblaticium*, golden wreaths that had been presented to the Roman emperor upon his coronation.[10]

3. Florenskij 1985, 1:305–07.
4. Shepherd 1969, 93–94.
5. See the materials assembled in Krücke 1905.
6. Matt. 17:2.
7. Loerke 1984, 47.
8. A. Grabar 1968, 117.
9. Ps. 8:5; Heb. 2:9.
10. Kostof 1965, 90.

28. Christ Child, detail from *Icon of the Virgin*

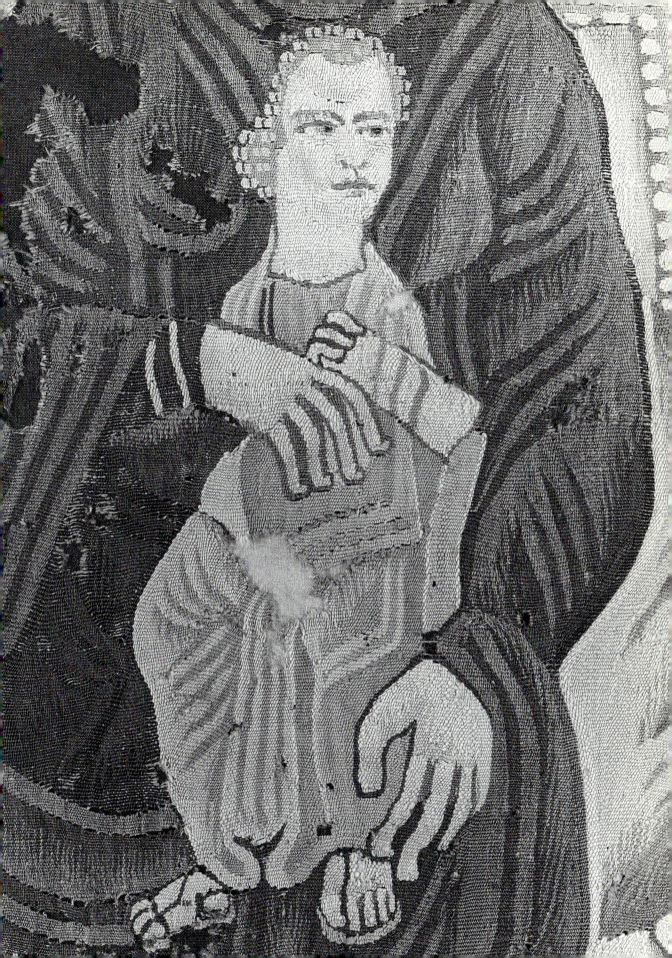

In addition to the use of the nimbus as a visual device, this icon confronts us, at least by indirection, with the psychological and philosophical, and ultimately theological, problem of the relation among the senses in another respect as well. For there is one striking difference between the layout of its upper zone and that of its lower zone. Unless the damage to the tapestry has obliterated them, which would seem to be highly unlikely, there are no inscriptions over the portraits of Christ and of the angels in the upper zone (Fig. 7); it can perhaps be argued that, at least in part, this was so because no identifications of them were deemed necessary. By contrast, all of the figures in the lower zones except the Christ Child himself—not only the central figures of Mary and the angels, who would certainly have been easily identifiable to any Christian viewing the icon, but also the medallions of the apostles—are accompanied by labels giving their names, as well as, in the case of Mary and the angels, the title "holy" or "saint" (Fig. 29). The use of names or entire titles was a way of relating the picture to the words identifying the persons, objects, and events it represented. Analogous to it, following a practice known also in Classical antiquity, was the Christian use of acronyms and monograms,[11] such as the conventional acronym for the Virgin Mary, consisting of the Greek letters *MR THU*, which in Byzantine iconography but also in Western art stood for "*Mētēr Theou* [Mother of God]." Thus, to recur to the contrast drawn earlier on the basis of Vladimir Nabokov, it was a device for connecting the "image" to the "idea" that was in the image. And although such words or names happened to be written rather than spoken and were therefore, in a technical sense, addressed to the sense of sight rather than to the sense of hearing, they were still words, not pictures, and they had been spoken long before they were written. Underlying the aesthetics at work in such a connection of picture to word was a way of relating the sense of sight to the sense of hearing through the use of the words to explain the images, whose meaning could have been lost or at least diminished without the words.

The English word "aesthetics" comes from the Greek word *aisthēsis*, which in Classical Greek meant "sense-experience" or "sense-perception," whether it was artistic or not.[12] The term was a central theme of the *Theaetetus*, the dialogue of Plato in which, according to Werner Jaeger, "the noblest expression of Plato's paideia" had been articulated, because it dealt more explicitly than almost any other of the dialogues with psychology and epistemology, and hence with the relation of empirical sense-perception

11. For a general account, see Gardthausen 1924.
12. Liddell–Scott–Jones 42.

to genuine knowledge (in the Platonic sense of knowledge).[13] In the *Theaetetus* Socrates reported on one of the most widely circulated contemporary theories of sensation, according to which "the senses [*hai aisthēseis*] are variously named—seeing, hearing, smelling, and heat and cold"; nevertheless, the senses had not been created equal, but the sense of sight stood out from all the others, by virtue of the fact that "each variety of seeing has a corresponding variety of color."[14] Carrying this Socratic or Platonic analysis of *aisthēsis* several steps further, Aristotle would open his *Metaphysics* with the oft-quoted words:

> All men by nature desire to know. An indication of this is the delight we take in our senses. For even apart from their usefulness they are loved for themselves—and above all others the sense of sight. For not only with a view to action, but even when we are not going to do anything, we prefer seeing (one might say) to everything else. The reason is that this [sense of sight], most among all the senses, makes us know and brings to light many differences between things.[15]

This belief in the primacy of sight was not invented by Aristotle, for already in Book VI of the *Republic* Plato had expounded it. On the basis of his familiar doctrine of Forms, that "the many are seen but not known, and the Ideas are known but not seen," Plato asserted that "sight is by far the most costly and complex piece of workmanship which the artificer of the senses [*ho tōn aisthēseōn dēmiourgos*] ever contrived." For although hearing required only the voice and the ear to function, sight required not only color and the eye but "a third nature [*genos triton*]" in addition, namely "light," which was divine in nature.[16] Grammatically, the word *oida*, "I know," in Classical Greek is the perfect form of the Classical Greek verb *eidō*, "I see," and thus it means "I have seen and therefore I know."[17] With the restoration of its lost initial digamma, it is related both to the Latin *video*, "I see," and to words in various of the Germanic and Slavic languages for "I know."

This Classical epistemological tradition made it unavoidable that the place of the concept of "sense-perception [*aisthēsis*]" in human psychology as constituted by its Creator, and therefore its place in the relation between

13. Jaeger 1939–44, 2:287.
14. Plato *Theaetetus* 156b.
15. Aristotle *Metaphysics* 980a.
16. Plato *Republic* 507–08.
17. Liddell–Scott–Jones 483.

humanity and its Creator, would play a prominent role in the efforts of early Christian thought to define itself in relation to the philosophies of the Greeks.[18] Especially important and influential is the treatment of this concept in the thought of Athanasius of Alexandria.[19] Athanasius composed his apologetic treatise *Against the Heathen* probably around 318.[20] In it he attacked the materialistic pagan notion "that man is nothing more than the visible form of the body."[21] He then went on to draw a contrast between "the rational nature of the [human] soul" and the "irrational creatures." From this it followed, he argued, that there had to be a corresponding contrast, within human consciousness itself, between "the intelligence [*nous*] of mankind," which was rational and nonphysical, and "the bodily senses [*tōn aisthēseōn*]," which were neither rational nor nonphysical; for in a healthy person the intelligence was expected to regulate the bodily senses as their "judge [*kritēs*]."[22] When the relation between the intelligence and the bodily senses was functioning as it should, according to Athanasius, it would produce someone like the Egyptian monk Antony. His soul was "free from disturbances [*athorybos*]," and therefore Antony manifested this same quality of utter serenity also in "the outward senses [*tas exōthen aisthēseis*]."[23] Despite the seemingly Hellenizing tone of its anthropology, this emphasis of Athanasius on the rationality of the soul and on its superiority to the senses was, as the very title of the book *Against the Heathen* indicates, being directed explicitly against the Greeks, "who worship idols."[24]

Clearly, Athanasius was continuing here the practice of the early Christian apologists. They had differentiated between "the perception of the senses [*aisthēsis*]" and "the reason [*logos*]." A corollary of the differentiation was their contrast between the sensual worship of paganism, which consisted in smelling the "fragrance" of incense or seeing the sight of the "blood or fat of sacrifice," and Christian "bloodless sacrifice, the worship which we, as rational creatures, should offer [*logikē latreia*]," which did not depend on any of the senses.[25] The Greek phrase *logikē latreia* had been employed by the apostle Paul in the Epistle to the Romans to characterize proper

18. The entry in Lampe 52, a miniature monograph on the psychological theories of the Greek fathers, is fundamental to the discussion that follows here.

19. Müller 35.

20. On this date, see Quasten 1951–86, 3:24–26.

21. Athanasius *Against the Heathen* xxx.4, xxx.2 (PG 25:60–61; NPNF-II 4:20).

22. Athanasius *Against the Heathen* xxxi.1–3 (PG 25:61; NPNF-II 4:20).

23. Athanasius *Life of Antony* 67 (PG 26:940; NPNF-II 4:214).

24. Athanasius *Against the Heathen* xxx.4, xxx.2 (PG 25:60–61; NPNF-II 4:20).

25. Athenagoras *Embassy for the Christians* xiii.2 (PG 6:916; ACW 23:44).

Christian worship.[26] The normative interpretation of the phrase in Greek Christian theology was the one provided by John Chrysostom:

> What is *logikē latreia*? It means spiritual ministry, a way of life according to Christ. . . . This will be so if every day you bring him sacrifices, and become the priest of your own body, and of the virtue of your soul. . . . For in doing this you offer the kind of worship that we, as rational creatures, should offer, namely, a worship without anything that is bodily or gross or entangled in the life of the senses [*aisthēton*].[27]

So well established was this principle in the tradition that nothing in the subsequent development of Christian thought could ever go behind that celebration of a "worship offered by mind and heart," which transcended all the experience of the senses. Even if they had wanted to—which they definitely did not—the defenders of icons could not have repealed that principle. In a classic fourth-century Christian enumeration of the four senses of sight, hearing, taste, and touch, together with a diagnosis of the special sins attaching to each, Gregory of Nyssa, commenting on the Old Testament passage "Death has climbed in through our windows,"[28] declared that "what Scripture calls 'windows' are the senses," each of which could, "as the passage says, make an entrance for death" in its own special and insidious way and each of which was therefore to be resisted and avoided by the special grace and moral caution appropriate to it.[29]

But this critical attitude toward the senses was not the complete story for Christian thought. For the youthful treatise by Athanasius bearing the title *Against the Heathen* was only the first installment of a two-volume work, whose second and better-known half was entitled *On the Incarnation of the Logos*. And as this second volume made the concept of the Son of God as the "Reason [*Logos*]" of the Father the basis for all other discussion of human "rationality [*logos*]," rather than basing the discussion of Christ as the transcendent Reason of God on the immanence of reason within the human soul, so the fuller meaning of "reasonable worship [*logikē latreia*]" in its implication for the life of the senses and hence for Christian icons was to be provided only in the light of the second half of the dialectic, which was the function of the material world in such "Logos-centered wor-

26. Rom. 12:1, using the alternate translation suggested in *The New English Bible*, where the first translation reads: "the worship offered by mind and heart."
27. John Chrysostom *Homilies on Romans* xx.2 (*PG* 60:597; *NPNF*-I 11:497).
28. Jer. 9:21.
29. Gregory of Nyssa *The Lord's Prayer* 5 (*PG* 44:1185; *ACW* 13:78–79).

ship." By its announcement that "a new order has already begun,"[30] the doctrine of the Incarnation had given a new meaning to the entire world of created matter, which had now been blessed by the presence of the material flesh in which the very Logos of God had become truly human. The full import of that positive implication of the material world took much longer to come into Christian thought than had the overt denunciation of idolatry as materialism. The course of its history does raise the question, moreover, whether such a reorientation in the Christian interpretation of materiality would ever have been drawn out of the doctrines of the tradition in such detail if there had not been a series of challenges, both from inside and from outside the Christian movement, that made this new appreciation of the goodness of matter necessary. In this way, as Justin Martyr had already observed, heresy could contribute to orthodoxy by making it "more faithful and steadfast."[31] The recognition of the unintended positive contribution of heresy to orthodoxy was to become a standard part of the orthodox argument against heresy in later centuries, also in the Latin West.[32]

As it happened, however, much of the early challenge of Gnosticism to the church's doctrine of the person of Christ had been perceived by the orthodox teachers of the church, accurately or not, as a hostility to the entire created, physical world, and therefore as a rejection of the intrinsic goodness, or even of the very reality, of the material nature that had been assumed by the Logos in the Incarnation. Therefore Athanasius insisted that the body of the Logos had to be a real human body "not in mere appearance or fantasy but in reality [*mē phantasiai alla alēthōs*],"[33] a body that was "of no different sort from ours,"[34] a body which, "sharing the same nature with all . . . [and] being mortal, was to die,"[35] so as to rescue real human bodies from the tyranny of corruptibility and death.[36] Already in the later books of the New Testament, this persistent emphasis on the reality and therefore the materiality of the body that had been assumed in the Incarnation often included explicit and iterated references to the perceptibility of this body by the several human senses. In a post-Resurrection scene in the Gospels, which was depicted on an ivory diptych from Constantinople (Fig.

30. 2 Cor. 5:17.
31. Justin Martyr *Dialogue with Trypho* 35 (PG 6:549; *ANF* 1:212).
32. The biblical warrant for this recognition was provided by the Vulgate translation of 1 Cor. 11:19, "*oportet haereses esse.*"
33. Athanasius *Orations against the Arians* III.32 (PG 26:392; *NPNF*-II 4:411).
34. Athanasius *On the Incarnation of the Logos* viii.2 (PG 25:109; *NPNF*-II 4:40).
35. Athanasius *On the Incarnation of the Logos* xx.4 (PG 25:132; *NPNF*-II 4:47).
36. Athanasius *On the Incarnation of the Logos* xliv.6 (PG 25:176; *NPNF*-II 4:60).

21), "doubting Thomas" was invited to "reach your finger here, see my hands."[37] These words of Christ to Thomas were proof to the early church fathers of "the substance of the flesh."[38] But perhaps the most striking accumulation anywhere of such references to the several human senses had come in the words with which the First Epistle of John opened:

> It was there from the beginning; we have *heard* it; we have *seen* it with our own eyes; we *looked* upon it, and *felt* it with our own hands; and it is of this we tell. Our theme is the word of life. This life was made *visible*; we have *seen* it and bear our testimony; we here declare to you the eternal life which dwelt with the Father and was made *visible* to us.[39]

Significantly, those words were followed a few verses later by one of the standard proof texts for the Christian metaphysics of light, initially grounded, however, in the sense of hearing rather than primarily in the sense of sight: "Here is the message we heard from him and pass on to you: that God is light, and in him is no darkness at all."[40] The same Gregory of Nyssa who had warned about the "windows" of the senses was also capable of describing a veneration of the relics of a martyr in which "those who behold them embrace, as it were, the living body itself in its full flower; they bring eye, mouth, ear, all their senses into play; and then, shedding tears of reverence and passion, they address to the martyr their prayer of intercession as though he were hale and present."[41] As Ernst Kitzinger has observed, "in this ecstatic passage, in which the shapeless relic is merely a tool for conjuring up the physical presence of the saint, one can discern something of the roots of future image worship. For if a sensual perception of the living form is the devout's primary need, it is obvious that the work of the painter and sculptor can be of greater assistance to him than a handful of dust and bones."[42]

By the time of the Iconoclastic controversy, therefore, the "Christian idealism" that was so prominent especially in the thought of many of the Alexandrian church fathers such as Clement and Origen had been counterbalanced by what could no less legitimately be styled a "Christian materialism." That does not seem to be too strong a term with which to characterize

37. John 20:27.
38. Irenaeus *Against Heresies* V.vii.1 (Harvey 2:336; *ANF* 1:532).
39. 1 John 1:1–2; italics added.
40. 1 John 1:5.
41. Gregory of Nyssa *Encomium of Saint Theodore* (PG 46:740); translation by Ernst Kitzinger.
42. Kitzinger 1954, 116.

the recognition of the material nature of man, and therefore of the material nature of the Incarnation, and therefore of the material nature of the sacraments and of the other means by which the grace of the Incarnation was communicated to and through the five senses. This positive assessment of matter had decisively shaped the liturgy and theology of the church. John of Damascus, defender of the icons, was also the interpreter of what he called "a twofold worship [*diplē proskynēsis*]." Such twofold worship was necessary if the Christian relation to God was to be in accordance with a humanity that was at one and the same time "visible" and "invisible," for human nature was "a synthesis between the intellectual and the sensate [*noētēs kai aisthētēs syntetheimetha*]." That made itself evident in the church's liturgy, in which "we sing both with our intellect [*tōi nōi*] and with our physical lips," as well as in the sacraments, in which, according to the *locus classicus* from the Gospel of John,[43] "we are baptized with both water and spirit." The very union of believers with the Lord Jesus Christ itself took place "in a twofold manner," involving both the grace of the Holy Spirit and a participation in the sacramental "mysteries."[44] All of this was said in the context of a defense of the practice of "orientation [*proskynein pros anatolas*]," prayer facing east, even though, as Basil had already pointed out in his defense of the authority of unwritten tradition, orientation was admittedly based on an "apostolic tradition" that was not set down explicitly anywhere in the New Testament.[45] From this discussion of orientation John of Damascus turned to a consideration of the sacraments, for which a Christian reassessment of each of the five senses was prerequisite, since each of the five had by this time been assigned a particular liturgical and therefore theological function.

Among the five senses, the sense of smell became a component part of the liturgical sense-experience within the church only very gradually. As is evident from the pejorative reference to "fragrance" in pagan worship quoted earlier from Athenagoras,[46] early Christian practice seems to have avoided the use of incense in worship, despite the prominent place it had held in the Old Testament, as "a regular burning of incense before the Lord for all time."[47] Therefore the well-known passage in the Book of Revelation, which describes an angel with a "golden censer" and "a great quantity

43. John 3:5.
44. John of Damascus *The Orthodox Faith* IV.12 (PG 94:1133; *NPNF*-II 9:81.)
45. Basil *On the Holy Spirit* xxvii.66 (PG 32:188; *NPNF*-II 8:41).
46. Athenagoras *Embassy for the Christians* xiii.2 (PG 6:916; *ACW* 23:44).
47. Ex. 30:8.

of incense," should probably be seen as totally figurative, or perhaps at most as an allusion to the Jewish ritual rather than to anything then current in the Christian liturgy.[48] But by the early sixth century—which is also almost exactly the time to which our tapestry *Icon of the Virgin* can be dated—we find one of the earliest uncontested references to the presence of incense in the Christian cultus, although when such a reference finally appears it does seem to be presupposing the practice rather than treating it as a novelty.[49] For in his exposition of how the people in the congregation were to be censed by the clergy, the unknown Christian Neoplatonist who took the name of Dionysius the Areopagite was already speaking about the use of incense in the divine liturgy as a matter of course, and he found a mystical meaning in liturgical actions that he seems to have been able to expect his readers to recognize without any further explanation. The service of "Holy Communion [*synaxis*]" opened with incense.[50] As Dionysius described it, the bishop "spreads the lovely fragrance to even the least sacred areas" of the church building.[51] By this action he was, according to Dionysius, symbolizing the movement of the transcendent and immovable Deity to the faithful.[52] It seems, moreover, that for a long time the use of incense was a standard part of the service of Holy Communion solely in the East, taking hold only much later in the Western Church.[53] In any case, by the time the Byzantine defenders of the icons came to argue for the rehabilitation of the visual on the basis of a comprehensive theological interpretation of "sense-perception [*aisthēsis*]," they were in a position to appeal to a standard liturgical practice that had meanwhile learned to address even the sense of smell.[54]

The sense of touch was addressed by the anointing with "the holy chrism [*to timion myron*]."[55] Chrismation eventually came to be associated also with various nonsacramental rituals of consecration, but especially with the three sacraments of baptism, confirmation, and ordination.[56] All three of these

48. Rev. 8:3–5.

49. Holl 1928, 396 attributes the earliest use of incense to the circle around Simeon Stylites (who died in 459), where, in his judgment, it "has a strong flavor of paganism."

50. Pseudo-Dionysius the Areopagite *The Ecclesiastical Hierarchy* III.2 (PG 3:425; CWS 210).

51. Pseudo-Dionysius the Areopagite *The Ecclesiastical Hierarchy* IV.iii.3 (PG 3:476; CWS 227).

52. Pseudo-Dionysius the Areopagite *The Ecclesiastical Hierarchy* III.iii.3 (PG 3:429; CWS 212–13).

53. Atchley 1909.

54. Stein 1980, 66–67.

55. Pseudo-Dionysius the Areopagite *The Ecclesiastical Hierarchy* IV.iii.10 (PG 3:484; CWS 231).

56. Lampe 889–90.

sacraments involving chrism conferred what the Scholastic formula of the Latins would eventually call an "indelible character" on the recipient, and therefore they could not be repeated.[57] The authority of Scripture and tradition for the practice of chrismation was far stronger than it was for the Christian use of incense. In the Gospels the preaching of the disciples of Jesus was sometimes accompanied by a curative anointing.[58] In the Epistle of James this idea was carried further with the admonition: "Is one of you ill? He should send for the elders of the congregation to pray over him and anoint him with oil in the name of the Lord," which would convey not only healing but the forgiveness of sins.[59] The passage from James was to become, also in the West, the proof text for chrism. The most detailed early patristic explanation of the chrism comes from a book that has been called "one of the most precious treasures of Christian antiquity,"[60] the *Catechetical Lectures* delivered by Bishop Cyril of Jerusalem around the middle of the fourth century, the final portion of which bore the title *Mysta-gogical Catecheses* and dealt with the sacraments (or "mysteries" as they were called in Greek). Cyril drew a comparison between the "chrismation" of Christ himself and that of the believer. By his anointing Jesus had acquired the title "Christ" or "Messiah"; this chrismation had taken place without any "material ointment," but only with the Holy Spirit.[61] The anointing of the Christian initiate, by contrast, did involve a chrism with "material ointment" and a physical unction, which was "applied to your forehead and your other organs of sense [*epi metōpou kai tōn allōn aisthēriōn*]"—to the forehead, then to the ears, then to the nostrils, then to the breast.[62] As one commentator on this passage has suggested quite plausibly, "the forehead may be regarded as representing the sense of touch."[63]

For the sense of taste, the Eucharist represented the obvious sacramental point of contact. Cyril of Jerusalem, who was "the first theologian to interpret this transformation [in the Eucharist] in the sense of a transsubstanti-ation,"[64] made a point of warning his hearers: "Judge not the matter from the taste, but from faith be fully assured [of it]."[65] From that warning,

57. Landgraf 1952–56, 3-I:269–78.
58. Mark 6:13.
59. James 5:14–15.
60. Quasten 1951–86, 3:363.
61. Cyril of Jerusalem *Catechetical Lectures* XXI.2 (*PG* 33:1089; *NPNF*-II 7:149).
62. Cyril of Jerusalem *Catechetical Lectures* XXI.3 (*PG* 33:1092; *NPNF*-II 7:150).
63. *NPNF*-II 7:150, n. 8.
64. Quasten 1951–86, 3:375.
65. Cyril of Jerusalem *Catechetical Lectures* XXII.6 (*PG* 33:1101; *NPNF*-II 7:152).

however, he went on in the very next lecture to invite believers to a participation in their Lord that would be communicated to them precisely through their sense of taste:

> After this you hear the cantor inviting you with a sacred melody to the communion of the Holy Mysteries, and saying, "Taste, then, and see that the Lord is good."[66] Trust not the judgment to your bodily palate; no, but to faith unfaltering. For those who taste are bidden to taste, not bread and wine, but the antitypical body [*antitypou sōmatos*] and blood of Christ.[67]

In the catalogue of the senses mentioned earlier, Gregory of Nyssa had identified the sense of taste as, "one may well say, the mother of each individual evil . . . pretty nearly the root of the sins committed in the physical life," because it was the sense that led to "satiety."[68] But like Cyril of Jerusalem, he also invited those who "hunger and thirst to do what is right"[69] to taste and eat. For by this sanctified exercise of the same sense of taste they would find a spiritual satiety that transcended "the greed of the glutton and the drinker's pleasure."[70]

Nevertheless, in the Byzantine apologia for the icons, as well as in the theological interpretation of the senses throughout the Judeo-Christian tradition, the two senses that have been the most important for their psychological bearing on the arts of worship and on religious experience—as well as the two senses that have been the most problematical for their theological relation to each other—have long been hearing and seeing. Discussing the character of Leontes in Shakespeare's *A Winter's Tale*, Northrop Frye has commented in quite another context on the psychological objectivity of these two senses, by contrast with the subjectivity of "the contact senses" of smell, touch, and taste: "[Leontes] says he smells and feels and tastes his situation, but seeing and hearing [are] the primary senses of the objective," and these were, significantly, the two that Leontes failed to mention.[71] In biblical religion, both in the Old Testament and in the New, and then in

66. Ps. 34:8. It is instructive to compare with this use of Ps. 34:8 the passage in Clement of Alexandria *Stromata* V.10 (*GCS* 15:370; *ANF* 2:460), which takes it as a reference to "those who partake of such food in a more spiritual manner."

67. Cyril of Jerusalem *Catechetical Lectures* XXIII.20 (*PG* 33:1124; *NPNF*-II 7:156); on the meaning of the term "antitypical" as applied to the sacraments in this and related passages in Cyril, see Lampe 159.

68. Gregory of Nyssa *The Lord's Prayer* 5 (*PG* 44:1185; *ACW* 13:78–79).

69. Matt. 5:6.

70. Gregory of Nyssa *Sermons on the Beatitudes* 4 (*PG* 44:1244; *ACW* 13:126–27).

71. Frye 1986, 162.

the subsequent Christian tradition, hearing was assigned a decisive function: "Faith cometh by hearing," as the Authorized Version has it, "and hearing by the word of God."[72] In a direct allusion to that text from the Epistle to the Romans, an important twentieth-century interpretation of the theology of the doctrine of justification in Martin Luther bears the title *Fides ex auditu.*[73] But the application of the principle of the superiority of the word to the image was carried out even more consistently and thoroughly in Islam than it was anywhere in Christianity. In Islam, the corollary of this principle was the superiority of writing to any of the representative arts, as a recent essay on the subject has explained:

> Invested with God's power, and as an instrument of his will, writing acquired a special status that no other artistic expression was able to attain. . . . Given Arabic's unique role within the Muslim world as the bearer of divine revelation, it is easy to see how calligraphy—the act of recording God's words as transmitted by the prophet through the Qur'an—became central to any artistic expression.[74]

The word as written and spoken was God's revelation, which the believer was commanded to hear, while refusing to heed the idolatrous allurement of the nonverbal visual image.

The same text from Romans had provided John of Damascus, champion of icons and of the primacy of the visual though he was, with the basis for affirming that "by hearing the divine Scriptures we believe in the teaching of the Holy Spirit."[75] In his systematic theology, *The Orthodox Faith,* John of Damascus included chapters on many topics that have not ordinarily been treated in such theological manuals. A major part of Book II, for example, was devoted to a discussion of human psychology, including the various human pleasures, the imagination, and memory.[76] One of the longest portions of this miniature textbook of psychology was chapter eighteen, bearing the caption "Concerning Sense-Perception [*peri aistheseōs*]."[77] Yet it is noteworthy, if a bit surprising, that the Damascene's passing observation, "The Creator fashioned all the other organs of sense [except for touch] in pairs," was the only reference to any theological consideration at all in this entire discussion of "sense-perception." But else-

72. Rom. 10:17.
73. Bizer 1966.
74. Lowry 1986, 102–03.
75. John of Damascus *The Orthodox Faith* IV.10 (PG 94:1125–28; NPNF-II 9:79).
76. John of Damascus *The Orthodox Faith* II.13–24 (PG 94:929–56; NPNF-II 9:33–39).
77. John of Damascus *The Orthodox Faith* II.18 (PG 94:933–37; NPNF-II 9:34–35).

where, when he was defending the icons, John of Damascus had expanded on these psychological doctrines to embed his interpretation of this same word, "hearing [*akoē*]," in a comprehensive psychological, but also theological, theory of sense-perception as a whole:

> The ancient Israel did not see God, but we [the Christian Church as the new Israel] behold the glory of the Lord by means of the face that has been revealed to us.[78] And through the use of our bodily senses [*aisthētōs*] we perceive his express image [*ton autou charaktēra*[79]] everywhere. Through it we sanctify the primary [sense]—for the primary one among the senses is the sense of sight—just as by means of the words [of God] we sanctify hearing. For the icon is a reminder. What the book is to those who have learned to read, that the icon is to the illiterate. And what the word is to the [sense of] hearing, that the icon is to the [sense of] sight. We are united to it by our intellect [*noētōs*].[80]

In this passage John of Damascus was continuing the argument propounded earlier by various Christian thinkers, notably by Augustine in the *City of God*, that far from denying the testimony of the physical senses, as it had been accused of doing by critics who lumped it with a kind of vulgarized Platonic idealism, Christianity had taught its followers to "trust the evidence of the senses, which the mind uses by aid of the body, since [although those who trust their senses are sometimes deceived], those who fancy that they should never trust their senses will be even more wretchedly deceived."[81] John of Damascus was also summarizing the doctrine that the title of this chapter has called "the senses sanctified: the rehabilitation of the visual."

To bring this set of psychological and aesthetic theories about the primacy of the visual into conformity with the standards of Christian teaching, it was necessary to pursue several lines of argumentation simultaneously. The most fundamental, and one of the most fruitful, was the metaphysics of light, whose significance for medieval Western aesthetics has been analyzed by Umberto Eco.[82] The metaphysics of light was, if anything, even more important for medieval Eastern aesthetics. As we have noted earlier, Plato had identified light as divine in nature, describing it as the third factor, in

78. Or perhaps: "by means of the person who has been revealed to us [*anakekalymmenōi prosōpōi*]."

79. This may well be an allusion to Heb. 1:3, rendered in the Authorized Version as "the express image of his person."

80. John of Damascus *Orations on the Holy Icons* I.16–17 (PG 94:1248).

81. Augustine *City of God* XIX.18 (*CCSL* 48:685–86; *NPNF*-I 2:413).

82. Eco 1986, 43–52.

addition to color and the eye itself, that was required for human sight.[83] With at least some echoes of this Classical usage, the New Testament, particularly in various of the writings bearing the name of John, had repeatedly gone beyond confessing merely that God had created light or that light was a symbol of God, to affirm that "God *is* light."[84] The immediate corollary of the statement that "God is light" was the insistence that "in him there is no darkness at all."[85] The identification of human sin as "darkness" and of the battle against the devil and the other enemies of God as a conflict "against cosmic powers, against the authorities and potentates of this dark world"[86] had another advantage for the light metaphysics of orthodox philosophical theology. It enabled Christian thought to speak about the power of sin in the emphatic language of a moral dualism without lapsing into the ontological dualism which had, in Manicheism and other heresies, made evil into a second reality alongside the reality of God.[87] For even someone who was terrified of the darkness was obliged to admit, at least by the clear light of day, that darkness did not possess any reality of its own, but was the absence of light; so it was also with "God's darkling world," which was in the valley of the shadow but which remained God's world nonetheless. That same orthodox version of dualism underlay the Eastern use of the metaphor of *Christus Victor* for the doctrine of the Atonement.[88]

The metaphysics of light was especially important as a way of speaking about Christ.[89] And because the New Testament had described the relation between the Son and the Father as analogous to the relation of the "radiance or effulgence [*apaugasma*] of God's splendor" to its source in the light,[90] "Light from Light" as a title for the Son of God became part of the text of the Niceno-Constantinopolitan Creed.[91] At the hands of the most influential defender of the faith of the Council of Nicaea, Athanasius of Alexandria, "Light from Light" proved itself to be ideally suited for making the orthodox case that the Light (God the Father) and the Effulgence (the Son of God) were of a single nature, yet distinct. "The God-who-is,"

83. Plato *Republic* 508a.
84. Bultmann 1948, 1–36.
85. 1 John 1:5.
86. Eph. 6:12.
87. John of Damascus *The Orthodox Faith* IV.20 (*PG* 94:1193–97; *NPNF*-II 9:93–94).
88. Aulén 1969.
89. Dölger 1936, 1–43.
90. Heb. 1:3.
91. First Council of Constantinople (Alberigo 24; *NPNF*-II 14:163).

Athanasius argued, "is eternally. Since the Father always is, his Effulgence also is eternally, because it is his Logos. And again, from himself the God-who-is has the Logos, who also is."[92] But unlike the more technical term of the Nicene Creed for that tenet, the celebrated "one in being with the Father [*homoousios tōi patri*]," which was alien in tone and heretical in provenance,[93] this metaphor had the advantage of being biblical in origin. Meanwhile, for reasons that are still not clear, the designation of the Son of God as "Word," which also came from the New Testament writings bearing the name of John, was not incorporated into the language of the Nicene Creed. As a consequence, when the time came to affirm the primacy of the sense of sight over the sense of hearing as a way of defending the icons, the liturgical recitation of "Light from Light," together with its possession of a more privileged creedal status than "Word of God" as a title for the Son of God, does seem to have helped in some ways to prepare the ground.

In keeping with the standard distinction between "theology" and "economy," it should be noted that it was not any of these orthodox ways of speaking about the preexistent relation of the Son to the Father in eternity ("theology"), but the orthodox way of speaking about the Incarnation of the Son in time and history ("economy"), that not only carried the day doctrinally in the defense of the icons, but that provided the fundamental justification for making the visual dimension central and "the eye first" among the organs of sense.[94] The defenders of the icons described the devil, who as a fallen angel had no body, as resenting the Incarnation and the salvation of the human body through the body of the incarnate Son of God.[95] Similarly, apparently wishing that the Incarnation had not taken place at all or at any rate that it had not been so total and so utterly physical, various Gnostic heretics had, according to their accusers, attributed to Christ a "heavenly body [*sōma ouranion*]," which had not been created and had not been born of the Virgin Mary but had preexisted and had been brought down by him from heaven.[96] The chronic heretical preference for a "heavenly body," the orthodox charged, had now moved from the Gnostics to the Iconoclasts, whose arrogant claim to be purely spiritual prompted them to disparage everything about Christ that was physical and visible.[97]

92. Athanasius *Orations against the Arians* I.25 (PG 26:64; *NPNF*-II 4:321).
93. Prestige 1956, 197–241.
94. Theodore the Studite *Orations* IX.8 (PG 99:781).
95. John of Damascus *Orations on the Holy Icons* III.3 (PG 94:1320).
96. John of Damascus *On Heresies* 30–31 (PG 94:696–97).
97. Theodore the Studite *Refutation* I.4 (PG 99:332–33; Roth 23); see also his references to various heretics, *Refutation of the Poems of the Iconoclasts* 8 (PG 99:452).

The Iconoclastic Synod of 754 had spoken about "worthless and dead matter" as an unworthy instrument for authentic Christian worship.[98] What they wanted, according to their Iconodule critics, was "a purely mental contemplation [*hē kata noun theōria*]."[99] Therefore "they saw the images drawing the spirit of man from the lofty adoration of God to the low and material adoration of the creature."[100] Jesus had declared: "God is spirit, and those who worship him must worship in spirit and in truth."[101] Into modern times this passage from the Gospel of John has been interpreted as a criticism of formal liturgical worship of various kinds. But according to the Iconodules the passage was not to be taken to mean, as the Iconoclasts could be accused of claiming, that it was either possible or necessary for Christian prayer to circumvent the flesh in order to achieve an unambiguously spiritual worship. "You perhaps," the Iconodule could say sarcastically to his Iconoclast opponent, "are more exalted and nonmaterial [*ahylos*], and have risen above the body, so that, being nonfleshly [*asarkos*], you can despise everything that presents itself to the sight." For his part, however, he acknowledged that "since I am a human being and occupy a body, I want to deal in a bodily fashion with the things that are holy." And therefore, he concluded, "I want to look at them," and he proposed to do so by viewing the holy icons.[102]

To substantiate the psychological and theological case for the legitimacy of Christian icons, Iconodule apologists paid special attention to those passages of Scripture in which hearing and seeing had been juxtaposed in one way or another. Prominent among such passages was one in which, during the days of his visible presence on earth, Christ had said to his disciples: "Happy are your eyes because they see, and your ears because they hear! Many prophets and saints, I tell you, desired to see what you now see, yet never saw it; to hear what you hear, yet never heard it."[103] This statement characterized the situation of believers before Christ, even of "many prophets and saints," as one in which both seeing and hearing Christ in person had been denied to them and in which they had been obliged to rely on hearing the prophetic word; those believers were also the ones to whom the Mosaic prohibition of any image or likeness had been explicitly addressed.

98. Iconoclastic Synod of Constantinople, quoted by Second Council of Nicaea (Mansi 13:277; Sahas 105).

99. Theodore the Studite *Refutation* 1.7 (PG 99:336; Roth 26).

100. Martin 1930, 115.

101. John 4:24.

102. John of Damascus *Orations on the Holy Icons* I (PG 94:1264).

103. Matt. 13:16–17.

By contrast, the disciples had been granted the privilege both of seeing Christ and of hearing him. Surely, the Iconodules argued, it had not been the intention of Christ that those who became his disciples only after the Ascension were to relapse into the condition of the "prophets and saints" before the Incarnation. For although the visible presence of the historical Christ had been withdrawn, that did not mean that the eyes of his latter-day disciples could not share in that blessing of sight; they could still do so, but now through the instrumentality of the icons.[104] It was said to be noteworthy, moreover, that Christ had spoken here first of their eyes, and only then of their ears. The message of the gospel had been preached to the hearing of the disciples, but only after they had first seen Christ himself and his mighty deeds with their own eyes; now it was the icons that took the place of the events and thus served as the visible basis for the oral-aural message.[105]

To this it had to be added, moreover, that although the Old Testament prophets had desired to see what the disciples and their successors could now see, but had not been granted the opportunity to do so, that was not to be taken to mean that even the prophets had been dependent exclusively on the sense of hearing. A "prophet" was one who "told forth" the word of God, which was meant to be heard.[106] Nevertheless, the careers of the Old Testament prophets, too, had demonstrated that "sight has priority over hearing."[107] Not only as the direct biblical source for the *Sanctus* of the Mass in the Latin West but as the indirect biblical source for the *Trisagion* of the Divine Liturgy in the Greek East,[108] the scene in the Old Testament that recounted the calling of "the divine Isaiah" held a special place both in Western exegesis and in the liturgical theology of the Greek fathers and their Byzantine successors.[109] But before he began his prophetic ministry of receiving and transmitting the word of God for the people of Israel to hear, Isaiah, as he himself said, "in the year of King Uzziah's death . . . *saw* the Lord seated on a throne." He also described how "the house was filled with smoke" from the incense.[110] Here, too, therefore, seeing had preceded hearing, and so it could do now. Consequently, if a heathen today

104. John of Damascus *Orations on the Holy Icons* III.12 (*PG* 94:1333).

105. Nicephorus *Refutation* III.4 (*PG* 100:381).

106. Lampe 1194–97.

107. Theodore the Studite *Refutation* III.i.2 (*PG* 99:392; Roth 78).

108. Brightman 527.

109. John of Damascus *On the Hymn "Trisagion"* 12 (*PG* 95:44–45), quoting Cyril of Alexandria.

110. Isa. 6:1, 4; italics added.

were to ask, "Show me your faith, so that I too may believe," it would be necessary to lead him "from the data of sense-perception [*ek tōn aisthētōn*]" to things invisible, and therefore to take him to see the icons in the church. After seeing them, he would be moved by the visual impact of the images to inquire about them, asking "Who is that man who has been crucified?" And then he would finally be ready to hear the message of the gospel about the Crucifixion of Christ and about the other persons and events depicted in the icons.[111]

From these examples it is evident that despite their theological speculations based on the psychology of sense-perception, on the metaphysics of light, and on the aesthetic implications of the Incarnation, even the later defenders of the icons never gave up also employing the far simpler method of argumentation on the basis of the didactic use of icons. "What the book is to those who have learned to read, that the icon is to the illiterate," John of Damascus said,[112] and others went on repeating that point. The words just quoted from John of Jerusalem about taking an unbeliever to view the icons in the church even suggest that icons might have served that purpose in the evangelization of illiterate non-Christians[113]—not including, of course, the Jews and Muslims who were attacking the use of icons as evidence of a relapse of the Christian Church into heathenism. In the so-called Pannonian Legends of the apostles to the Slavs, Saints Cyril and Methodius, the *Life of Constantine* described a disputation between the young scholar Constantine, who as Cyril became apostle to the Slavs, and the deposed Iconoclastic patriarch, Johannes Grammaticus, where the standard Byzantine arguments for the use of images were rehearsed. This *Life* was written, perhaps by Methodius himself, for converts from idolatrous Slavic paganism to Byzantine Christianity, and its Byzantine author "was anxious to preserve his new converts from any Iconoclastic danger" no less than from their old idolatry.[114] In the Byzantine catechesis of the young as well, the icons provided the narrative starting-point for doctrinal and moral instruction.[115] Because of the reliance of Byzantine preaching on its liturgical context and its constant references to the various elements of the worship service, the icon for the saint's day being observed or for the Gospel event being recounted could act as a point of reference for the sermon, in which, as the examples

111. John of Jerusalem *Against Constantine V* 10 (PG 95:325).
112. John of Damascus *Orations on the Holy Icons* I.17 (PG 94:1248).
113. John of Jerusalem *Against Constantine V* 10 (PG 95:325).
114. Dvornik 1970, 62.
115. Lange 1969.

of John of Damascus and Theodore the Studite showed, "the feasts offered a Christian orator an opportunity for joyous encomium."[116]

And that, in many ways, identifies the principal focus of the entire Byzantine apologia for icons: the centrality of the liturgy. For "the triumph of the venerators of images under Irene and Theodore restored the union between liturgy and art. From the second half of the ninth century the concordance between the spoken word and its translation into visible form becomes more and more precise."[117] The concordance between hearing and seeing, together with the appeal to all five senses that the apologists for icons were defending, came in the setting of worship, where the worshiper could smell the incense, be touched by the holy chrism, taste the divine Eucharist, hear the word of God and the chants—and see the icons. Again, as Lossky has said, "through the Incarnation, which is the fundamental dogmatic fact of Christianity, 'image' and 'theology' are linked so closely together that the expression 'theology of the image' might become almost a tautology."[118] But the Incarnation of the Logos in the historical flesh of Jesus Christ, which provided the Byzantines with their principal theological weapons, was not merely an abstract theological dogma for them; it was the faith celebrated in the words of the liturgy and reenacted in its actions. The twentieth-century Russian theologian Pavel Florenskij expounded the thesis that in Eastern Orthodox worship the entire movement of "entrances" from the darkness behind the iconostasis to the congregation must be understood as the Incarnation in liturgical action today.[119] In substantiation he quoted the decrees of the Second Council of Nicaea of 787 against Iconoclasm.[120] All of that, the council fathers at Nicaea and the other apologists for Christian images were convinced, would have been in jeopardy if Iconoclasm had been successful. Therefore they believed that in defending the icons they were defending the very identity of their faith and worship.

116. Kennedy 1983, 271.
117. Dalton 1911, 648.
118. Lossky 1974, 133.
119. Florenskij 1985, 1:193–316.
120. Florenskij 1985, 1:227.

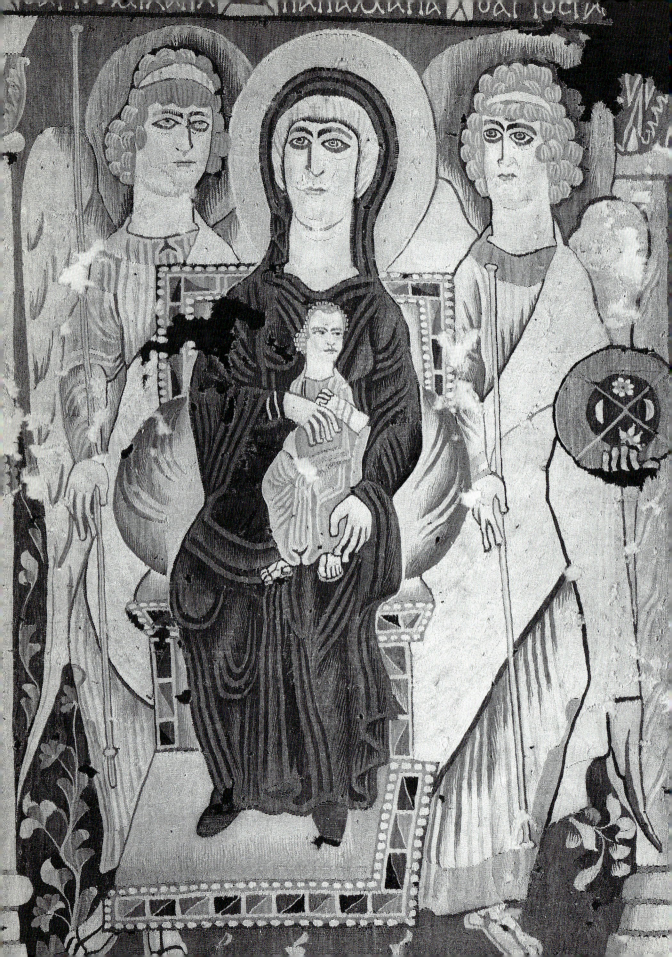

HUMANITY MADE DIVINE
Mary the Mother of God

Iconographically as well as theologically, the supreme person represented on the tapestry *Icon of the Virgin* is not the Virgin Mary but Christ. As Christ enthroned in glory, it is he who occupies the higher of the two zones, which, though smaller in area, is certainly the preeminent one in honor. In the lower zone, moreover, the Christ Child is still Christ the Lord, as he grasps the top of a scroll, probably the scroll of the Law (Fig. 28). Nevertheless, the most prominent figure in size, and in many ways the most striking in style, is the portrait of Mary the Mother of God seated on her throne, with an archangel on either side (Fig. 29):

> On our tapestry the Virgin sits on an elaborately jewelled throne of Byzantine type with an enormous red cushion. She is clad in a simple purple *palla* and tunic and black shoes. One end of the *palla*—or *maphorion*, to use its Greek name—is draped over her head as a veil; beneath it her hair is concealed by a little white cap on which is an "embroidered" gold cross. Her head is framed by a large yellow nimbus. The Christ Child, without a nimbus, is seated in her lap at the left. He is dressed in a golden-yellow tunic and *pallium*; purple *clavi* decorate the shoulders of the tunic. . . .
>
> The Virgin's costume is that of a woman of the ordinary classes in late antiquity. This is the costume in which she is universally represented on all pre-Iconoclastic Byzantine monuments. Although never represented in the elaborate costume of an empress, as was frequently done in contemporary Roman art, her simple garments are nevertheless consistently purple, the color reserved for Byzantine royalty.[1]

1. Shepherd 1969, 93.

121

29. Mary, Michael, and Gabriel, detail from *Icon of the Virgin*

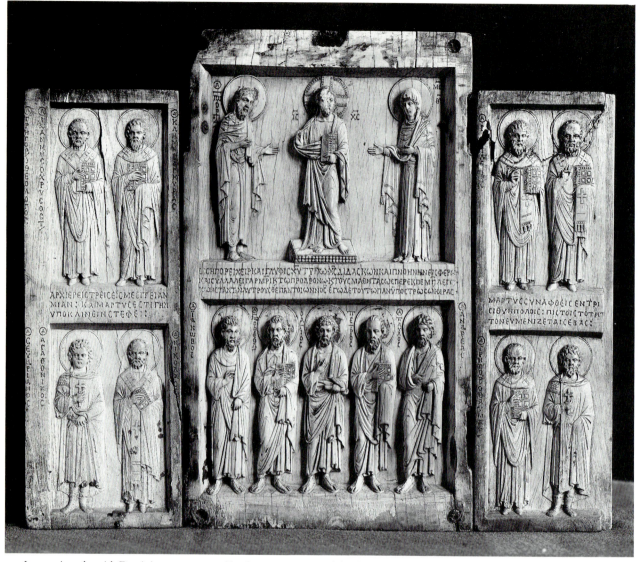

30. Ivory triptych, with Deesis in upper center. Tenth century. Museo del Palazzo di Venezia, Rome

Although this is a tapestry rather than a painting, it does appear iconographically necessary to associate its distinctive treatment of the figure of Mary the Mother of God, including the throne, with the history of the Byzantine liturgical and theological definition of Mary as *Theotokos* in the fifth century, which would thereafter help to determine the way she was to be portrayed in the Christian art of the West no less than in that of the East.[2]

Perhaps the most dramatic of all the traditional portrayals of the Virgin Mary in Byzantine art was the so-called Deesis (from the Greek word *deēsis*,

2. Stubblebine 1966, 379–81.

122

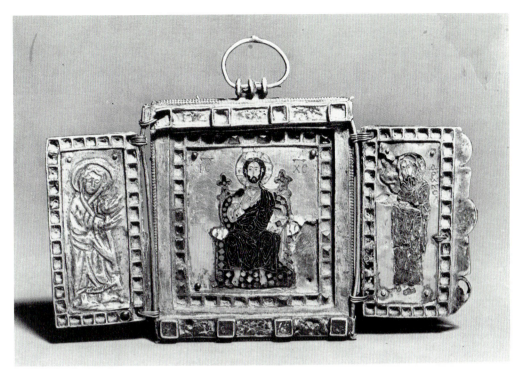

31. Front and back: Eleventh-century Byzantine reliquary. Hermitage, Leningrad

"entreaty or intercession").[3] This had been the word regularly used already in Classical Greek for an "entreaty" of one kind or another.[4] In Byzantine Greek it was employed for various sorts of secular petitions and supplications, such as those that were addressed to the emperor by his subjects.[5] But it also became the standard term in patristic Greek, and then in Byzantine Greek, for intercessory prayers: for those that were addressed by the church "not only to God but also to holy men, though not to others"; for the prayer which Christ as the eternal Mediator presented to the Father; but also for the prayers which the saints, and especially the Mother of God, as created mediators presented to Christ and to the Father on behalf of the church.[6] The Deesis as an art form was divided into three sections or panels. At the center was the figure of Christ as Lord. On either side of Christ were the Mother of God and Saint John the Baptist (who was often identified as "the Forerunner [*ho Prodromos*]"),[7] both of them pleading with Christ on behalf of sinners. The Deesis could be presented in artistic creations of various sizes (Fig. 30). On one tiny eleventh-century Byzantine reliquary, which is approximately eight centimeters square when folded, the Deesis appears in cloisonné treatment, and the two panels of Mary and John can be folded over the panel of the central figure (Fig. 31). On the other hand, the uncovering of the mosaic of the Deesis on a wall in Hagia Sophia in Istanbul has provided documentation of the prominence of this Byzantine motif on a very large scale (Fig. 32).

Historians of Byzantine art and architecture have exploited the significance of the Deesis with sensitivity and skill,[8] and as a result the term "Deesis" has established itself in English usage and now appears in English dictionaries. Unfortunately, historians of Byzantine spirituality and theology have not investigated it with equal thoroughness, despite the profound and suggestive way it presents several of the central motifs in the Eastern Christian understanding of the entire "dispensation [*oikonomia*]" of the history of salvation. The juxtaposition of Mary and John the Baptist in the Deesis was a way of identifying the two figures who, according to the Christian understanding of the history of salvation, had stood on the border between the Old Testament and the New. According to the saying

3. Walter 1968.
4. Liddell–Scott–Jones 372.
5. Sophocles 347.
6. Lampe 334.
7. Lampe 1144.
8. See C. Mango 1962, 29.

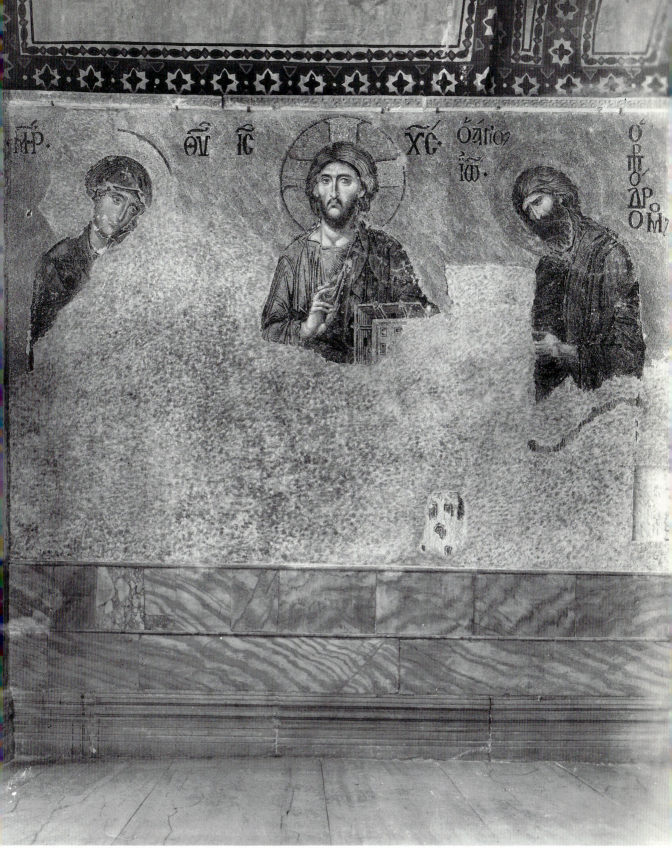

32. Thirteenth-century mosaic of the Deesis. Hagia Sophia, Istanbul

of Christ in the Gospel, the line of the Old Testament prophets had come only as far as John the Baptist.[9] This was taken by Justin Martyr in the second century to prove that after John there would no longer be any prophets among the people of Israel.[10] Zechariah, the Baptist's father, was a priest of the "tribe of Levi," who continued the sacerdotal mediation between God and the people going back to Aaron. John's parents were the recipients of an "annunciation [*euangelismos*]" by the angel Gabriel, analogous to that which was to come a few months later to the Virgin Mary, the cousin of John's mother Elizabeth.[11] The place of honor in which John the Baptist was held can be seen from an encaustic icon of him that may go back to the sixth century (Fig. 33). According to Gregory of Nyssa, "the gift in him was pronounced by Him who sees the secrets of a man greater than any prophet's."[12] For Christ himself had said about John the Baptist: "Never has there appeared on earth a mother's son greater than John the Baptist."[13]

No mother's *son* was greater than John the Baptist, but one mother's *daughter* was greater than any mother's son or daughter, namely, Mary the Mother of God, whom Gregory of Nyssa earlier in the same treatise had called "Mary without stain [*amiantos*]."[14] Not only iconographically but theologically, she occupied a unique place in Eastern Christendom, which was where both the devotion and the speculation about her had been concentrated throughout the early centuries of Christian history.[15] The devotion to Mary had found its supreme expression in the Byzantine liturgy.[16] From its sources in the Greek church fathers and in Byzantine Christianity, Eastern Mariology went on to exert a decisive influence on Western interpretations of Mary throughout the patristic and early medieval periods, with church fathers like Ambrose of Milan functioning as transmitters of Greek Mariology to the Latin Church.[17] Beginning already at the end of the second century, the Greek church fathers and their Byzantine successors recognized with singular clarity that if the liturgical and dogmatic witness

9. Matt. 11:13.
10. Justin Martyr *Dialogue with Trypho* 51 (PG 6:589; *ANF* 1:221).
11. Therefore the Greek term was used in patristic Greek both for the annunciation to Zechariah (Luke 1:8–23) and for the annunciation to Mary (Luke 1:26–38): Lampe 559.
12. Gregory of Nyssa *On Virginity* 6 (PG 46:349; *NPNF*-II 5:351).
13. Matt. 11:11; Luke 7:28.
14. Gregory of Nyssa *On Virginity* 2 (PG 46:324; *NPNF*-II 5:344).
15. Walter J. Burghardt in Carol 1954–61, 2:88–153.
16. Bouyer 1954, 79–94.
17. Huhn 1954.

33. Encaustic icon of Saint John the Baptist. Sixth century. Museum of Western and Eastern Art, Kiev

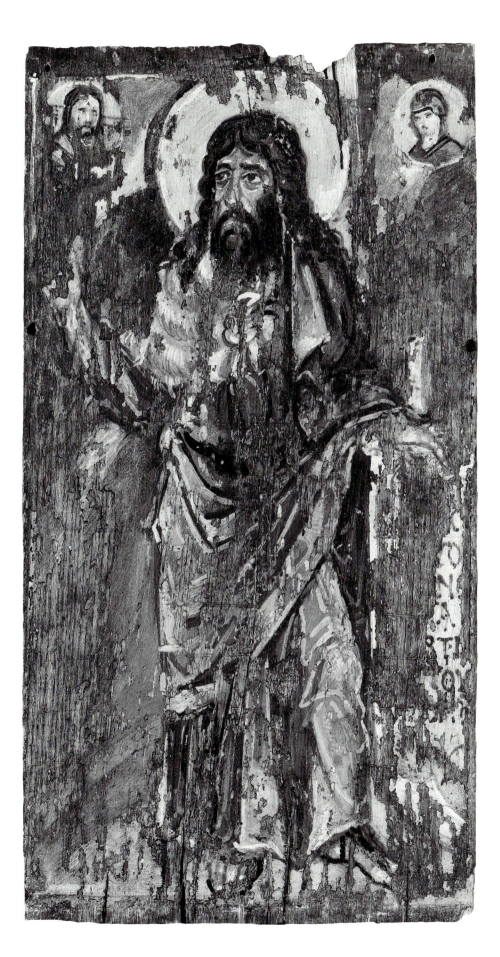

of the church was obliged to speak about Jesus Christ as it did, it finally could not do so without at the same time finding some special language in which to describe Mary also. The image of Christ in Christian doctrine seemed to have as its necessary implication the formulation of an image of Mary in Christian doctrine, and therefore the icon of Christ in Christian art necessarily implied the icon of Mary in Christian art. At every crucial point in the development of the orthodox dogma of the person of Christ, therefore, the doctrine of Mary has become a central issue of the debate; and it was itself a striking example of the way Christian doctrines have developed through time. Hence a consideration of the place of Mary in the "economy" of God has repeatedly served in the history of the doctrine of Jesus Christ himself as an epitome of the church's confession about him: the development of Christology and the development of Mariology have been inextricably connected, and in both directions.

For example, a study of how Athanasius of Alexandria, the fourth-century champion of the doctrine of the Trinity, connected the doctrine of Mary to the doctrine of Christ provides some instructive insights into the place of Mariology within the spirituality and doctrine of Greek Christianity, and consequently within its art as well. It was the lifelong obsession of Athanasius to insist that to be the Mediator between Creator and creature Christ the Son of God must be God in the full and unequivocal sense of the word: "through God alone can God be known," as the refrain of many orthodox church fathers put it. On the other hand, the Arian opponents of Athanasius, with their unstinted praise for Jesus as the crown of creation and as the supreme created embodiment of human nobility, were attributing to Christ as creature the kind of mediation that, according to Athanasius, only the Creator could exercise. In the words of Henry M. Gwatkin, they "degraded the Lord of Saints to the level of his creatures,"[18] but in the process they did make of him the supreme creature. Yet no creature, howsoever sublime metaphysically or exalted morally, could qualify as the Mediator who had saved the world; for to be a creature meant to be "subject to decay, corruption [*phthartos*]."[19] Being itself subject to decay and corruption, no creature could make another creature "incorruptible [*aphthartos*]" or confer on it the gift of "incorruption [*aphtharsia*]" and of authentic participation in the divine nature.[20] By drawing the line

18. Gwatkin 1882, 265.
19. Lampe 1474.
20. Lampe 276–77 (adjective), 274–76 (noun).

between Creator and creature and confessing that the Son of God belonged on God's side of that line, Nicene orthodoxy made possible and necessary a qualitative distinction between him and even the highest of the saints. When the church, after several false starts, finally made its own this position of Athanasius that the Son and Logos of God now incarnate in Jesus Christ was the uncreated Mediator between God and the human race, that act of doctrinal legislation left the position of supreme created mediator vacant. Now that the subject of the Arian sentences was changed, what was to become of all the predicates? And so, in a sense quite different from that implied by Harnack, "what the Arians had taught about Christ, the orthodox now taught about Mary."[21] And that was the position that the Mary of orthodoxy came to occupy, in place of the Christ of the Arians: the crown of creation and the supreme created embodiment of human nobility.

As herself a creature, she was as well the one through whom the Logos Creator had united himself to a created human nature. In the striking formula of Gregory of Nyssa quoted earlier, contrasting the First Adam with the Second Adam, "the first time, [God the Logos] took dust from the earth and formed man, [but] this time he took dust from the Virgin and did not merely form man, but formed man around himself."[22] Although the Arianism that Athanasius combated is usually (and correctly) seen as the denial of the full and complete divinity of Christ, many earlier heresies about Christ—and, at least according to the charge of some interpreters,[23] Arianism itself—were guilty of denying his full and complete humanity. Beginning already with the teachings against which the later writers of the New Testament had directed their emphasis on the visibility and the tangibility of the human "flesh" of Christ, various early interpretations of the figure of Christ had striven to exempt him from the loathsome concreteness that flesh is heir to. And since nothing about human flesh was more concrete, and to many of them nothing was more loathsome, than the processes of human procreation and birth, they were especially intent on rescuing his humanity from an involvement in those processes. This inevitably made Mary the primary focus of their reinterpretations, as well as of the orthodox replies. Not only had some of the Gnostics said that Christ "received nothing from the Virgin,"[24] but (also according to the report

21. Harnack 1931, 2:477.
22. Gregory of Nyssa *Against Eunomius* IV.3 (PG 45:637; *NPNF*-II 5:158).
23. See the discussion of these views in Haugaard 1960, 251–63.
24. Quoted by Irenaeus *Against Heresies* III.xxxi.1 (Harvey 2:121; *ANF* 1:454).

34. Fourth-century fresco showing the Annunciation. Catacomba di Via Latina, Rome

of John of Damascus),[25] they had said that he passed through the body of Mary as "through a channel [*dia sōlēnos*]," that is, without being affected by the passive medium of his mother. This would appear to have been an exaggerated form of a notion that was widespread in antiquity, that even in a normal conception and birth the mother functioned only as the "soil" for the child, which was produced by the "seed [*sperma*]" of the father.[26] In response to this Gnostic view of Mary, the earliest orthodox theologians had made a point of insisting that although Christ had been conceived in a supernatural manner without the agency of a human father, he was "truly [*alēthōs*] born," in the same manner as all other human beings are.[27] Even

25. John of Damascus *On Heresies* 31 (PG 94:697).
26. Brown 1988, 111–14.
27. Ignatius *Epistle to the Trallians* ix.1 (Lightfoot 118; *ACW* 1:77).

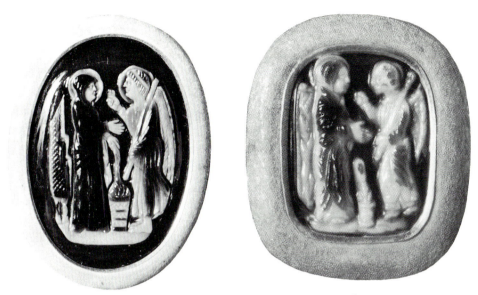

35–36. Cameos of the Annunciation. Sixth century. Hermitage, Leningrad

earlier, when the apostle Paul had wanted to assert that the Son of God, who had come "in the fullness of time," had participated in an authentic humanity, he said that he was "born of a woman,"[28] though apparently without implying thereby any explicit reference to the Virgin Birth or to the person of the Virgin Mary herself.

There was yet another implication of the Byzantine image of Christ for the Byzantine image of Mary, and one that expressed, subtly but clearly, the distinction of emphasis between the Greek East and the Latin West. As has been mentioned earlier, the Annunciation of the Angel Gabriel to Mary—which was, to be sure, the theme of many paintings in the medieval West as well[29]—was called "evangelization" in Byzantine Greek, and it constituted one of the Twelve Feasts of the Byzantine church year (Figs. 21 and 23). The earliest artistic representation of it may have been one discovered in Roman catacombs from the fourth century, which were excavated in 1956 (Fig. 34). Eventually the Annunciation became the subject of many icons in the East, including two Byzantine cameos that have been dated by some art historians to as early as the sixth century.[30] More grandly, the Annunciation often appeared on the "royal portal" of the iconostasis

28. Gal. 4:4.
29. Robb 1936, 480–526.
30. Figs. 35 and 36. On the dating, see the comments and bibliography in Bank 1985, 289.

131

in a Byzantine church. At the "great entrance" of the priest through the iconostasis in the course of the Byzantine *Liturgy of Saint Basil*, he recited the several "comings" of God and Christ in the course of the history of salvation.[31] So also the Annunciation painted on that portal represented the supreme coming of God the Logos in the flesh that he received from the Virgin Mary. The primary importance of the Annunciation always lay in the miracle of the Incarnation, as, in the dramaturgic structure of the first chapter of the Gospel of Luke, the narrative counterpart to the climax of the first chapter of the Gospel of John: "And the Word was made flesh."[32]

Less often noted has been the function of the Annunciation story as the prime exemplar of "evangelization," as this was depicted in such icons of the event and as it was expounded in commentaries on the narrative. That function becomes evident in the formulations of Gregory of Nyssa, as he commented on the words of the Annunciation story from the Gospel of Luke:

> At once, with the coming upon her of the Holy Spirit and with her being overshadowed by the power of the Most High, the human nature in Mary (where Wisdom built her house),[33] though naturally part of our sensuous compound [of flesh and spirit], became that which that overshadowing power in essence was; for "beyond all dispute the lesser is always blessed by the greater."[34] Seeing, then, that the power of the Godhead is an immense and immeasurable thing, while man is a weak atom, at the moment when the Holy Spirit came upon the Virgin and the power of the Most High overshadowed her, the tabernacle formed by such an impulse was not clothed with anything of human corruption; but, just as it was first constituted, so it remained, even though it was man, Spirit nevertheless, and Grace, and Power. And the special attributes of our humanity derived luster from this abundance of divine power.[35]

For, despite the extraordinary, indeed unique, character of the event, it was also a model of how the "gospel [*euangelion*]" functioned. In the Annunciation to Mary, the word of God was communicated through a created messenger (and "angel" originally meant "messenger" in Greek, as the equivalent term had in Hebrew), the angel Gabriel, who is also depicted

31. Brightman 318–20.
32. John 1:14.
33. Prov. 9:1.
34. Heb. 7:7.
35. Gregory of Nyssa *Epistles* 3 (*PG* 46:1021; *NPNF*-II 5:543–44).

here in both zones of our tapestry icon and is even identified by name at the top of the lower zone (Figs. 43–44). But unlike the "angel of the Lord" who in one night had slain 185,000 Assyrian soldiers from the armies of Sennacherib,[36] Gabriel brought the word of God to Mary in order to evoke a response from her that was free and unconstrained. To the Greek church fathers, Mary was predestined to be the Mother of Christ; she was the chosen one of the Almighty. And the will of the Almighty was law, for, in the formula of Gregory of Nyssa, "the power of the divine will is a sufficient cause for the things that are and for their coming into existence out of nothing."[37] Yet they insisted at the same time that it was only when Mary said, and of her own free will, "I am the Lord's servant; as you have spoken, so be it,"[38] that the will of the Almighty was carried out.

As Irenaeus had put it, contrasting Eve and Mary, "just as the former was led astray by the word of an angel, so that she fled from God when she had transgressed His word; so did the latter, by an angelic communication, receive the glad tidings that she should be the bearer of [*portaret*] God, being obedient to His word. And if the former did disobey God, yet the latter was persuaded [*suasa est*] to be obedient to God, in order that the Virgin Mary might become the patroness [*advocata*] of the virgin Eve."[39] She was "persuaded," not compelled, to yield an obedience that was no less voluntary in its affirmation than the disobedience of Eve had been in its negation. It was a differentiating characteristic of Byzantine theology, and one that has often provoked puzzlement or exasperation in Western theologians both Roman Catholic and Protestant, that in its views of the relation of grace and free will it did not work with the alternatives developed in the time of Augustine and the (related but not identical) alternatives formulated in the time of the Reformation. In the paradoxical formula of Maximus Confessor, God "grants a reward as a gift to those who have believed him, namely, eternal deification";[40] apparently "reward" and "gift" were not mutually exclusive concepts, but complementary ones, and together they produced "deification." One scholar has pointed out, in commenting on such passages as this, that it was "possible for Maximus to say, on the one hand, that there is no power inherent in human nature which is able to deify man, and yet, on the other, that God becomes man *insofar* as man

36. 2 Kings 19:35.
37. Gregory of Nyssa *On the Making of Man* 23 (PG 44:212; NPNF-II 5:414).
38. Luke 1:38.
39. Irenaeus *Against Heresies* V.xix.1 (Harvey 2:376; ANF 1:547).
40. Maximus Confessor *Questions to Thalassius* 61 (PG 90:637).

has deified himself."[41] But in support of that distinctive Byzantine emphasis on the active role of free will as it accepted the word and grace freely given by God, the active response of the Mother of God in the Annunciation as she accepted the word and grace of God was the key incident. Therefore she was "full of grace [*kecharitōmenē*]," as the angel Gabriel had said in saluting her.[42] For "the entire treasure of grace" dwelt in her,[43] but even though it was the grace of the Almighty, it did so by her own free will.

"Mary full of grace" became a familiar title to Western ears, from about the twelfth century onwards, because of its use in the *Ave Maria*. Less familiar were the many other titles and metaphors invented in Christian liturgy and Christian poetry throughout the patristic and Byzantine periods to celebrate her: for example, all-holy, immaculate, supremely blessed Queen; unwed bride; invincible general; guard of the channel [the Bosporus]; fortress; temple, throne, and ark of God. Of the titles that came from the Old Testament, one of the most profound was the parallelism by which she was identified as the Second Eve, which, in such passages as the one quoted earlier, Irenaeus of Lyons worked out in considerable detail already in the second century.[44] The ease with which Irenaeus was able to take it for granted that because Christ was, according to the New Testament, the Second Adam,[45] his Mother must be the Second Eve suggests that the parallelism between Eve and Mary, like that between Adam and Christ, may well have already been current when Irenaeus was writing. (Having taken over the parallel from the Greeks, Western theologians were eventually able to take advantage of a verbal coincidence in the Latin language to play with the palindrome *Ave/Eva*.) The First Eve had been, according to the etymology of the Book of Genesis, "the mother of all who live," and therefore the Septuagint read: "And Adam called the name of his wife Life [*Zōē*]," rather than "Eve."[46] So the Second Eve, too, had become the new mother of all who believed, and who lived through believing in her divine Son.

Yet the most comprehensive—and, for some, the most problematical—of all the terms invented for Mary by Eastern Christianity has certainly been the title *Theotokos*, which does not mean simply "Mother of God," as it is usually rendered, but more precisely and fully: "the one who gave birth to the One who is God." Although the linguistic history of the title remains

41. Thunberg 1965, 457–58; italics his.
42. Luke 1:28; "full of grace" represents a translation of the Vulgate rendition, "*gratia plena*."
43. Lampe 1519.
44. Irenaeus *Against Heresies* V.xix.1 (Harvey 2:375–76; *ANF* 1:547).
45. This was based especially on the parallelisms drawn in Rom. 5:12–21 and 1 Cor. 15:45–49.
46. Gen. 3:20 (LXX).

obscure, it does seem to have been a term of Christian coinage, rather than, as might superficially seem to have been the case, an adaptation to Christian purposes of a name originally given to a pagan goddess.[47] The name appears in some manuscripts of the works of Athanasius.[48] On the other hand, the textual evidence leaves ambiguous the question of how often Athanasius did in fact use the title *Theotokos* for Mary.[49] In any event, it receives negative corroboration from its appearance, during the lifetime of Athanasius, in the attacks upon the church by the emperor Julian "the Apostate," who criticized the superstition of the Christians for invoking the *Theotokos*.[50] In the fifth century, the fear of mingling the divine and human natures in the person of Christ led Nestorius, patriarch of Constantinople, to stipulate that because only the human nature had been born, Mary should be called not *Theotokos*, which gave the blasphemous impression that she had given birth to the divine nature itself and which therefore sounded like the title of the mother deities of paganism, but *Christotokos*, "the one who gave birth to Christ." In response to Nestorius, the Council of Ephesus in 431 made dogmatically official what the piety of orthodox believers had already affirmed, in the words of the first *Anathematism* of Cyril of Alexandria against Nestorius: "If anyone will not confess that the Emmanuel is very God, and that therefore the Holy Virgin is the Mother of God [*Theotokon*] inasmuch as in the flesh she bore the Logos of God made flesh, let him be anathema."[51] It was, moreover, in honor of the definition by the Council of Ephesus of Mary as *Theotokos* that right after the council Pope Sixtus III built the most important shrine to Mary in the West, the Basilica of Santa Maria Maggiore in Rome; its celebrated mosaic of the Annunciation and the Epiphany gave artistic form to that definition (Fig. 37). John of Damascus summarized the orthodox case for this special title:

> Hence it is with justice and truth that we call holy Mary *Theotokos*. For this name embraces the whole mystery of the divine dispensation [*to mystērion tēs oikonomias*]. For if she who bore him is the *Theotokos*, assuredly he who was born of her is God and likewise also man. . . . The name [*Theotokos*] in truth signifies the one subsistence and the two natures and the two modes of generation of our Lord Jesus Christ.[52]

47. Liddell–Scott–Jones 792 cites no pre-Christian instance of it.
48. Athanasius *Orations against the Arians* III.29 (*PG* 26:385; *NPNF*-II 4:409).
49. Müller 650.
50. Julian *Against the Galileans* 262 (*LCL* 3:398).
51. Council of Ephesus (Alberigo 59; *NPNF*-II 14:206).
52. John of Damascus *The Orthodox Faith* III.12 (*PG* 94:1029–32; *NPNF*-II 9:56).

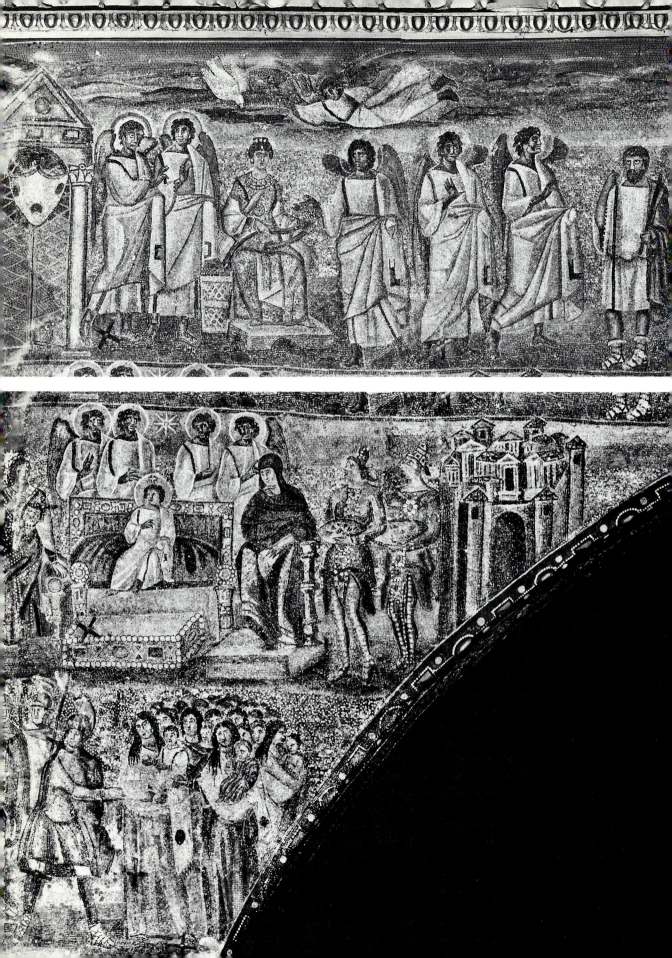

And, as he argued elsewhere, that is what she was on the icons: *Theotokos* and therefore the orthodox and God-pleasing substitute for the pagan worship of demons.[53] At the same time, the defenders of the icons insisted that "when we worship her icon, we do not, in pagan fashion [*Hellēnikōs*], regard her as a goddess [*thean*] but as the Mother of God [*Theotokon*]."[54]

As *Theotokos*, Mary—and that included the Mary of the icons—was the legitimate object of orthodox Christian "worship [*proskynēsis*]." According to their opponents, the Iconoclasts attacked not only the worship of icons generally, but the orthodox devotion to Mary specifically.[55] They were also reported to have rejected the orthodox belief in the special intercession of Mary on behalf of the church.[56] It is entirely possible that this testimony against the Iconoclasts has been distorted by Iconodule polemics; once again, we have no firsthand way of knowing for certain just what the Iconoclast position on Mary was in detail. But it was in response to such perceived attacks, whatever the quarter from which they may actually have been emanating, that an orthodox theologian like John of Damascus, who argued that "the honor paid to an image was meant not for the depiction but for the person depicted,"[57] felt compelled to refine with greater clarity the basic distinction between the various forms of "worship [*proskynēsis*]" that Christians were to render to creatures and the "adoration [*latreia*]" that could be addressed only to God the Creator, not to any creature.[58] If paid to idols, such worship was (in the original term) "idolatry [*eidōlolatreia*],"[59] although the Iconodules of course insisted that this term did not apply at all to their own worship of icons. But by "God the Creator" orthodox theology since the Council of Nicaea and even much earlier had meant God the Holy Trinity, Father, Son, and Holy Spirit, to each of whom it was legitimate to pay a "worship [*proskynēsis*]" that was "adoration [*latreia*]," exclusively restricted to the true God. Such "adoration [*latreia*]," moreover, was addressed, as it had been since the New Testament, to the person of Jesus Christ: while Christ had said on the cross, according to Luke, "Father, into thy hands I commit my spirit,"[60] Stephen, the first Christian martyr, had, also according to Luke, "called out, 'Lord Jesus, receive my

53. John of Damascus *Orations on the Holy Icons* II.11 (PG 94:1293–96).
54. Theodore the Studite *On the Images* 1 (PG 99:489).
55. Nicephorus *Refutation* II.4 (PG 100:341).
56. Nicephorus *Refutation* I.9 (PG 100:216).
57. Treadgold 1988, 88.
58. John of Damascus *Orations on the Holy Icons* I.14, III.27–28 (PG 94:1244, 1348–49).
59. Lampe 408 (including cognates).
60. Luke 23:46.

37. Fifth-century mosaic of the Annunciation and the Epiphany. Santa Maria Maggiore, Rome

spirit,'"[61] thus moving with evident ease from a prayer addressed to the Father to the same prayer addressed to the Son. For "at the name of Jesus," the apostle Paul declared, "every knee should bow—in heaven, on earth, and in the depths—and every tongue confess, 'Jesus Christ is Lord,' to the glory of God the Father."[62] This "bowing the knee" and "worship [*proskynēsis*]" was genuine and complete "adoration [*latreia*]," and it included as its proper object the entire person of the Son of God incarnate—not his divine nature alone, since his divine nature was not alone after the Incarnation but was permanently and "inseparably [*achōristōs*]" united to the human nature, which could not be the object of "adoration [*latreia*]" in and of itself, being a creature, but which could and should be adored in the undivided person of the God-man.

All other orthodox "worship [*proskynēsis*]," by contrast, was simple "reverence [*douleia*]," hence not a violation of the First Commandment. In at least some passages of his works, John of Damascus did operate with such a distinction between "adoration [*latreia*]" and "reverence [*douleia*]."[63] But by a curious turn of linguistic history, the best available documentation for this distinction between the two Greek terms is not to be found in his writings, nor in those of any other Greek patristic or Byzantine thinkers at all, but in Latin Christian authors, including above all Augustine of Hippo. Augustine wrote in his *City of God*:

> For this is the worship which is due to the Divinity, or, to speak more accurately, to the Deity; and to express this worship in a single word, as there does not occur to me any Latin term sufficiently exact, I shall avail myself, wherever necessary, of a Greek word. *Latreia*, whenever it occurs in Scripture, is rendered by the word "service." But that service which is due to men, and in reference to which the apostle writes that servants must be subject to their own masters,[64] is usually designated by another word in Greek [*douleia*], whereas the service which is paid to God alone by worship, is always, or almost always, called *latreia* in the usage of those who wrote from the divine oracles.[65]

It is this passage from Augustine that seems to have been among the first witnesses—or, at any rate, among the earliest preserved witnesses—to make

61. Acts 7:59.
62. Phil. 2:10–11.
63. John of Damascus *Orations on the Holy Icons* III.27–28 (*PG* 94:1348–49).
64. Eph. 6:5.
65. Augustine *City of God* X.1 (*CCSL* 47:272; *NPNF*-I 2:180).

the distinction specific.[66] It must be added that for Augustine to occupy that position in the history of Greek is not without a certain irony, in view of his own repeated admissions about his unreliable knowledge of Greek: he had developed an intense dislike for the Greek language, even for the reading of Homer, as a schoolboy,[67] and then as a Catholic bishop defending the Nicene doctrine of the Trinity he had to confess that he did not fully grasp the terminological subtleties in the fundamental trinitarian distinctions made by Greek theologians during the preceding several generations.[68]

Such distinctions were all the more necessary because of the many postures and gestures of respect toward many persons that were prescribed not only by Byzantine piety but by Byzantine social custom. Already in Classical Greek usage, all of these expressions of respect at all levels could come under the category of "worship [*proskynēsis*]," which therefore not only meant to "make obeisance to the gods or their images, fall down and worship," but pertained especially to "the Oriental fashion of prostrating oneself before kings and superiors."[69] That fashion was exaggerated still further by what Charles Diehl calls "the thousand refinements of the precise and somewhat childish etiquette which regulated every act of the imperial life" in Constantinople.[70] In this profusion of acts of "worship,"[71] there needed to be a special way of speaking about the worship of God and about the worship of the saints, and particularly about the worship of the Virgin Mary. Therefore medieval Latin theology, illustrated for example by Thomas Aquinas, found that the simple distinction between "adoration [*latreia*]" and "reverence [*douleia*]," as it had been drawn by John of Damascus,[72] did not do full justice to the special position of the *Theotokos*. For she was certainly less than God, but just as certainly more than an ordinary human being and more than any saint; therefore she was not entitled to *latria*, but on the other hand she was entitled to more than *dulia*.[73] For her cultus, then, the appropriate term was *hyperdulia*.[74] After the Middle Ages, the Latin Church was to find the distinction between *latria* and *dulia* (including *hyperdulia*) additionally useful when, in the aftermath of the Reformation,

66. Lampe 384, 793.

67. Augustine *Confessions* I.xiii.20–xiv.23 (*CCSL* 27:11–13; *NPNF*-I 1:51–52).

68. Augustine *On the Trinity* VII.vi.11 (*CCSL* 50:261–62; *NPNF*-I 3:111).

69. Liddell–Scott–Jones 1518.

70. Diehl 1936, 755.

71. The ambiguity appears also in earlier English usage, for example in the Authorized Version of Luke 14:10: "Then shalt thou have *worship* in the presence of them that sit at meat with thee."

72. John of Damascus *Orations on the Holy Icons* III.27–28 (*PG* 94:1348–49).

73. *DTC* 3:2404–27, esp. 2406–09.

74. Deferrari–Barry 346, 627–28, 494.

Protestant polemics was regularly accusing it of "Mariolatry." "Mariolatry" would have to be defined as a form of *latria* paid to Mary; and extravagant though the language of prayers and hymns addressed to her did undoubtedly become also in the West, this distinction was intended to stand as a barrier against "Mariolatry"—albeit a barrier that may sometimes have been all but invisible to the piety of ordinary believers, whether Western or Eastern, in their prayers to her and to her icon.[75] As even the defenders of the icons had to acknowledge, the relation between technical theology and the piety of ordinary believers was a difficult problem to handle.[76]

There was, however, one issue in the historical development of the doctrine of Mary that was in great measure confined to the Latin West: the dogma of the Immaculate Conception.[77] The reason was the form that the doctrine of original sin had taken in the West through the thought of Augustine of Hippo, which in turn made necessary a special treatment of the place of Mary in the schema of sin and salvation. In a famous and controversial passage of *On Nature and Grace*, one of the most important treatises that he devoted to the defense of the doctrine of original sin, Augustine had listed the great saints of the Old and New Testament, who had nevertheless been sinners. Then he continued:

> We must make an exception of the holy Virgin Mary, concerning whom I wish to raise no question when it touches the subject of sins, out of honor to the Lord. For from him we know what abundance of grace for overcoming sin in every particular [*ad vincendum omni ex parte peccatum*] was conferred upon her who had the merit to conceive and bear him who undoubtedly had no sin.[78]

When he made such a statement, Augustine was being more faithful to the Greek tradition in his doctrine of Mary than he was in his doctrine of human nature. Despite the differences between Augustine's theory of original sin and the definitions of "ancestral sin [*propatrikon hamartēma*]" in the Greek fathers, therefore, they were agreed about the *Theotokos*; but the universal Western adoption of Augustine's formulation of the doctrine of sin obliged his later followers, above all Duns Scotus in the fourteenth century and finally on that basis Pope Pius IX in the bull *Ineffabilis Deus*

75. Savramis 1960, 174–92.
76. Theodore the Studite *Orations* XI.iv.24 (*PG* 99:828).
77. O'Connor 1958 contains important historical and iconographic materials on this dogma.
78. Augustine *On Nature and Grace* xxxvi.42 (*CSEL* 60:263–64; *NPNF*-I 5:135).

of 8 December 1854, to elaborate the Immaculate Conception as a way of affirming the special "prerogatives" of the Blessed Virgin.

Behind those differences between Augustine and the Greek theologians on the doctrine of original sin lay an even more profound difference, which was likewise reflected in the Byzantine view of Mary as *Theotokos*. It was the difference identified by the title of this chapter, "humanity made divine," the teaching of Greek Christian theology that salvation conferred on its recipients nothing less than a transformation of their very humanity, by which they received a participation in the reality of the Divine. Anders Nygren sees the idea that "the human is raised up to the Divine" as one that the Greek church father Irenaeus shared "with Hellenistic piety generally."[79] And it is clear that there are echoes of Hellenism in the Christian version of the doctrine.[80] But this idea of salvation as deification was not exclusively Greek; it appeared in various of the Latin fathers, including Augustine, and, as Nygren acknowledges, it would even find an occasional echo in the writings of the Protestant Reformers and their followers.[81] At almost the same time as the creation of our tapestry *Icon of the Virgin*, a Latin Christian writer incorporated it into a work of philosophical reflection that was to achieve wide circulation in the Middle Ages:

> Since that men are made blessed by the obtaining of blessedness, and blessedness is nothing else but divinity, it is manifest that men are made blessed by the obtaining of divinity. And as men are made just by the obtaining of justice, and wise by the obtaining of wisdom, so they who obtain divinity must needs in like manner become gods. Wherefore everyone that is blessed is a god, but by nature there is only one God; but there may be many by participation.[82]

The idea could, moreover, lay claim to explicit biblical grounding. As it stood, "I said: 'You are gods,'" was a mysterious Old Testament statement in the Psalms, addressed to the rulers of this world.[83] But as quoted by Christ in the New Testament, this statement became proof that "those are called gods to whom the word of God was delivered—and Scripture cannot be set aside."[84] Since believers in Christ were preeminently "those to whom the word of God was delivered," it followed, according to the Greek

79. Nygren 1953, 412.
80. Bieler 1935–36.
81. Nygren 1953, 734.
82. Boethius *The Consolation of Philosophy* III.pr.x.23–25 (*CCSL* 94:54; *LCL* 271–73).
83. Ps. 82:6.
84. John 10:35.

Christian tradition, that they were also preeminently those who should be called "gods." For this, too, was a "Scripture that cannot be set aside."

Above all, the Scripture that provided justification for the idea, and that therefore became the *locus classicus* cited in support of it especially in Byzantine theology, was the arresting New Testament formula: "Through them you may escape the corruption with which lust has infected the world, and come to share in the very being of God [*theias koinōnoi physeōs*]."[85] Both the negative emphasis of the Greek church fathers on salvation as escape from "transiency, corruption [*phthora*]" and their positive emphasis on salvation as participation in the divine nature came to voice in this one New Testament passage. Thus the Greek word "*theōsis* [deification or divinization]" came to stand for a distinctive view of the meaning of salvation, summarized in the Eastern patristic formula, current already in the second and third centuries: "God became human so that man might become divine." This view had then been fundamental to the development of the doctrine of the Trinity; as Athanasius had put it, "by the participation of the Spirit, we are knit into the Godhead."[86] While striving to protect the biblical formula of "sharing in the very being of God" from any trace of pantheism by emphasizing the inviolable transcendence of a God beyond language or thought or even being, the Greek fathers and their Byzantine pupils strove no less assiduously to give concrete content to its dazzling promise of a "humanity made divine" through the Incarnation of the Logos of God in the person of Jesus Christ.

That concrete content found its supreme exemplar in the person of Mary the *Theotokos*. The painters of the icons seem to have manifested no hesitation in portraying Mary as "divine," and the defenders of the icons often seemed to be almost insouciant in their manner of speaking about her "divine" qualities; for "divine" was indeed the right word for her as *Theotokos*. In its ultimate significance, of course, "salvation as deification," like every heavenly promise, was eschatological and could not be fully achieved by anyone here in this present life on earth. But Mary was proof positive that it could be achieved, truly though not fully, and already in this world; and in her icons she was pictured in such a manner as to produce that evidence. In the Magnificat, which was (and still is) sung as part of the *Orthros* or Morning Office of the Greek Church,[87] she had said:

85. 2 Peter 1:4.
86. Athanasius *Orations against the Arians* III.24 (*PG* 26:373; *NPNF*-II 4:407).
87. Mearns 1914.

Tell out, my soul, the greatness of the Lord,
rejoice, rejoice, my spirit, in God my saviour;
so tenderly has he looked upon his servant,
 humble as she is.
For, from this day forth,
all generations will count me blessed,
so wonderfully has he dealt with me,
 the Lord, the Mighty One.[88]

The theological presentation of Mary in Byzantine thought related these several themes of the Magnificat to one another. And, as the entire history of representations of Mary in Byzantine art suggests, it was the particular vocation of the icons of the *Theotokos* to find graphic ways of simultaneously depicting the two key adjectives in the narratives of the Annunciation of the Angel Gabriel to Mary and of the Visitation of Mary to Elizabeth (Fig. 21): "humble" and "blessed." Neither of these attributes was to be slighted, and on the other hand neither of them was to be emphasized at the expense of the other. That combination makes itself evident on our tapestry *Icon of the Virgin* (Fig. 38). Therefore "the Virgin's costume is that of a woman of the ordinary classes in late antiquity," and yet "her simple garments are nevertheless consistently purple, the color reserved for Byzantine royalty.[89] Similarly, it was the function of the icons of her Son to present both "the divine nature" and "the nature of a slave"[90] as they had been inseparably united in his person through the Incarnation, and to present them simultaneously.

His "divine nature" had not always been perceptible to his contemporaries behind "the nature of a slave" which they did see, but in the Transfiguration it had become visible already in this world and even before his Resurrection. This was expressed in the earliest mosaic of the Transfiguration that has been preserved (Fig. 24), whose iconographic interpretation William Loerke has skillfully connected to the theological interpretation of the event by Maximus Confessor:

About seventy-five to eighty years after the mosaic was set, Maximus the Confessor gave the Transfiguration an imaginative and profound interpretation. He saw Christ in this vision as a symbol of himself, a manifestation of the hidden in the visible, in which the luminous garments

88. Luke 1:46–49.
89. Shepherd 1969, 93.
90. Phil. 2:6–7.

143

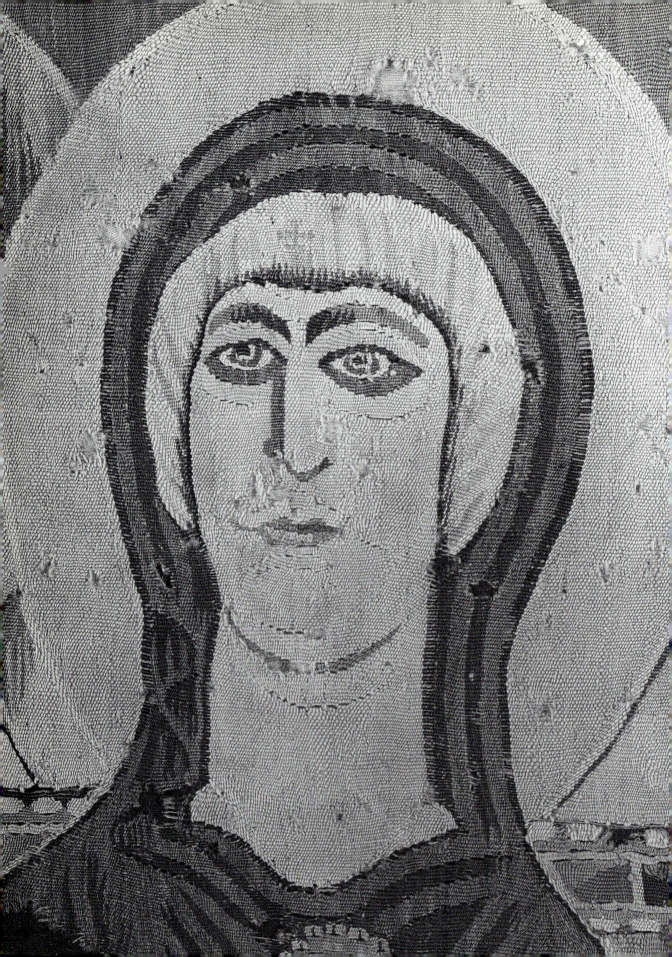

at once clothe the human nature and reveal the divine. The event was not a fixed image, but an unfolding drama. The brilliant garments of Christ, the changing tones of blue in the aureole, and the transparencies in the rays of light coming from the aureole, suggest a hidden force coming into view—the visual analogue of Maximus' interpretation.[91]

And the historical analogue for it, a reality that was at one and the same time both the anticipation and the result of the miracle of the Transfiguration of Christ, was Mary the Mother of God. She did not have a preexistent divine nature, as Christ did, but was completely human in her origin, just as all other human beings are. Yet because she had been chosen by God to be the *Theotokos*, "the one who gave birth to the One who is God," that completely human nature of hers had been transfigured; and already in this earthly existence she had in a special way "come to share in the very being of God," as the Second Epistle of Peter had promised that all who believed in her divine Son would.

Another subject of many icons in which Mary's unique participation in the process of humanity being made divine was celebrated was the hour of her death or "Dormition [*Koimēsis*]."[92] Because of its prominence in the iconographic tradition (Figs. 39–40), the defenders of the icons also had occasion to speak about the Dormition. Theodore the Studite, for example, described it as an "ineffable" mystery, at which the twelve apostles, together with the Old Testament figures of Enoch and Elijah (both of whom had been assumed bodily into heaven)[93] attended the *Theotokos* at the end of her earthly life.[94] There is a homily on the subject of the Dormition attributed to the seventh-century patriarch of Jerusalem, Modestos, thus to a time not long after the weaving of our tapestry *Icon of the Virgin*.[95] On the basis of internal evidence, however, the date of the homily has been moved forward to a century or so after Modestos, but many of the mariological themes celebrated in it were, of course, much older.[96] For, as a later Byzantine historian reports, around the end of the sixth century the festival celebrating the Dormition had, by imperial decree, been appointed for 15 August (which also became the date in the Western Church for the Feast of the Assumption of the Blessed Virgin Mary).[97] Thus it eventually became

91. Loerke 1984, 47.
92. Lampe 760.
93. Gen. 5:24; 2 Kings 2:11.
94. Theodore the Studite *Orations* V.2–3 (PG 99:721–24).
95. Modestos *On the Dormition of the Blessed Virgin Mary* (PG 86:3277–312).
96. Jugie 1944, 214–24.
97. Nicephorus Callistus *Ecclesiastical History* XVII.28 (PG 147:292).

38. Head of Mary, detail from *Icon of the Virgin*

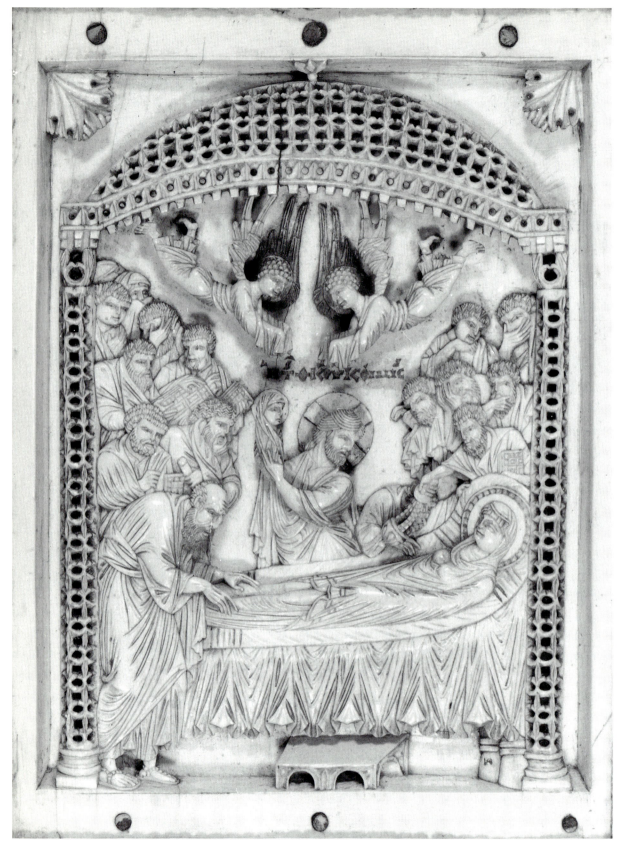

39. Ivory plaque of the Dormition of the Virgin. Constantinople, tenth century. Bayerische Staatsbibliothek, Munich

40. (right) Iconostasis beam depicting the Dormition of the Virgin, labeled "*hē koimēsis tēs Theotokou.*" Constantinople, twelfth century. Cathedral of San Marco, Venice

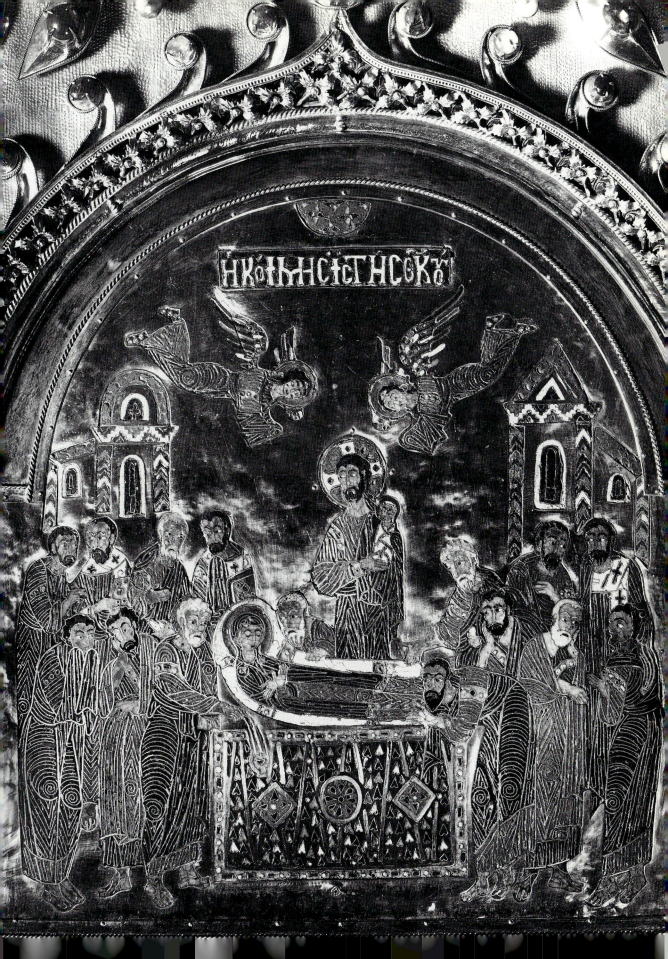

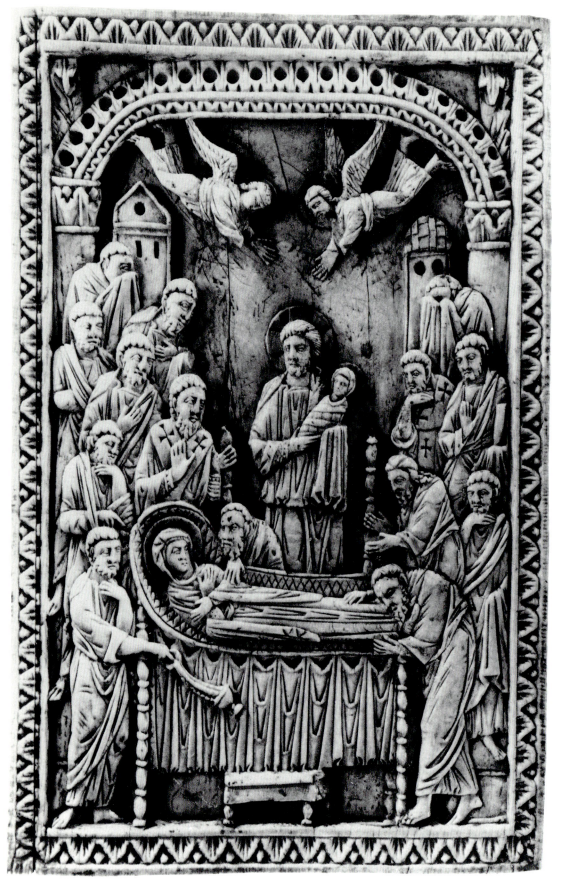

41. Ivory plaque of the Dormition of the Virgin. Twelfth century? Hermitage, Leningrad

one of the Twelve Feasts observed in the Eastern Church (Fig. 23). It is likewise to that period that the earliest iconographic treatments of it by Byzantine artists are traced. Although an ivory plaque of the Dormition (Fig. 41) comes from a later period in the history of Byzantine art (perhaps as late as the twelfth century), it is an especially comprehensive treatment of the theme: the *Theotokos* is surrounded by the figures of the twelve apostles, in addition to two others with their faces covered; angels hover overhead, hands extended to receive her into heaven. At the center of the plaque—in a striking reversal of the roles they take in the conventional icons of Mother and Child, including our tapestry icon—is Christ in Majesty with the infant Mary in his arms. And the adult Mary reposes in tranquility, as she is about to be received into heaven—in body and in soul, as the East and eventually the West came to affirm—where the process by which her humanity was made divine would be completed.[98]

As the distinction between East and West that led to the Western dogma of the Immaculate Conception of Mary made clear, therefore, it was, according to Byzantine theology, necessary but not sufficient to speak of human salvation as the forgiveness of sins. The interpretation of the Passion and Crucifixion of Christ as the sacrifice for sin—an interpretation that came from Scripture itself and that was therefore common to East and West—had as its corollary the image of *Christus Victor* as the distinctive way for the Christian East to speak about the mystery of the Redemption (Figs. 26–27). This depiction of the Atonement was the ground for "deification" as a depiction of salvation. It also affected the Byzantine perspective on a speculative question that has dogged Western theology since the Middle Ages: Would the divine Logos have become incarnate even if Adam and Eve had not fallen into sin? As Lovejoy has noted, "the Paradox of the Fortunate Fall has . . . found recurrent expression in the history of Christian religious thought," including John Milton's *Paradise Lost*. Its earliest important occurrence seems to have been the familiar exclamation of the *Exultet* in the service for Holy Saturday: "O blessed guilt, which merited having such a great Redeemer [*O felix culpa, quae talem ac tantum meruit habere Redemptorem*]!"[99] Because the fundamental human predicament was guilt, and not "transiency [*phthora*]" as well, the salvation wrought by Christ had to be related primarily or even exclusively to the guilt of sin.

That was not the basic approach that the Greek church fathers and their Byzantine heirs took to the matter. Because for them salvation was defined

98. Wenger 1955.
99. Lovejoy 1955, 279.

as "escaping the corruption with which lust has infected the world, and coming to share in the very being of God"[100]—partial now, though real, but total in the life everlasting—Adam and Eve, too, would have had to receive it even if they had not fallen into sin. They had been created out of nothing, and therefore they were vulnerable to the threat of relapsing into the nothingness from which they had come and of being subjected to "corruption." Therefore "deification" was teleological in content, part of the "goal [telos]" of human life, and it had been so also for the first human couple before the fall. But Christ as Second Adam had manifested this teleology, above all in the Transfiguration, where he gave humanity a glimpse of its own eventual destiny; and Mary as Second Eve had also manifested it, because of her Son and because of the divine life that he had conferred—conferred first on her, and then on all. Unquestionably, such a view of the human condition and of salvation sometimes came dangerously close to defining the sin of Adam and Eve as the consequence not of their having transgressed the commandments of God, but merely of their being temporal and finite; such a definition of sin would then seem to have manifested greater affinities to Neoplatonism than to the New Testament. But the very concentration on Mary the *Theotokos* as the historical fulfillment of this promise of "humanity made divine" served to protect this view from falling completely into the Neoplatonic teaching.

As the battle over iconizing Christ provided the grounds for a defense of the practice of iconizing his Mother, so her icon, in turn, supplied the justification for the icons of all the other saints, including eventually the "martyrs" to iconoclasm.[101] Our tapestry *Icon of the Virgin* offers striking documentation of that connection between Mary and the other saints: surrounding the imposing figures of the *Theotokos* and the archangels Michael and Gabriel are medallions of apostles and saints (Figs. 2, 4–6, 13, 14). The medallions are small, but they are clearly identifiable and explicitly, if somewhat quaintly, labeled in Greek. The objections of the Iconoclasts to the icons of the saints proved to the Iconodules that all the arguments against icons on the basis of whether or not the divine nature of Christ was "capable of circumscription [perigraptos]" were a distraction: everyone admitted that the saints were human and hence capable of circumscription, and yet it was said to be wrong to iconize them also.[102] Indeed, the Iconoclasts were accused of opposing not only the icons of the saints, but the accounts of

100. 2 Peter 1:4.
101. Ilarion 1954, 109–10.
102. Nicephorus *Refutation* III.49 (PG 100:468).

150

the lives of the saints as well.[103] And there were at least some theologians who appeared to be saying that icons of Christ and of the *Theotokos* should be the only ones, but that icons of the saints were wrong; this, John of Damascus insisted, was a denial not of images, but of honor to the saints.[104]

Conversely, however, the defense of portraying the divine-human Christ led to a defense of portraying the human Mary who, through him and because she was chosen to give birth to him, had been made divine. And since the concept of deification was in fact the fundamental constituent of the Byzantine definition of sainthood as well, it was an obvious extrapolation from these mariological discussions to affirm that the saints, too, were to be iconized. How, the Iconodules asked, was it possible to portray the Supreme Commander without portraying his troops?[105] For the life of Christ depicted in the icons was not merely the life he had lived while on earth during the first century. The resurrected Christ lived on in the life of his church—and in the lives of his saints. It would, they argued, be a disastrous foreshortening of perspective on his image if the portrayal of that life did not include portrayals of all those in whom it had continued, and was still continuing, to make sacred history. If a saint had lived at an identifiable place, that was a logical location for an icon of that saint. If a church could be dedicated to a particular saint, the saint through the icon had to be there. And if a believer had received the name of a patron saint, an icon of the saint was a constant reminder of the grace of baptism and the hope of glory.

Yet the theology of icons could not stop even there. The Logos whose incarnate form it was legitimate to iconize was himself the living image of God and the one through whom heaven and earth and all that is therein had been created. The Mother of God whom it was permissible to depict on an icon was the Queen of Heaven. The saints whose lives were celebrated on the iconostasis and on individual icons were now in the presence of God in heaven. And standing by, not as recipients of salvation but nevertheless as participants in the drama, were the angels, who in the upper zone of our icon attend the exalted Christ and who in the lower zone stand on either side of his Mother. All of these images stood in relation to one another, in what Byzantine theology makes it necessary to call a "great chain of images."

103. Nicephorus *Apologia for the Icons* 38 (PG 100:645).
104. John of Damascus *Orations on the Holy Icons* I.19 (PG 94:1249).
105. John of Damascus *Orations on the Holy Icons* II.15 (PG 94:1301).

THE GREAT CHAIN OF IMAGES
A Cosmology of Icons

The two central figures of the exalted Christ with nimbus, "divinity made human," in the upper zone (Fig. 7) and of the glorified *Theotokos* with nimbus, "humanity made divine," in the lower zone (Fig. 29), both of them seated on their thrones, are not the only faces that appear at the center of our tapestry *Icon of the Virgin*. For not only is the entire lower zone of the icon surrounded on three sides by the medallions of several of the apostles and evangelists, representing the church to which human beings belong; but also, adorned with halos in the upper zone, representing the church to which heavenly beings belong, there are figures of two relatively small angels, one of them with a foot protruding beyond the frame of the zone (Fig. 43). They themselves have no inscriptions giving their names. But it does seem plausible to suggest that the inscriptions below them, which pertain to the figures in the lower zone, may apply to the angels in the upper zone as well, so that the undamaged figure of the angel on the left side would represent Saint Michael (Fig. 42). Borne up by their wings on either side of the central figure and evidently in a posture of motion, these angels in the upper zone are in turn bearing aloft the figure of Christ in Majesty. Although this is not in itself a representation of the Ascension of Christ, it does seem to have been derived from some such representations of the ascending Christ with angels that were already in Christian use. Even more striking are the two figures of the archangels in the lower zone. On the Virgin's left and the viewer's right, with part of the inscription damaged, is "Saint Gabriel" (Fig. 44). Gabriel is equipped with orb and scepter (Fig. 29). To the Virgin's right and the viewer's left—at what should be regarded, not only for God but surely also for her, as a "symbol of honor, glory,

153

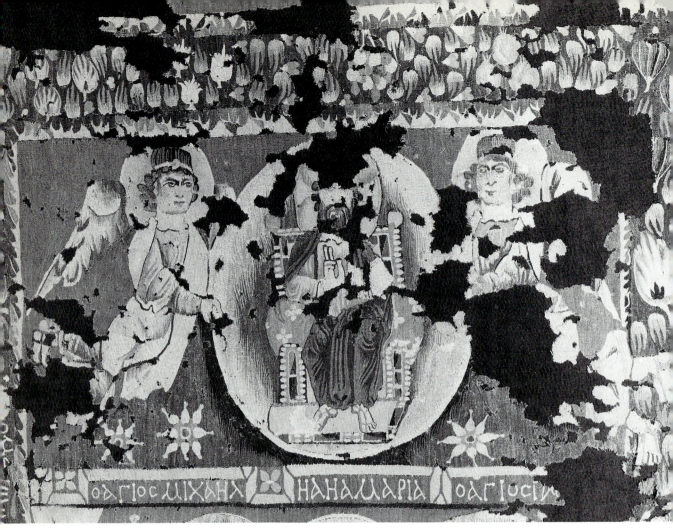

43. Upper zone from *Icon of the Virgin*

and power"[1]—is "Saint Michael" (Fig. 50). Because of the way the tapestry was woven, Michael is shown holding only a scepter; but his orb, which he is probably holding in the other hand, would seem to be hidden behind the Virgin's throne (Fig. 29).

This pairing of Gabriel and Michael was a commonplace in Byzantine iconography.[2] At the same time, each of them was also accorded individual treatment.[3] Because the angel who came to Zechariah to tell him that he and Elizabeth were to become the parents of John, and who then came to the Virgin Mary to tell her that she was to become the mother of Christ, was identified by name in the Gospel as "Gabriel, who stand[s] in the presence of God,"[4] it seems safe to assume that among icons of Gabriel

1. Lampe 337.
2. *DTC* I:1253.
3. See, in general, Stuhlfauth 1897.
4. Luke 1:19, 26.

154

44. Archangel Gabriel, detail from *Icon of the Virgin*

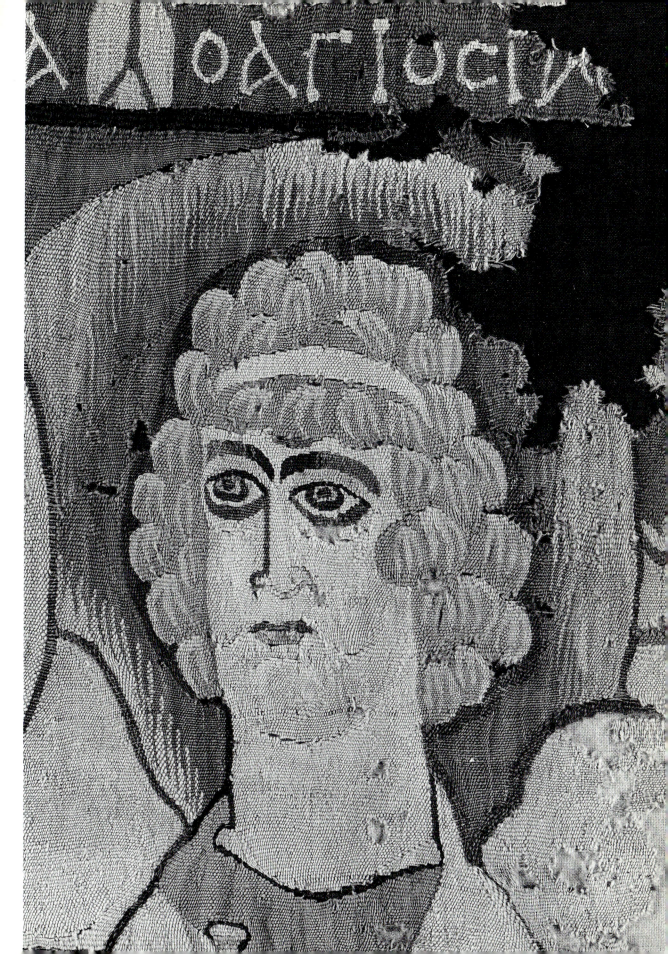

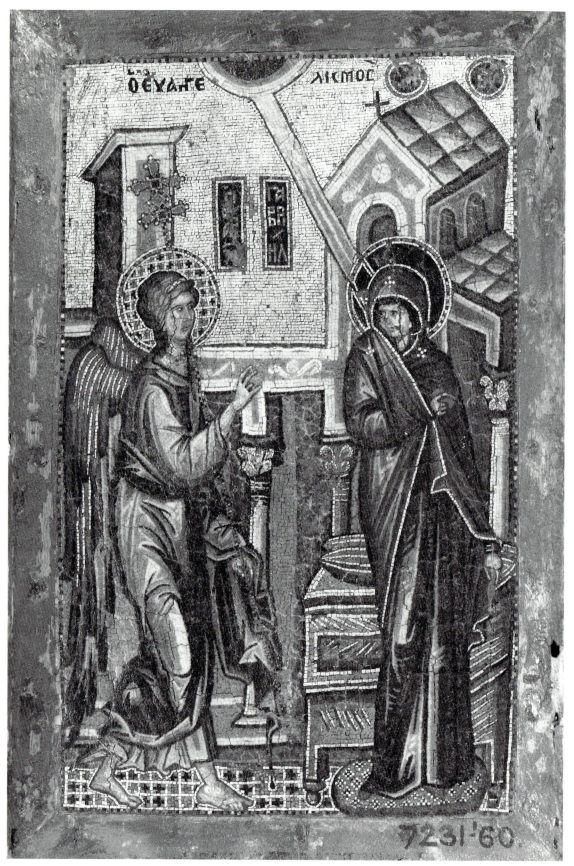

45. Mosaic of the Annunciation, bearing the inscription "*ho euangelismos.*" Constantinople, fourteenth century. Victoria and Albert Museum, London

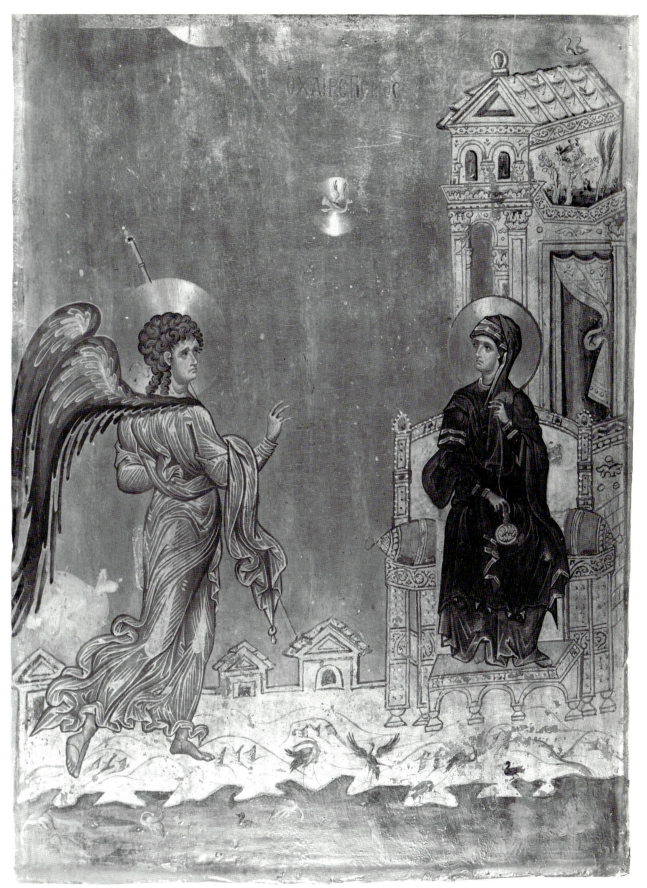

46. Tempera of the Annunciation, with the inscription "*ho chairetismos.*" Constantinople, twelfth century. Saint Catherine's Monastery, Sinai

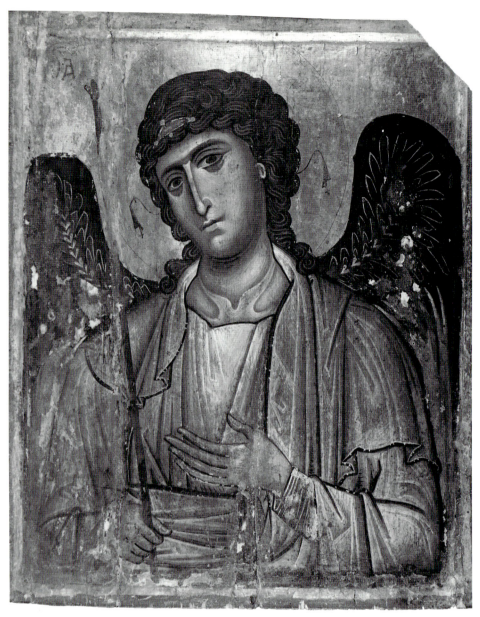

47. Archangel Gabriel. Constantinopolitan artist working at Sinai, early thirteenth century. Saint Catherine's Monastery, Sinai

there are probably more that portray him as part of the scene of the Annunciation than there are of him in any other setting, because the Annunciation was such a common theme of both Byzantine teaching and Byzantine iconography. Sometimes the icon showing Gabriel and Mary would bear the inscription "the Annunciation [*ho euangelismos*]" in Greek (Fig. 45). There are also icons of the Annunciation in which the inscription reads "the salutation [*ho chairetismos*]" (Fig. 46). This is a reference to the Greek of

158

the "Ave Maria [*Chaire, kecharitōmenē*]," addressed by Gabriel to Mary.[5] In addition, however, there are also icons of Gabriel himself, one of the most powerful being the later work of a Byzantine artist at Mount Sinai (Fig. 47). Gabriel was, according to Theodore the Studite, "the Godlike servant of God [*ho theoeikelos latris*]" and the "exarch" of the divine army.[6] On the basis of the references to Saint Michael the Archangel in the New Testament, which describe him as having "waged war upon the dragon" or at any rate as having engaged "in debate with the devil,"[7] such military nomenclature was at least as appropriate to apply to Michael as to Gabriel.[8] Thus an eleventh-century Byzantine enamel depicts him full-length as a standing figure in armor, holding not a scepter, as in our tapestry *Icon of the Virgin*, but a sword; he is surrounded by medallions of pairs of figures with shields (Fig. 48). There is, in the same location and perhaps from the same source, another enamel icon of Saint Michael in a more beneficent attitude, apparently pronouncing a blessing (Fig. 49). The specifically military connotations likewise seem to be absent from the portrait of Saint Michael in our tapestry *Icon of the Virgin* (Fig. 50).

In Byzantine iconography but in Byzantine theology as well, the angels played a complex role in relation to the icons of the Mother of God. The first scholar to study this *Icon of the Virgin* has described this role succinctly:

> The iconography of the Virgin in Majesty flanked by the archangels Michael and Gabriel seems to have been an innovation of the sixth century. According to the descriptions, in all of the fifth-century apse mosaics the *Theotokos* was flanked by saints or martyrs and donors; but there are no angels. In the sixth-century mosaics, however, she first appears attended by archangels, as on our tapestry. This is precisely the iconography which dominates the sixth-century autonomous representations of the Virgin in other media—fresco, painted icons, stone sculpture, ivory, and metalwork—to which we now add our textile. Indeed, this theme so outnumbers all others that one is inclined to regard it as *the* sixth-century iconography of the *Theotokos*.[9]

Once it had established itself in the sixth century, the practice of showing the *Theotokos* with angels, usually with the two archangels Michael and Gabriel, became a standard pattern in Byzantine icons. In addition, of course,

5. Luke 1:28.
6. Theodore the Studite *Orations* VI.9 (*PG* 99:741).
7. Rev. 12:7; Jude 9.
8. On Michael, see the comprehensive study of Wiegand 1886.
9. Shepherd 1969, 93; italics hers.

48. Enamel of standing Archangel Michael with sword. Constantinople, eleventh century. Treasury of San Marco, Venice

49. Enamel of bust of Archangel Michael. Constantinople, late tenth or early eleventh century. Treasury of San Marco, Venice

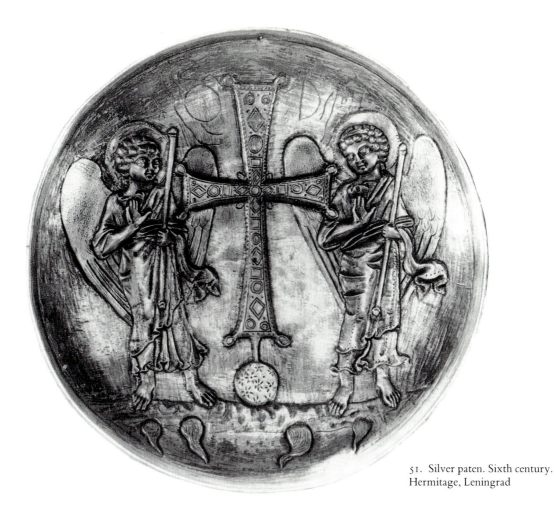

51. Silver paten. Sixth century. Hermitage, Leningrad

there were many other representations of angels by themselves, not only on icons but on other sacred objects. One early example is a silver paten, which shows two angels standing, with the cross between them; each angel holds a staff or scepter in the left hand and has the right hand raised in blessing.[10]

The reference cited to data provided by the "descriptions" of earlier representations of the Virgin, rather than by such artistic representations themselves, is yet another reminder that for much of our information about pre-Iconoclastic Christian art in the Byzantine East we are obliged to depend on evidence from literary rather than from iconographic monuments. In the same way, negative testimony for the prevalence of icons depicting angels is provided by the special criticism for which they were singled out by the Iconoclasts. Even before the outbreak of the Iconoclastic controversy, such criticism had come from one of the leading thinkers of the

10. Fig. 51, and the bibliography in Bank 1985, at plate 78.

163

Monophysite party in the fifth and sixth centuries, Philoxenus of Mabbug.[11] At least as he was cited by the anti-Iconoclastic Second Council of Nicaea, Philoxenus seems to have objected to anthropomorphic representations of angels, as well as to pictures of the Holy Spirit as a dove.[12] But such objections to extravagant iconizing of angels were by no means confined to theologians whom orthodoxy regarded as heretical. Vigorous champion of the icons though he was, the abbot Theodore the Studite disapproved of the fashion of iconizing angels as crucified—an artistic whimsy that may have been based on the argument that since the angels could not be portrayed historically anyway, they should be made to resemble the historical Christ on the cross.[13] When, therefore, defenders of the icons invoked the historical argument, citing the historicity of Mary and of John the Baptist—perhaps in a reference to an icon of the Deesis (Figs. 30–32)—or the historicity of Peter, Paul, and Stephen, as a justification for iconizing these saints in order to make them visible also to those who had never seen them historically, the Iconoclasts could object: "But no one has ever seen an angel. How, then, do [the iconographers] portray an angel historically?" More specifically, they asked, referring to such depictions of angels as the ones appearing here in both zones of this *Icon of the Virgin*, with their blond curly hair and (in the upper zone) their wings raised in flight or (in the lower zone) their wings folded in repose: "And how is it that they make and portray angels historically as though they had human form and came adorned with two wings? Do you mean to imply that the nature of angels is equipped with wings?"[14] For if angels were by nature without bodies, how was it possible to depict them, since they must be either embodied and therefore circumscribed or bodiless and therefore not circumscribable?[15]

In replying to these objections, John of Jerusalem catalogued the "many instances when the all-holy *Theotokos* saw Gabriel," as well as a host of other incidents from both the Old Testament and the New when various mortals were permitted to "see" angels:[16] the women at the empty tomb of Christ on Easter morning (to whom, according to Matthew, there appeared "an angel of the Lord," whose "face shone like lightning [and] his garments were white as snow," while according to Luke, what they

11. On Philoxenus of Mabbug, see the perceptive comments of Elert 1957, 59–63, 98–100, 161–63.
12. Quoted by Second Council of Nicaea (Mansi 13:180–81).
13. Theodore the Studite *Epistles* I.15 (PG 99:957).
14. Quoted by John of Jerusalem *Against Constantine V* 11–12 (PG 95:328).
15. Quoted by Theodore the Studite *Refutation* III.i.47 (PG 99:412; Roth 95).
16. John of Jerusalem *Against Constantine V* 11 (PG 95:328).

52. Fifth-century mosaic of Abraham and the "Old Testament Trinity." Santa Maria Maggiore, Rome

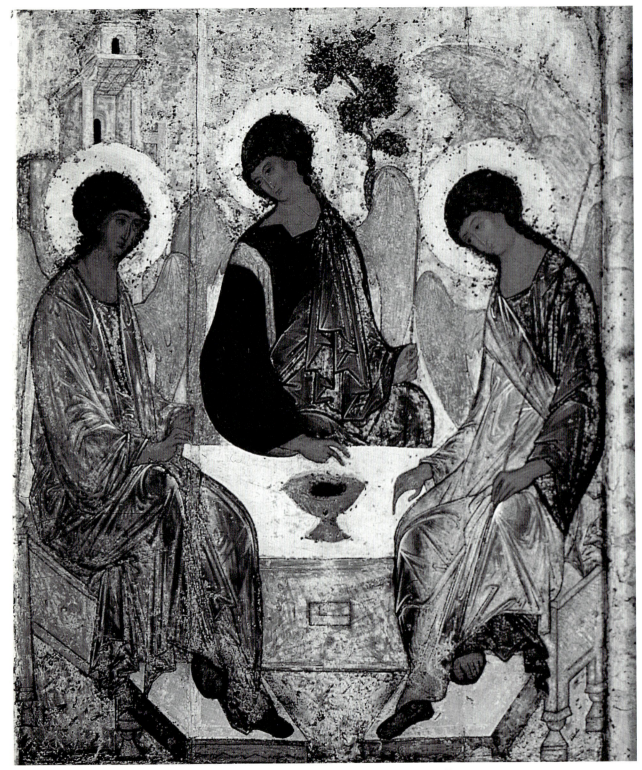

53. Andrej Rublev, *The Holy Trinity*. Late fourteenth or early fifteenth century. Tretyakov Gallery, Moscow

saw was "two men in dazzling garments," which was certainly also meant to refer to angels);[17] the apostles in prison;[18] and various of the prophets in their visions.[19] As Pseudo-Dionysius the Areopagite had pointed out, the shapes of animals and birds had sometimes been employed to make the angels visible to human eyes, although the angels of course had no such shapes by nature: the lion, because "the heavenly beings approximate as much as they can the hiddenness of the unspeakable Deity, by covering the tracks of their own intellects"; the ox, because the angels had "the capacity to plough deeply the furrows of knowledge"; the eagle, because of their "contemplation which is freely, directly, and unswervingly turned" toward the divine sunshine; the horse, because of their "obedience and docility."[20] According to the Gospel of Luke, an angel of the Lord appeared to Zechariah, father of John the Baptist, to foretell the birth of his child.[21] Since every believing Christian was obliged to accept the historicity of that appearance, why should it be illegitimate for this angel to be iconized in a form in which he could be presumed to have appeared to Zechariah?[22] Therefore this "annunciation" to Zechariah would be no less appropriate as the subject for an icon than was the more frequently portrayed appearance of the archangel Gabriel to the Virgin Mary (Figs. 34–36).

It was also possible to proceed by an argument *a majori ad minus*. Long before the Iconoclastic controversies there had already been in existence various icons of the "Old Testament Trinity," as well as other iconographic renditions of this mystery.[23] As it happens, one of the earliest of these to have survived was a Western rather than a Byzantine example, the mosaic of the Trinity at Santa Maria Maggiore in Rome (Fig. 52). Nevertheless, the theme was to become a special motif in Byzantine and then in Slavic iconography.[24] The artistic and spiritual climax of this Eastern Orthodox development came with Andrej Rublev's well-known icon at the end of the fourteenth or the beginning of the fifteenth century (Fig. 53). But Rublev was not innovating when he undertook to paint the Trinity this way; on the contrary, he was consciously drawing on a long iconographic

17. Matt. 27:1–7; Luke 24:4.
18. Acts 12:1–11.
19. Above all, of course, Isa. 6:2, but also such reports as Dan. 6:22, Zech. 3:1, and others.
20. Pseudo-Dionysius the Areopagite *The Celestial Hierarchy* XV.8 (*PG* 3:336–37; *CWS* 188–89).
21. Luke 1:8–23.
22. Theodore the Studite *Orations* VII.5 (*PG* 99:752).
23. Hackel 1931.
24. I. Grabar 1966, 112–208.

and exegetical tradition, Western as well as Eastern.[25] Such icons as Rublev's depicted the incident recorded in the eighteenth chapter of the Book of Genesis, when God had "appeared to Abraham by the terebinths of Mamre," but had done so in the form of three men.[26] According to the consensus of Christian exegesis, this had been a theophany of God the Holy Trinity. To Irenaeus of Lyons, for example, it was evidence, in opposition to heretical distortions, that God the Trinity "spoke in human shape to Abraham."[27] Augustine expanded on that argument, also in response to heretics:

> What do they say of our father Abraham, who was certainly awake and ministering when, after Scripture had premised, "The Lord appeared to Abraham," not one, or two, but three men appeared to him, no one of whom is said to have stood prominently above the others, no one more than the others to have shone with greater glory, or to have acted more authoritatively?[28]

Now if it was legitimate for the church fathers to interpret the appearance of these three angels as a theophany, indeed as a manifestation of the Holy Trinity, whose being was not only invisible but utterly transcendent, "incomprehensible, inseparable, and indivisible [*akatalēptos kai achōristos kai adiairetos*]," why should it not be possible to "see," and therefore to make icons of, these and other angels, not of course according to the nature which they had in reality, which was invisible and could not be iconized, but according to the shapes which they had temporarily assumed for the purpose of being seen by Abraham as well as by later believers?[29]

What was in many ways the clinching exegetical argument for the legitimacy of iconizing the angels also came from the Pentateuch, although from the Second rather than from the First Book of Moses. Its implications, however, extended far beyond the specific question addressed by the theophany to Abraham at Mamre—the question of the use of visible shapes as a device for "portraying historically" a being that was by nature invisible—to the entire question of the legitimacy of representational art in the worship of the one true God. If even this method of iconizing could be defended, the entire practice of making and using icons could be justified. For the prohibition of representational art by Moses (or rather by the Lord

25. Eckardt 1958, 145–76.
26. Gen. 18:1.
27. Irenaeus *Against Heresies* IV.xiv.1 (Harvey 2:164; *ANF* 1:470).
28. Augustine *On the Trinity* II.xviii.34 (*CCSL* 50:125; *NPNF*-I 3:53).
29. John of Jerusalem *Against Constantine* V 12 (*PG* 95:328–29).

God speaking through Moses at Mount Sinai) in the Second Commandment of the Decalogue as set down in the twentieth chapter of the Book of Exodus, which the Iconoclasts were constantly quoting, was not the only reference in the Book of Exodus to artistic representation. In the thirty-sixth chapter of Exodus, Moses had gone on to describe how in decorating the Tabernacle "they made the Veil of finely woven linen and violet, purple, and scarlet yarn, with cherubim worked on it, all made by a seamstress."[30] Nor was even this representation of cherubim on textile the only one. For according to the following chapter, Bezalel, who built the Ark of the Covenant, "made a cover of pure gold, two and a half cubits long and one cubit and a half wide. He made two gold cherubim of beaten work at the ends of the cover, one at each end; he made each cherub of one piece with the cover. They had wings outspread and pointing upwards, screening the cover with their wings; they stood face to face, looking inwards over the cover."[31] Quoting these two passages *in extenso* after having recited the Second Commandment, the Iconodule could ask rhetorically, "Moses, what in the world are you doing?!"[32] Everyone admitted that cherubim were spiritual beings, which had no bodies or other visible forms and which had never become incarnate in a human body, as the Son of God had; yet this showed that it was possible for any such spiritual beings "to be iconized, just as Moses iconized the cherubim."[33] Such a way of reading the Old Testament affected the interpretation of the New Testament as well, including the statement of the Epistle to the Hebrews that above the ark of the covenant were "the cherubim of God's glory, overshadowing the place of expiation."[34] This was a reference not to "incorporeal [*asōmatoi*]" cherubim, but to "the holy depictions of them."[35] Thus there could be a total aesthetics of the invisible, not only an aesthetics of the Incarnation.

Thanks to the development of the doctrine of angels, the Byzantine apologia for icons helped the theology of the church not only to codify for the first time such a Christian aesthetics of the invisible, but also to round out the comprehensive and radical reinterpretation to which Christian doctrine was subjecting the entire system of Classical metaphysics, including ontology and cosmology. Many intellectual and theological historians have described patristic and Byzantine theology as having taken over the Classical

30. Ex. 36:35.
31. Ex. 37:6–9.
32. John of Damascus *Orations on the Holy Icons* III.9 (PG 94:1329).
33. John of Damascus *Orations on the Holy Icons* III.24 (PG 94:1344).
34. Heb. 9:5.
35. Nicephorus *Refutation* II.8 (PG 100:348).

metaphysical system wholesale in its philosophical and theological defense of image worship, but that is not accurate. On the contrary, the conflict over icons makes it clear how misleading it is to apply, even to this Neoplatonizing Christian theology, Arthur O. Lovejoy's celebrated metaphor of "the great chain of being" as a philosophical doctrine.[36] It would probably be much more precise to speak about a liturgical doctrine of "the great chain of images," in which each link was, in one or another manner, tied to what was below it and to what was above it. Ernst Kitzinger has suggested that gradually, as the Byzantine apologia for icons evolved, "ways were sought to justify the icon as such, irrespective of personal and momentary experience, and to find its true meaning in its objective existence. It was lifted out of the pragmatic sphere of tools and utensils (however sacred) and was given a status of its own in the divine order of the universe."[37] Within the Christian version of the great chain of images, which was interpreted as showing forth this "divine order of the universe," the two crucial links were man and angel, each of them identified as a "microcosm" of sorts.

There do not seem to be any instances in Classical Greek of *mikrokosmos* as a single word.[38] Nor do there appear to be any Christian precedents for the word before the eighth century, that is, before John of Damascus.[39] As two words, of course, the term had appeared more than a millennium before, as early as the pre-Socratic philosopher Democritus, whose principal work, now lost, was entitled *Mikros Diakosmos*.[40] In what would appear, then, to have been the first recorded instance of the term itself as a single word, John of Damascus wrote:

> Man, therefore, is a microcosm. For he has both a soul and a body, and he occupies a middle position between intelligence and matter [*mesos nou kai hylēs*]. Therefore he is a link [*syndesmos*] between the visible and the invisible creations, between that creation which is endowed only with sense-perception and that creation which is endowed with intelligence [*aisthētēs te kai noētēs ktiseōs*].

He went on to point out the reason for man's being a microcosm, and therefore also an important link in the great metaphysical chain: he shared his

36. Lovejoy 1936, 67–98.
37. Kitzinger 1954, 139.
38. Liddell–Scott–Jones 1132–34.
39. Lampe 870.
40. Jaeger 1947, 183–84, which includes a discussion of "the beautiful fragment which Clement of Alexandria has preserved for us" from Democritus.

material nature with inanimate objects, his appetitive nature with animate but irrational beasts, and his reason with "the noncorporeal and intelligent powers," that is, with the angels.[41] John of Damascus does not seem to have employed the actual word "microcosm" to refer to the angels. Nevertheless, in speaking about man in another passage, he did call him "a kind of second cosmos, the small in the great, another worshiping angel [*tina kosmon deuteron, en megalōi mikron, angelon allon proskynēten*]." The translator of John of Damascus into English felt justified in rendering this Greek phrase with the English phrase "like a sort of second microcosm within the great world, another angel capable of worship," implying thereby that the angels were the first microcosm and man the second.[42]

The speculations of various Christian Neoplatonists about these "noncorporeal and intelligent powers" had helped to supply the other missing link of the chain. Within Christian thought such speculations at a high metaphysical level had begun with Clement of Alexandria and Origen and had continued with Gregory of Nyssa, but it was above all Pseudo-Dionysius the Areopagite in the sixth century who had formulated the definitive view of the angels. He had likewise provided the defenders of icons with a definitive theory of the relation between "image" and "archetype," for which they were able to cite him as an authority.[43] This he had done by showing, in the paraphrase of Nicephorus, that "truth is in the likeness and the archetype in the image, each in the other except for the difference of essence."[44] Pseudo-Dionysius does not seem to have used the specific word "link [*syndesmos*]" in speaking about the angels.[45] In the third chapter of his *Celestial Hierarchy* Pseudo-Dionysius had identified the general nature of any hierarchy by means of a threefold definition: "a sacred order, a state of understanding, and an activity approximating as close as possible to the divine."[46] He proceeded to explain that "the transcendent Deity has out of goodness established the existence of everything and brought it into being," and that the angels shared with humanity and with all things this quality of possessing existence by virtue of having been divinely created. There was nevertheless a hierarchy among things created: nonliving things;

41. John of Damascus *On the Two Wills in Christ* 15 (*PG* 95:144).

42. John of Damascus *The Orthodox Faith* II.12 (*PG* 94:921; *NPNF*-II 9:31).

43. Theodore the Studite *Refutation* II.11 (*PG* 99:457; Roth 48).

44. Pseudo-Dionysius the Areopagite *The Ecclesiastical Hierarchy* IV.iii.1 (*PG* 3:473; *CWS* 225–26).

45. Lampe 1310, which does, however, cite the passage about man just quoted from John of Damascus *On the Two Wills in Christ*.

46. Pseudo-Dionysius the Areopagite *The Celestial Hierarchy* III.1 (*PG* 3:164; *CWS* 153).

living but nonrational thing; and "beings endowed with reason and intelligence" such as man.[47] But, in a parallel to the discourse of John of Damascus on man, Pseudo-Dionysius went on to speak about the special position of the angels in that hierarchical chain:

Compared with (1) the things which merely are, with (2) irrational forms of life, and indeed with (3) our own rational natures, the holy ranks of heavenly beings are obviously superior in what they have received of God's largess. Their thinking processes imitate the divine. They look on the divine likeness with a transcendent eye. They model their intellects on him. . . . They nonmaterially receive undiluted the original enlightenment. . . . They have the first and the most diverse participation in the divine.[48]

Yet withal they remained creatures, sharing this with man and with the rest of the cosmos. On the other hand, they were "nonmaterial [*ahylos*]," a term sometimes predicated "of the Godhead" and at other times predicated "of angels as pure spirits."[49] In this respect, consequently, the angels were more like God than like man. Therefore John of Damascus could argue that when Joshua saw the figure of a man with a sword, who called himself "the commander-in-chief of the army of the Lord,"[50] what Joshua saw was "not the nature of an angel, but its image," the visible representation of a being which, though it was not God, was nevertheless, like God himself, invisible by its very nature and which had made itself temporarily visible for this particular event.[51]

"That the angels exist and that these angels are created by God," according to an authoritative essay on the patristic doctrine of angels, "are the two truths which the church fathers regard as obvious in the realm of faith."[52] Therefore in the systematic description of the Christian and patristic doctrine of the angels which John of Damascus propounded within the framework of his book of dogmatics, *The Orthodox Faith*, the angels were, quite literally from the first sentence to the last, unequivocally declared to be creatures of God: "God is himself the Maker and Creator of the angels" is how the chapter begins; it ends with the declaration that "since they are created things they are not creators, but he who creates and provides for

47. Pseudo-Dionysius the Areopagite *The Celestial Hierarchy* IV.1 (PG 3:177; *CWS* 156).
48. Pseudo-Dionysius the Areopagite *The Celestial Hierarchy* IV.2 (PG 3:180; *CWS* 156–57); numerals added to the text.
49. Lampe 265.
50. Josh. 5:13–15 (LXX).
51. John of Damascus *Orations on the Holy Icons* III.26 (PG 94:1345).
52. *DTC* 1:1193.

all things is God, who alone is uncreated [*ho monos aktistos*]."[53] Like the world and like all other creatures, they owed their existence to their having been made *ex nihilo* by the Almighty. From this first principle it followed that if anyone ascribed to the angelic creatures the power to create essences, a power that belonged to the uncreated God alone, that was nothing short of blasphemy. They did not have bodies, but that was not to be taken to imply that they were omnipresent, as God was; "for when they are in the heaven, they are not on the earth." They were, moreover, endowed with a free will, because they possessed "intellect or rationality [*nous*]" and "a rational nature [*physis logikē*]." It seems to have been on that basis, albeit without explicit biblical warrant corresponding to the verses in the first chapter of the Bible concerning the creation of man,[54] that Christian theology spoke of God as having "created them according to His very own image or icon [*kat' oikeian eikona*]." Hence the orthodox doctrine of the angels was, throughout, an effort to differentiate between them and God, and to differentiate at the same time between them and man. They were not to be called "eternal," for only God was eternal; they were indeed "immaterial and incorporeal," yet not in the same sense that God was; although they were "free of all bodily passion," their nature was not "passionless [*apathēs*]," because only the divine nature truly was so in the full sense of the word.[55] Their nature was also radically different from human nature: it was "by grace an immortal nature," able to communicate without speaking or hearing words, endowed with unimaginable speed in carrying out the service of God, and capable of assuming various forms as required by such service. In an apostrophe to the angels, Theodore the Studite exclaimed: "O angels, you were the supercosmic cosmos before the cosmos, and to this cosmos you proclaimed Christ, the supercosmic cosmos!"[56]

Nevertheless, as such an apostrophe showed and as all these theologians themselves were the first to acknowledge, the central locus of expression for this Byzantine affirmation of the place of the angels in the cosmos was not in any theological treatise, neither in *The Celestial Hierarchy* of Pseudo-Dionysius the Areopagite nor in *The Orthodox Faith* of John of Damascus, but in the liturgy, in which angels, apostles, prophets, and martyrs all participated.[57] In the well-known inaugural vision of the prophet Isaiah in the

53. John of Damascus *The Orthodox Faith* II.3 (PG 94:865–73; *NPNF*-II 9:18–20).
54. Gen. 1:26–27.
55. Lampe 171–72.
56. Theodore the Studite *Orations* VI.1 (PG 99:729).
57. Theodore the Studite *Orations* II.2 (PG 99:693).

temple, he "saw the Lord seated on a throne" as well as the "attendant seraphim," and heard the angels sing,

> Holy, Holy, Holy is the Lord of Hosts:
> the whole earth is full of his glory.[58]

By "the expansion of the temple into heaven, of the earth into the whole cosmos, of simple praise into perpetual praise," the Byzantine liturgy put a Christian and trinitarian elaboration on this Old Testament vision of the Thrice-Holy.[59] That liturgical and cosmological angelology was expressed in a prayer from the Byzantine *Liturgy of Saint Basil*, as this was celebrated in the ninth century: "Lord and Master, our God, who hast appointed the orders and hosts of angels and archangels to minister to thy glory in heaven, grant that the holy angels may go in with us to join in our service and glorifying of thy goodness."[60]

In other Greek liturgies, too, the angels were part of the church's worship, providing the cosmic *cantus firmus* that accompanied the variations of the liturgical chant here in the church that was still on earth. So, for example, the long prayer in the Greek *Liturgy of Saint Mark* from Egypt reads:

Thou art exalted high above all princedoms and powers, all virtues and dominions, and above every name that is known, not in this world only but in the world to come. Around thee are assembled ten thousand times ten thousand myriads of angels, and all the hosts of archangels. Around thee stand these two most venerable beings, the many-eyed cherubim and the six-winged seraphim who with two wings cover their eyes, with two their feet, and with two do fly. With tireless tongue, in never-silent praise of God they cry out to one another the Thrice-Holy hymn of victory, singing, crying, glorifying, and shouting to thy great Majesty, saying: "Holy, Holy, Holy is the Lord of Hosts, heaven and earth are full of thy glory." For ever, all things hallow thy name. Accept, then, O Lord God, our hymns of praise, which, in concert with all who praise thee, we offer, saying: "Holy, Holy, Holy is the Lord God of Sabaoth, heaven and earth are full of thy glory."[61]

It is this prayer that the standard scholarly monograph on the angels and the liturgy makes "the foundation of our analysis,"[62] because it brings

58. Isa. 6:3.
59. Peterson 1964, 20.
60. Brightman 312; Attwater 24.
61. Brightman 131.
62. Peterson 1964, 14.

together so many of the motifs of the place of the angels in the liturgy both of the church and of the cosmos. The angels, with the "speechless and piercing" sound of "the secret silence of their hymns of victory," led the worship of the entire creation as well as of the church.[63] From all of these prayers it was evident that "it is always the whole cosmos which takes part in the praise of God," but this cosmic dimension is assured because "it is the heaven of the angels . . . which is the central point, the most spiritual part of the universe."[64] The doctrine of the angels was a carefully wrought theological and philosophical construct, with implications for dogmatics and for metaphysics; but it was as well, and in a fundamental way, a dimension of Byzantine liturgical worship, in which, as the theologians of the eighth and ninth centuries themselves made clear through their apologia, the icons formed an indispensable part.

Indeed, as the passage about man as microcosm just quoted comes from the treatise *On the Two Wills in Christ* written by John of Damascus, so also much of this material about angels comes from the third of the same author's *Apologetic Orations against Those Who Are Expelling the Holy Icons*. In six paragraphs of the same *Apologetic Oration*, moreover, he had also, in a text that covers scarcely two and one-half columns of Greek in the printed version, propounded an entire cosmology, in which Creator and creation were linked through a comprehensive schema of images.[65] His cosmological schema may correctly be said to have summarized, more precisely but also more profoundly than any other single anti-Iconoclast document (with the possible exception of the actual decrees of the Second Council of Nicaea in 787 itself), the whole of the Byzantine apologia for the icons. The apologia issues in what can be called nothing less than a "cosmology of icons." Therefore the schema of John of Damascus seems well suited to perform a summarizing function also here. The fundamental theological and christological presupposition for this cosmology of icons had already been formulated by John of Damascus earlier, in the second of his *Apologetic Orations*: "Just as throughout the entire cosmos the gospel has been preached in an unwritten message, so throughout the entire cosmos it has been handed down in an unwritten tradition that we should iconize Christ the God-made-flesh."[66] Now in the third *Apologetic Oration* he went on to examine the six links in the great chain of images. His examination of images proceeded in descending order, beginning with the summit of all the images

63. Theodore the Studite *Orations* VI.1 (*PG* 99:732).
64. Peterson 1964, 23.
65. John of Damascus *Orations on the Holy Icons* III.18–23 (*PG* 94:1337–44).
66. John of Damascus *Orations on the Holy Icons* II.16 (*PG* 94:1304).

in the Creator Logos, going on to the creatures as images, and concluding with the images as icons.

1. "Who first made an icon?" Whether this present heading of the twenty-sixth chapter in the edition of the third of the *Orations* was provided by John of Damascus himself and therefore forms part of the original of the work or whether it was supplied by a later scribe or editor, it does precisely identify the trinitarian theological presupposition of the entire argument for icons. For as if to answer that question, the first sentence of the chapter declares: "God himself was the first to do so, when he begat his only-begotten Son and Logos as his own image—a living image, an image by [very] nature, a precisely similar express image of his own eternity [*aparallakton charaktēra tēs autou aïdiotētos*]."[67] The term "express image [*charaktēr*]" had already been used in the New Testament, in a passage quoted by John of Damascus, where Christ was called "the stamp of God's very being [*charaktēr tēs hypostaseōs autou*]."[68] It also appeared in the *Liturgy of Saint Basil*.[69] The term *charaktēr* came from "the impression on coins," which was an exact "impress, reduction, representation" of the original.[70] At the hands of the church fathers of the fourth and fifth centuries in their defense of the First Council of Nicaea, the word had assumed the status of a technical term of christological and trinitarian doctrine, which proved that the image and the one being imaged were identical, as the Niceno-Constantinopolitan Creed affirmed.[71] The quality of being not merely an image, but an image "by very nature [*physikos*]," set the Son and Logos of God apart from all creatures (and of course, not incidentally, from all other images as well). For the Son of God was the one and only image of God that was the same as God "in every single respect [*en hekastōi pragmati*]";[72] only this image could be said to be "one in being [*homoousios*]" with its Original, while by definition every other image of God was ontologically other than God.

When the Gospel of John began by asserting "No one has ever seen God" but proceeded to have Jesus announce in a later chapter "Anyone who has seen me has seen the Father,"[73] it was presenting in these two sentences

67. John of Damascus *Orations on the Holy Icons* III.26 (*PG* 94:1345).

68. Heb. 1:3.

69. Brightman 325.

70. Bauer–Gingrich 876. This made the term all the more appropriate to the discussion of icons, because of the argumentation of the Iconodules cited earlier, on the basis of coins and images of the emperor.

71. Lampe 1513.

72. John of Damascus *Orations on the Holy Icons* III.18 (*PG* 94:1337).

73. John 1:18, 14:9.

both elements of the oxymoron expressed by a single sentence elsewhere in the New Testament: "He is the image of the invisible God."[74] An "invisible" God who nevertheless had an essential and ontologically identical "image," which had now become visible in flesh and in time, was therefore a God who was no longer "invisible" in the same sense as before. The full cosmological import of that oxymoron, quoted here by John of Damascus from the first chapter of the Epistle to the Colossians, is articulated in the same chapter of Colossians, two verses later: "All things are held together in him [*ta panta en autōi synestēken*]," still referring to Christ.[75] On the basis of this proof text, Athanasius had argued that the Logos through whom the cosmos had been created and by whom it was being held together could not be a creature, since that would threaten the entire cosmos with the "dissolution" to which all creatures were subject and from which they could be saved only by the Logos-Creator of the cosmos, who transcended all corruptibility and transiency and in whom therefore the cosmos as a whole truly could hold together.[76] In a later treatise he developed this use of the words of Colossians 1:17 still further, to insist that no one could "contemplate the harmony and order of the creation without reflecting on the Framing Logos within it": it was impossible to comprehend the cosmos as a system (*systēma*, which means "that which holds together [*synestēken*]") without knowing that which held it together, the living and now incarnate icon of the invisible God.[77]

2. The speculation underlying this cosmology of icons as a great chain of images, however, made it necessary to posit—between the invisible Logos-Creator, as the eternal image of God by nature, and the empirical universe of visible creatures—a second and intermediate class of images: "the idea in God of those things which are to come to pass through God [*hē en tōi theōi tōn hyp' autou esomenōn ennoia*]."[78] The God who dwelt in eternity and transcended time nevertheless determined that things would come to be at a predetermined time. These were the divine "predeterminations [*proorismoi*]."[79] They had been described by Pseudo-Dionysius, in his discussion of causality, as "exemplars [*paradeigmata*] of everything"; these exemplars, he said, "preexist as a unity in God and produce the essences

74. Col. 1:15.
75. Col. 1:17.
76. Athanasius *Against the Heathen* 41 (PG 25:81–84; *NPNF*-II 4:26).
77. Athanasius *Orations against the Arians* I.12 (PG 26:36; *NPNF*-II 4:313).
78. John of Damascus *Orations on the Holy Icons* III.19 (PG 94:1340).
79. Lampe 1161.

of things."[80] Significantly, it was Pseudo-Dionysius whom John of Damascus quoted here as an authority on the definition of these "predeterminations." It does appear unavoidable to see in this language a more or less Christianized version of the Platonic, and then especially of the Neoplatonic, doctrine of the preexistent forms, as that doctrine was taught by Proclus.[81] The relation between these preexistent but created "exemplars of all things" and the preexistent and uncreated Logos would have to raise serious problems for any Christian Neoplatonism. The problems were to become evident at even greater length in the Latin West. Coming out of a Neoplatonic background and then influenced further by Pseudo-Dionysius, John the Scot in the ninth century sought to incorporate this Platonic doctrine of forms into a Christian ontology by calling the forms "a reality that is both created and creating [*natura creata et creatrix*]." The same problems were evident also in the thought of the Byzantine Neoplatonists who sought to adapt the doctrine of preexistent forms to the Christian definition of creation. In the cosmology of icons, however, that doctrine did have something of a compensatory advantage. It provided an important connection between the Logos as eternal image and the world of phenomena, by interposing the "images and exemplars of the future things that God is to make [*eikones kai paradeigmata tōn hyp' autou esomenōn*]" between the Logos and the world: icons as images could therefore be said to have their foundation not in a mere "symbolism" of some sort, but in a hierarchical metaphysical reality.

3. These first two classes of "image" made it possible to put into proper context the central affirmation of the Christian doctrine of man, the traditional teaching that man had been created in the image and likeness of God—or, more precisely according to the Septuagint version of the Book of Genesis, "according to/after the image and likeness [*kat' eikona kai kath' homoiōsin*]."[82] The distinction between creation "in" the image and creation "after" the image enabled several theologians in both East and West, including Thomas Aquinas, to draw a sharp line between the Son of God, who was fully "in" the image of God, and humanity, which was only "according to/after" the image of God. Here in the anti-Iconoclastic *Apologetic Oration* it was not necessary to expatiate at great length on the various component elements of divine creation according to that image and similitude, but only to define it as a creation "by imitation [*kata mimēsin*]" and then to enumerate

80. Pseudo-Dionysius the Areopagite *The Divine Names* V.8 (PG 3:842; CWS 102).
81. See O'Meara 1982, especially the article of H. D. Saffrey.
82. Gen. 1:26–27 (LXX).

the qualities of human life that reflected such an imitation of the divine: unity amid variety, in imitation of the Trinity; freedom of the will and authority over other creatures, in imitation of divine sovereignty.[83] Elsewhere, in *The Orthodox Faith*, his treatise of systematic theology, John of Damascus developed the orthodox interpretation in greater detail, distinguishing, as had been customary from early times, between the image of God as "the side of the divine nature which consists of mind and free will" (and which therefore was not lost through the fall into sin) and the likeness to God as "likeness in virtue so far as that is possible" (which had been lost, or at any rate fatally impaired, by the fall).[84] Having attributed an "image of God" also to the angels, he needed to clarify the differences between angel and humanity; for humanity, he said, "surveys the visible creation and is initiated into the mysteries of the realm of thought, . . . belonging both to the realm of sight and to the realm of thought [*oraton kai nooumenon*]." That set humanity apart from the angels, which did not have a physical nature and therefore did not have physical senses.

It was this very combination that made man the image unique. But that combination also made it both necessary and permissible for the revelation and redemption of God to be addressed to man according to the realm of sight, not only according to the realm of thought. That was the background for the sarcastic words of John of Damascus to his Iconoclast opponents quoted earlier: "You perhaps are more exalted and non-material, and have risen above the body, so that, being non-fleshly, you can despise everything that presents itself to the sight. But since I am a human being and occupy a body, I want to deal in a bodily fashion with the things that are holy, and I want to look at them."[85] For to be a human being, even a human being created after the image of God, meant to belong to the realm of sight as well as to the realm of thought, to have the "senses sanctified" as well as the reason.

4. The fourth class of images was to be found in the language of Scripture.[86] In the first chapter of his treatise *The Divine Names*, which John of Damascus quoted here, Pseudo-Dionysius had catalogued a large number of "the names for God favored by the Scripture writers," but he had done so only after reminding his readers that the writers of the Scriptures "praise [this divinely beneficent Providence] by every name—and as the Nameless

83. John of Damascus *Orations on the Holy Icons* III.20 (*PG* 94:1340–41).
84. John of Damascus *The Orthodox Faith* II.12 (*PG* 94:920; *NPNF*-II 9:30–31).
85. John of Damascus *Orations on the Holy Icons* I (*PG* 94:1264).
86. John of Damascus *Orations on the Holy Icons* III.21 (*PG* 94:1341).

One."[87] The intention of the names for God used in Scripture, therefore, was the precise opposite of providing some kind of literal information about the Nameless One: God was neither a rock nor a wind. Indeed, even the most sublime and most "metaphysical" of all scriptural language about the divine mystery, the revelation to Moses of the name "I am being [*egō eimi ho ōn*],"[88] was not literal; for the "being" of God was "supra-essential, transcendent Goodness transcendently there." Drawing upon the general assent of his readers to that way of defining the names for God in Scripture, John of Damascus was able to put it to good advantage by identifying those names, too, as what he might fittingly have called a "verbal icon." The twentieth-century scholar whose name is most closely linked with the phrase "verbal icon" explained the term in a way that is pertinent also here:

> The term *icon* is used today by semeiotic writers to refer to a verbal sign which *somehow* shares the properties of, or resembles, the objects which it denotes. The same term in its more usual meaning refers to a visual image and especially to one which is a religious symbol. The verbal image which most fully realizes its verbal capacities is that which is not merely a bright picture (in the usual modern meaning of the term *image*) but also an interpretation of reality in its metaphoric and symbolic dimensions. Thus: *The Verbal Icon*.[89]

By its very nature, Scripture was such a verbal icon, and was so in a unique sense. As such, it was as well an important link in the great chain of images. Both by the myriad of images it presented and especially by its keys to the interpretation and use of such images, it provided a hermeneutical key to all the other images, including especially the icons as images, also because of the predominantly scriptural context of the sacred personages and narrative events portrayed in the icons of the church.

5. A special part of Scripture as image, and one sufficiently important to warrant a separate status, was the image which "pre–iconizes and delineates in advance [*proeikonizōn kai prodiagraphōn*] the things that are to come."[90] John of Damascus was referring here not chiefly (though also) to the predictive powers of the biblical prophet in general, but specifically to those events and persons that had stood in the history of the Old Testament as "types" and "figures." The ones he mentioned specifically were

87. Pseudo-Dionysius the Areopagite *The Divine Names* I.6–8 (PG 3:596–97; *CWS* 54–57).
88. Ex. 3:14 (LXX).
89. Wimsatt 1966, x; italics his.
90. John of Damascus *Orations on the Holy Icons* III.22 (PG 94:1341).

various anticipations of the *Theotokos* such as the burning bush that appeared to Moses, which had frequently been seen, exegetically and also iconographically, as typifying the Virgin Mary.[91] The lifting up of the bronze serpent in the presence of Israel in the wilderness had been cited by Christ as an anticipation of his Crucifixion.[92] On that basis the church fathers had elaborated on the typological anticipations of the Crucifixion throughout the narrative of the Exodus from Egypt.[93] This view of typology in the Hebrew Bible had produced in the writings of the Greek church fathers a vast and learned literature, in which the counterpoint of type, prototype, and antitype encouraged the development of elaborate parallels between Old and New Testament, many of them quite fanciful and some of them altogether bizarre. But identifying this process of typifying as "pre-iconizing" also served to call attention to the extraordinarily fertile soil that its parallelisms had provided specifically for the history of Christian art: the cloud through which Israel passed as a "type" of Christian baptism;[94] the manna in the wilderness as a "type" of the Christian Eucharist; Eve as a "type" of Mary—and for that matter, Moses as a "type" of Constantine or Melchizedek as a "type" of Justinian. Such Christian iconizing was legitimate, the Damascene argued, because it reflected the pre-iconizing that had been going on throughout the history of salvation.

6. Only after enumerating all five of these classes of images did the catalogue in the third *Apologetic Oration* of John of Damascus get around to addressing the question of icons in particular.[95] It contented itself, moreover, with a somewhat matter-of-fact rehearsal of the didactic role that could be played by any icon, indeed by any image at all. "The sixth class of image is one established in memory of things that have happened, whether of a miracle or of some virtue [*aretē*], for the glory, honor, and monumental celebration of those who have stood out from the rest." As it stood, this comprehensive description was clearly intended to apply, as a general description, to a large number of commemorative images, secular ones no less than religious ones. Such monuments could, moreover, take various forms. They could be expressed in words and letters written down in books, but it was essential to remember that "the letter iconizes the word [*eikonizei gar to gramma ton logon*]," having been derived from the living reality of

91. Lampe 294.
92. Num. 21:9; John 3:14.
93. Daniélou 1960, 167–70.
94. 1 Cor. 10:1–2.
95. John of Damascus *Orations on the Holy Icons* III.23 (PG 94:1341–44).

the word in a way that was similar to the way the icon as image was derived from the living reality of the historical personage it represented. Therefore those who rejected icons by claiming to content themselves with the word of God and the book of Holy Scripture alone had their own icons nevertheless, no less than did those who were being accused of idolatry for their devotion to holy pictures. Conversely, because the pictures constituting this "sixth class of image" all carried some explicit reference to one or another or several of the first five classes of image that had been enumerated, the Iconoclastic rejection of the icons was tantamount to a rejection not only of one link but of the entire chain of images.

It was undeniably as true of the Iconoclastic controversy as it has been of every theological controversy that the two sides often argued past each other, and that the final settlement was brought about by a variety of factors—including personal prejudice, political pressure, popular superstition, rhetorical tricks, historical forgery, military force—and not only by doctrinal debate. Yet it is also as true of the Iconoclastic controversy as it was of any other theological debate that both sides were contending for fundamental convictions about the word of God and the mystery of being. Amid all the polemics, these apologists were able to identify the central issues in the struggle and their connection with the fundamental themes of faith, hope, and charity, by which Eastern Orthodox Christians and their church would live and die, in the twentieth century no less than in the eighth. Therefore the reinstatement of the icons by the Second Council of Nicaea in 787 truly was the recovery of the distinctive genius of Eastern Christendom.

Bibliography

Adeney, Walter Frederic. *The Greek and Eastern Churches.* New York: Charles Scribner's Sons, 1932.

Alexander, Paul J. "Hypatius of Ephesus: A Note on Image Worship in the Sixth Century." *Harvard Theological Review* 45 (1952):177–84.

————. "The Iconoclastic Council of St. Sophia (815) and Its Definition (Horos)." *Dumbarton Oaks Papers* 7 (1953):35–66.

————. *The Patriarch Nicephorus of Constantinople: Ecclesiastical Policy and Image Worship in the Byzantine Empire.* Oxford: Oxford University Press, 1958.

Alivisatos, Hamilcar S. *Die kirchliche Gesetzgebung des Kaisers Justinian I.* Reprint ed. Aalen: Scientia Verlag, 1973.

Allwohn, A. "Die Interpretation der religiösen Symbole, erläutert an der Beschneidung." *Zeitschrift für Religions- und Geistesgeschichte* 8 (1956):32–40.

Anastos, Milton V. "The Ethical Theory of Images Formulated by the Iconoclasts in 754 and 815." *Dumbarton Oaks Papers* 8 (1954):151–60.

————. "The Arguments for Iconoclasm as Presented by the Iconoclastic Council of 754." In *Late Classical and Mediaeval Studies in Honor of Albert Matthias Friend, Jr.*, edited by Kurt Weitzmann, 177–88. Princeton: Princeton University Press, 1955.

Antoniadis, Sophie. *Place de la liturgie dans la tradition des lettres grecques.* Leiden: A. W. Sijthoff, 1939.

Armstrong, A. Hilary. "Some Comments on the Development of the Theology of Images." *Studia Patristica* 9 (1963):117–26.

Atchley, Edward Godfrey Cuthbert Frederic. *A History of the Use of Incense in Divine Worship.* New York: Longmans, Green and Company, 1909.

Augusti, Johann Christian Wilhelm. *Beiträge zur christlichen Kunst-Geschichte und Liturgik.* 2 vols. Leipzig: Dyk, 1841–46.

Aulén, Gustaf. *Christus Victor: An Historical Study of the Three Main Types of the Idea of Atonement.* Translated by A. G. Hebert. Reprinted with an introduction by Jaroslav Pelikan. New York: Macmillan, 1969.

Bank, Alice. *Byzantine Art in the Collections of Soviet Museums.* Translated by Lenina Sorokina. 2d ed. Leningrad: Aurora Art Publishers, 1985.

Barnard, Leslie William. *The Graeco-Roman and Oriental Background of the Iconoclastic Controversy.* Leiden: Brill, 1974.

Bastgen, Hubert. "Das Capitulare Karls d. Gr. über die Bilder oder die sogenannten Libri Carolini." *Neues Archiv der Gesellschaft für ältere deutsche Geschichtskunde* 35 (1911):631–66; 36 (1912):13–51, 453–533.

Baumstark, Anton. "Altarkreuze in nestorianischen Klöstern des 6. Jahrhunderts." *Römische Quartalschrift für christliche Altertumskunde und für Kirchengeschichte* 14 (1900):70–71.

————. "Der antiochenische Festkalender des frühen sechsten Jahrhunderts." *Jahrbuch für Liturgiewissenschaft* 5 (1925):123–35.

Bayet, Charles Marie Adolphe Louis. *Recherches pour servir à l'histoire de la peinture et de la sculpture*

chrétiennes en Orient avant la querelle des iconoclastes. Paris: E. Thorin, 1879.

Baynes, Norman H. "The Icons before Iconoclasm." *Harvard Theological Review* 44 (1951):93–106.

Beck, Hans-Georg. *Kirche und theologische Literatur im byzantinischen Reich.* Munich: C. H. Beck'sche Verlagsbuchhandlung, 1959.

————. *Von der Fragwürdigkeit der Ikone.* Munich: C. H. Beck'sche Verlagsbuchhandlung, 1975.

Benz, Ernst. "Theologie der Ikone und des Ikonoklasmus." *Kerygma und Mythos* 6 (1964):75–102.

Berenson, Bernard. "Due dipinti del XII secolo venuti da Constantinopoli." *Dedalo* 2 (1921–22):285–304.

Berkhof, Hendrik. *Die Theologie des Eusebius von Caesarea.* Amsterdam: Uitgeversmaatschappij Holland, 1939.

Bernardakis, P. "Le culte de la croix chez les Grecs." *Echos d'Orient* 5 (1901):193–202, 257–64.

Bertelli, Carlo. "La Madonna del Pantheon." *Bolletino d'Arte* 46-4 (May–June 1961):24–35.

————. *La Madonna di Santa Maria in Trastevere: Storia, iconografia, stile di un dipinto romano dell'ottavo secolo.* Rome: Eliograf, 1961.

Bieler, L. *Theios anēr: Das Bild des "göttlichen Menschen" in Spätantike und Frühchristentum.* 2 vols. Vienna: O. Höfels, 1935–36.

Bizer, Ernst. *Fides ex auditu: Eine Untersuchung über die Entdeckung der Gerechtigkeit Gottes durch Martin Luther.* 3d ed. Neukirchen-Vluyn: Neukirchener Verlag des Erziehungsvereins, 1966.

Boespflug, François, and Lossky, Nicolas. *Nicée II, 787–1987: Douze siècles d'images religieuses.* Paris: Les Editions du Cerf, 1987.

Borella, P. "Cristo vittorioso in S. Ambrogio, nella liturgia e nell'arte cristiana." *Ambrosius* 1 (1939):75–80.

————. "Cristo coronato vincitore in S. Ambrogio e nell'arte cristiana." *Ambrosius* 1 (1939):149–150.

Bornert, René. *Les commentaires byzantins de la divine liturgie du VIIIe au XVe siècle.* Paris: Institut Français d'études byzantines, 1966.

Boswell, John. *The Kindness of Strangers: The Abandonment of Children in Western Europe from Late Antiquity to the Renaissance.* New York: Pantheon Books, 1988.

Bouyer, Louis. "Le culte de Marie dans la liturgie byzantine." *Maison-Dieu* 38 (1954):122–35.

Bréhier, Louis. *La querelle des images (VIIIe–IXe siècles).* Reprint ed. New York: Burt Franklin, 1969.

Brown, Peter. "A Dark Age Crisis: Aspects of the Iconoclastic Controversy." *English Historical Review* 88 (1973):1–34.

————. *The Body and Society: Men, Women and Sexual Renunciation in Early Christianity.* New York: Columbia University Press, 1988.

Bryer, Anthony, and Herrin, Judith, eds. *Iconoclasm.* Birmingham, Eng.: University of Birmingham Press, 1977.

Buchthal, Hugo, and Belting, Hans. *Patronage in 13th Century Constantinople: An Atelier of Late Byzantine Book Illumination and Calligraphy.* Washington, D.C.: Dumbarton Oaks, 1978.

Buchthal, Hugo, and Kurz, Otto. *A Hand List of Illuminated Oriental Christian Manuscripts.* London: The Warburg Institute, 1942.

Bultmann, Rudolf. "Zur Geschichte der Lichtsymbolik im Altertum." *Philologus* 97 (1948):1–36.

Bury, John Bagnell. *History of the Later Roman Empire.* 2 vols. Reprint ed. New York: Dover, 1958.

Campenhausen, Hans von. "The Theological Problem of Images in the Early Church." In *Tradition and Life in the Church: Essays and Lectures in Church History,* translated by A. V. Littledale, 171–200. Philadelphia: Fortress Press, 1968.

Carol, Juniper B., ed. *Mariology.* 3 vols. Milwaukee: Bruce Publishing Company, 1954–61.

Casel, Odo. "Älteste christliche Kunst und Christusmysterium." *Jahrbuch für Liturgiewissenschaft* 12 (1932):1–86.

Caspar, Erich. "Papst Gregor II und der Bilderstreit." *Zeitschrift für Kirchengeschichte* 52 (1933):28–89.

Cecchelli, Carlo. *Il trionfo della Croce. La Croce e i santi segni prima e dopo Costantino.* Rome: Edizioni Paoline, 1954.

Charanis, Peter. "Coronation and Its Constitutional Significance in the Later Roman Empire." *Byzantion* 15 (1940–41):49–66.

Chevalier, Célestin. *La Mariologie de saint Jean Damascène.* Rome: Pontifical Institute of Oriental Studies, 1936.

——. "Mariologie de Romanos." *Recherches de science religieuse* 28 (1938):48–69.

Clerc, Charly. *Les théories relatives au culte des images chez les auteurs grecs di IIe siècle après J. C.* Paris: Université de Paris, 1915.

Cochrane, Charles Norris. *Christianity and Classical Culture: A Study of Thought and Action from Augustus to Augustine.* London and New York: Oxford University Press, 1944.

Conant, Kenneth J. "The Original Buildings at the Holy Sepulchre in Jerusalem." *Speculum* 31 (1956):1–48.

Cotta Venetia, L. "*Hē exelixis tēs eikonographikēs parastaseōs tou elkomenou (Christou) en tēi Christianikēi technēi*" [Evolution of the representation of the wounded Christ in Christian art]. *Byzantinisch-Neugriechische Jahrbücher* 14 (1938):245–267.

Crouzel, Henri. *Théologie de l'image chez Origène.* Paris: Aubier, 1956.

Dalton, Ormonde Maddock. *Byzantine Art and Archaeology.* Oxford: Clarendon Press, 1911.

Daniélou, Jean. "The Problem of Symbolism." *Thought* 25 (1950):423–40.

——. "La charrue symbole de la Croix (Irénée *Adv. haer.* IV 34, 4)." *Recherches de science religieuse* 42 (1954):193–203.

——. *From Shadows to Reality: Studies in the Biblical Typology of the Fathers.* Translated by Dom Wulstan Hibberd. Westminster, Md.: The Newman Press, 1960.

Deér, J. "Das Kaiserbild im Kreuz." *Schweizer Beiträge zur Allgemeinen Geschichte* 13 (1955):48–110.

Demus, Otto. "Zwei Konstantinopler Marienikonen des 13. Jahrhunderts." *Jahrbuch der Österreichischen Byzantinischen Gesellschaft* 7 (1959):87–104.

Diehl, Charles. "Byzantine Civilization." In *The Eastern Roman Empire (717–1453).* Vol. 4 of *The Cambridge Medieval History,* 745–77. Cambridge: Cambridge University Press, 1936.

Diekamp, Franz, ed. *Doctrina patrum de incarnatione Verbi.* Münster in Westfalen: Aschendorff, 1907.

Diener, Bertha. *Imperial Byzantium.* Translated by Eden and Cedar Paul. Boston: Little, Brown and Company, 1938.

Dinkler, Erich. "Zur Geschichte des Kreuzessymbols." *Zeitschrift für Theologie und Kirche* 48 (1951):148–72.

Dobschütz, Ernst von. *Christusbilder: Untersuchungen zur christlichen Legende.* 2 vols. Leipzig: J. C. Hinrichs, 1899.

Doering, Oskar. *Christliche Symbole: Leitfaden durch die Formen- und Ideenwelt der Sinnbilder in der christlichen Kunst.* 2d ed. Freiburg im Breisgau: Herder, 1940.

Dölger, Franz. "Lumen Christi." *Antike und Christentum* 5 (1936):1–43.

Downey, Glanville. "The Builder of the Original Church of the Apostles at Constantinople." *Dumbarton Oaks Papers* 6 (1951):51–80.

Dumeige, Gervais. *Nicée II.* Paris: Editions de l'Orante, 1978.

Dvornik, Francis. *The Photian Schism: History and Legend.* Cambridge: Cambridge University Press, 1948.

——. "The Patriarch Photius and Iconoclasm." *Dumbarton Oaks Papers* 7 (1953):67–97.

——. *The Idea of Apostolicity and the Legend of the Apostle Andrew.* Cambridge, Mass.: Harvard University Press, 1958.

——. *The Slavs in European History and Civilization.* New Brunswick, N.J.: Rutgers University Press, 1962.

——. *Byzantine Missions among the Slavs: SS. Constantine-Cyril and Methodius.* New Brunswick, N.J.: Rutgers University Press, 1970.

Eckardt, Theodor. "Die Dreifaltigkeitsikone Rubljows und die russische Kunstwissenschaft." *Jahrbücher für die Geschichte Oesteuropas,* n.s. 6 (1958):145–76.

Eco, Umberto. *Art and Beauty in the Middle Ages.* Translated by Hugh Bredin. New Haven and London: Yale University Press, 1986.

Elert, Werner. *Der Ausgang der altkirchlichen Christologie: Eine Untersuchung über Theodor von Pharan und seine Zeit als Einführung in die alte Dogmengeschichte.* Edited by Wilhelm Maurer and Elisabeth Bergsträßer. Berlin: Lutherisches Verlagshaus, 1957.

Elliger, Walter. *Die Stellung der alten Christen zu den Bildern in den ersten vier Jahrhunderten (nach den Angaben der zeitgenössischen kirchlichen Schriftsteller).* 2 vols. Leipzig: Dieterich, 1930–34.

——. "Zur bilderfeindlichen Bewegung des achten Jahrhunderts." In *Forschungen zur Kirchengeschichte und zur christlichen Kunst,* 40–60. Leipzig: Dieterich, 1931.

Ensslin, Wilhelm. *Zur Frage nach der ersten Kaiserkrönung durch den Patriarchen und zur Bedeutung dieses Aktes im Wahlzeremoniell.* Würzburg: F. Schöningh, 1948.

Evans, David Beecher. *Leontius of Byzantium: An Origenist Christology.* Washington, D.C.: Dumbarton Oaks, 1970.

Eynde, Damien van den. *Les normes de l'enseignement chrétien dans la littérature patristique des trois premiers siècles.* Paris: Gabalds et Fils, 1933.

Felicetti-Liebenfels, Walter. *Geschichte der byzantinischen Ikonenmalerei von ihren Anfängen bis zum Ausklange.* Olten: Urs-Graf-Verlag, 1956.

Ferrua, Antonio. *Le pitture della nuova catacomba di Via Latina.* Rome: Pontifical Institute of Christian Archaeology, 1960.

Fink, Josef. "Die Anfänge der Christusdarstellung." *Theologische Revue* 51 (1955):241–52.

Flesseman-Van Leer, Ellen. *Tradition and Scripture in the Early Church.* Assen: Van Gorum, 1953.

Florenskij, Pavel. *Sobranie sočinenij* [Collected works]. Paris: YMCA-Press, 1985–.

Florovsky, Georges. *Collected Works.* Belmont, Mass.: Nordland, 1972–.

Forsyth, Ilene H. *The Throne of Wisdom: Wood Sculptures of the Madonna in Romanesque France.* Princeton: Princeton University Press, 1972.

Frye, Northrop. *On Shakespeare.* Edited by Robert Sandler. New Haven and London: Yale University Press, 1986.

Funk, Franz Xaver. "Ein angebliches Wort Basilius des Gr. über die Bilderverehrung." *Theologische Quartalschrift* 70 (1888): 297–98.

Galey, John. *Sinai and the Monastery of St. Catherine.* Introductions by Kurt Weitzmann and George Forsyth. Garden City, N.Y.: Doubleday and Company, 1980.

Gardner, Alice. "Some Theological Aspects of the Iconoclastic Controversy." *Hibbert Journal* 2 (1904):360–74.

Gardthausen, Viktor Emil. *Das alte Monogramm.* Leipzig: K. W. Hiersemann, 1924.

Gasquet, Amédée Louis Ulysse. *De l'autorité impériale en matière religieuse à Byzance.* Paris: E. Thorin, 1879.

Geffcken, J. "Der Bilderstreit des heidnischen Altertums." *Archiv für Religionswissenschaft* 19 (1916–19):286–315.

Geischer, Hans-Jürgen, ed. *Der byzantinische Bilderstreit.* Gütersloh: Gütersloher Verlagshaus, 1968.

Gelzer, Heinrich. "Das Verhältnis von Staat und Kirche in Byzanz." In *Ausgewählte kleine Schriften,* 57–141. Leipzig: B. G. Teubner, 1907.

Gerhard, Heinz Paul [Heinz Skrobucha]. *The World of Icons.* New York: Harper and Row, 1971.

Gerke, Friedrich. "Ideengeschichte der ältesten christlichen Kunst." *Zeitschrift für Kirchengeschichte* 59 (1940):1–102.

———. *Die christlichen Sarkophage der vorkonstantinischen Zeit.* Berlin: Walter de Gruyter, 1940.

———. *Christus in der spätantiken Plastik.* 3d ed. Mainz: F. Kupferberg, 1948.

Gero, Stephen. *Byzantine Iconoclasm during the Reign of Leo III, with Particular Attention to the Oriental Sources.* Louvain: Corpus Scriptorum Christianorum Orientalium, 1973.

———. *Byzantine Iconoclasm during the Reign of Constantine V, with Particular Attention to the Oriental Sources.* Louvain: Corpus Scriptorum Christianorum Orientalium, 1977.

Gibbon, Edward. *The History of the Decline and Fall of the Roman Empire.* Edited by John Bagnell Bury. 7 vols. London: Methuen and Company, 1896–1900.

Goldschmidt, Adolph. *Die byzantinischen Elfenbeinskulpturen des X.–XIII. Jahrhunderts.* 2 vols. Berlin: B. Cassirer, 1930–34.

Goldschmidt, Rudolf Carcl. *Paulinus' Churches at Nola: Texts, Translations and Commentary.* Amsterdam: N. v. Noord-Hollandsche uitgeversmaatschappij, 1940.

Gombrich, Ernst Hans. "*Icones Symbolicae*: Philosophies of Symbolism and their Bearing on Art." In *Symbolic Images: Studies in the Art of the Renaissance,* 123–95. Chicago: University of Chicago Press, 1985.

Gordillo, Mauricius. *Compendium theologiae Orientalis.* 3d ed. Rome: Pontifical Institute of Oriental Studies, 1950.

Gouillard, Jean. "Aux origines de l'iconoclasme: Le témoignage de Grégoire II?" *Travaux et mémoires* 3 (1968):243–307.

———. "Deux figures mal connues du second iconoclasme." *Byzantion* 31 (1961): 371–401.

186

Grabar, André. *L'Empereur dans l'art byzantin : Recherches sur l'art officiel de l'empire d'Orient.* Paris : Les Belles lettres, 1936.

————. *Martyrium : Recherches sur le culte des reliques et l'art chrétien antique.* 2 vols. Paris : Collège de France, 1943–46.

————. "Images de la théophanie et de la majesté du Christ dans les absides antiques et romanes." *Bulletin de la Société Nationale des Antiquaires de France* (1934–44 [1948]) :79–81.

————. "La représentation de l'intelligible dans l'art byzantin du moyen âge." *Actes du VIe Congrès Internationale d'Etudes byzantines* 2 (1951) :127–45.

————. *L'iconoclasme byzantin : Dossier archéologique.* Paris : Collège de France, 1957.

————. *Sculptures byzantines.* Paris : Bibliothèque archéologique et historique, 1963–76.

————. *Christian Iconography : A Study of Its Origins.* Andrew W. Mellon Lectures in the Fine Arts, 1961. Princeton : Princeton University Press, 1968.

Grabar, Igor. *O drevnerusskom iskusstve* [Early Russian art]. Moscow : Nauka, 1966.

Grabar, Oleg. *The Formation of Islamic Art.* 2d ed. New Haven and London : Yale University Press, 1987.

Grillmeier, Aloys. "Der Gottessohn im Totenreich." *Zeitschrift für katholische Theologie* 71 (1949) : 1–53, 184–203.

————. *Der Logos am Kreuz : Zur christologischen Symbolik der älteren Christusdarstellungen.* Munich : Max Hueber Verlag, 1956.

————. *Christ in Christian Tradition from the Apostolic Age to Chalcedon (451).* Translated by J. S. Bowden. New York : Sheed and Ward, 1965.

————, and Bacht, Heinrich, eds. *Das Konzil von Chalkedon : Geschichte und Gegenwart.* 3 vols. Würzburg : Echter-Verlag, 1951–54.

Grondijs, Lodewijk Hermen. *L'iconographie byzantine du crucifié mort sur la croix.* 2d ed. Brussels : Bibliotheca Bruxellensis, 1947.

————. "Images des saints d'après la théologie byzantine du VIIIe siècle." *Actes du VIe Congrès Internationale d'Etudes byzantines* 2 (1951) :145–70.

————. "La mort du Christ et le rit du zéon." *Byzantion* 23 (1953) :251–74.

————. *Autour de l'iconographie byzantine du crucifié mort sur la croix.* Leiden : E. J. Brill, 1960.

Grumel, Venance. "L'iconologie de Saint Théodore Studite." *Echos d'Orient* 20 (1921) : 257–68.

————. "L'iconologie de Saint Germain de Constantinople." *Echos d'Orient* 21 (1922) : 165–75.

————. "Recherches récentes sur l'iconoclasme." *Echos d'Orient* 29 (1930) : 92–100.

————. "La politique religieuse du patriarche Saint Méthode. Iconoclastes et Studites." *Echos d'Orient* 34 (1935) : 385–401.

Guénon, René. *The Symbolism of the Cross.* Translated by Angus Macnab. London : Luzac, 1958.

Gwatkin, Henry Melville. *Studies of Arianism.* Cambridge : D. Bell and Company, 1882.

Hackel, Alfred. *Die Trinität in der Kunst.* Berlin : Reuther und Reichard, 1931.

Harnack, Adolf von. [*Grundriß der*] *Dogmengeschichte.* 4th ed. Tübingen : J. C. B. Mohr (Paul Siebeck), 1905.

————. *Lehrbuch der Dogmengeschichte.* 5th ed. 3 vols. Tübingen : J. C. B. Mohr (Paul Siebeck), 1931.

Haugaard, William P. "Arius : Twice a Heretic ? Arius and the Human Soul of Jesus Christ." *Church History* 29 (1960) :251–63.

Hefele, Carl Joseph. *Conciliengeschichte.* 4 vols. Freiburg im Breisgau : Herder'sche Verlagsbuchhandlung, 1855–60.

Heisenberg, Augustus. *Grabeskirche und Apostelkirche : Zwei Basiliken Konstantins.* 2 vols. Leipzig : J. C. Hinrichs, 1908.

Hennecke, Edgar. *Altchristliche Malerei und altchristliche Literatur : Eine Untersuchung über den biblischen Cyklus der Gemälde in den römischen Katakomben.* Leipzig : Veit, 1896.

Hennephof, Herman, ed. *Textus byzantini ad iconomachiam pertinentes.* Leiden : E. J. Brill, 1969.

Henry, Patrick. "Theodore of Studios : Byzantine Churchman." Ph.D. diss., Yale University, 1967.

————. "The Formulators of Icon Doctrine." In *Schools of Thought in the Christian Tradition*, edited by Patrick Henry, 75–89. Philadelphia : Fortress Press, 1984.

Henze, Clément. *Lukas, der Muttergottesmaler : Ein Beitrag zur Kenntnis des christlichen Orients.* Louvain : Bibliotheca Alfonsiana, 1948.

Hesbert, René-Jean. *Le problème de la transfixion du Christ dans les traditions biblique, patristique,*

iconographique, liturgique et musicale. Paris, Tournai, and Rome: Société de Saint Jean Evangéliste, Descles et Compagnie, 1940.

Hoeck, Johannes M. "Stand und Aufgaben der Damaskenos-Forschung." *Orientalia Christiana Periodica* 17 (1951):5–60.

Holl, Karl. *Enthusiasmus und Bußgewalt beim griechischen Mönchtum.* Leipzig: J. C. Hinrichs, 1898.

―――. *Der Osten.* Vol. 2 of *Gesammelte Aufsätze zur Kirchengeschichte.* Tübingen: J. C. B. Mohr (Paul Siebeck), 1928.

Huhn, Joseph. *Das Geheimnis der Jungfrau–Mutter Maria nach dem Kirchenvater Ambrosius.* Würzburg: Echter Verlag, 1954.

Hussey, Joan Mervyn. *Church and Learning in the Byzantine Empire, 867–1185.* Oxford: Oxford University Press, 1937.

―――, ed. *The Byzantine Empire.* Vol. 4 of *The Cambridge Medieval History.* 2d ed. 2 parts. Cambridge: Cambridge University Press, 1966–67.

―――. *The Orthodox Church in the Byzantine Empire.* Oxford: Clarendon Press, 1986.

Ilarion, Metropolitan. *Ikonoborstvo: Istoryčno–dohmatyčna monohrafija* [Iconoclasm: a historical-dogmatic monograph]. Winnipeg: Ukrainian Greek Orthodox Church in Canada, 1954.

Ivánka, Endre von. *Hellenisches und Christliches im frühbyzantinischen Geistesleben.* Vienna: Herder, 1948.

―――. *Plato Christianus: Übernahme und Umgestaltung des Platonismus durch die Väter.* Einsiedeln: Johannes, 1964.

Jaeger, Werner. *Paideia: The Ideals of Greek Culture.* Translated by Gilbert Highet. 3 vols. New York: Oxford University Press, 1939–44.

―――. *The Theology of the Early Greek Philosophers.* Oxford: Clarendon Press, 1947.

Jeremias, Joachim. *The Eucharistic Words of Jesus.* Translated by Arnold Ehrhardt. Oxford: Basil Blackwell, 1955.

Jerphanion, Guillaume de. "L'image de Jésus-Christ dans l'art chrétien." *Nouvelle revue théologique* 65 (1938): 257–83.

Jones, Arnold Hugh Martin. *Were Ancient Heresies Disguised Social Movements?* Philadelphia: Fortress Press, 1966.

Jugie, Martin. *La mort et l'assomption de la Sainte Vierge: Etude historico-doctrinale.* Vatican City: Studi e Testi, 1944.

Kelly, John Norman Davidson. *Early Christian Creeds.* London: Longmans, Green and Company, 1950.

Kempf, Theodor Konrad. *Christus der Hirt: Ursprung und Deutung einer altchristlichen Symbolgestalt.* Rome: Officium Libri Catholici, 1942.

Kennedy, George A. *Greek Rhetoric under Christian Emperors.* Princeton: Princeton University Press, 1983.

Kitzinger, Ernst. "The Cult of Images before Iconoclasm." *Dumbarton Oak Papers* 7 (1954):85–150.

―――. "On Some Icons of the Seventh Century." In *Late Classical and Mediaeval Studies in Honor of Albert Matthias Friend, Jr.,* edited by Kurt Weitzmann, 132–50. Princeton: Princeton University Press, 1955.

―――. "Byzantine Art in the Period between Justinian and Iconoclasm." *Berichte zum XI. Internationalen Byzantinisten-Kongress* (1958):1–50.

Koch, Hugo. *Die altchristliche Bilderfrage nach den literarischen Quellen.* Göttingen: Vandenhoeck und Ruprecht, 1917.

Koch, Lucas. "Zur Theologie der Christus-Ikone." *Benediktinische Monatschrift zur Pflege religiösen und geistlichen Lebens* 19 (1937):375–87; 20 (1938):32–47, 281–88, 437–52.

―――. "Christusbild—Kaiserbild. Zugleich ein Beitrag zur Lösung der Frage nach dem Anteil der byzantinischen Kaiser am griechischen Bilderstreit." *Benediktinische Monatschrift zur Pflege religiösen und geistlichen Lebens* 21 (1939):85–105.

Kollwitz, Johannes. "Das Bild von Christus dem König in Kunst und Liturgie der christlichen Frühzeit." *Theologie und Glaube* 37–38 (1947–48):95–117.

―――. *Das Christusbild des dritten Jahrhunderts.* Münster in Westfalen: Orbis antiquus, 1953.

―――. "Zur Frühgeschichte der Bilderverehrung." *Römische Quartalschrift* 48 (1953):1–20.

Kostof, Spiro K. *The Orthodox Baptistery of Ravenna*. New Haven and London: Yale University Press, 1965.

Kötting, Bernhard. *Peregrinatio religiosa: Wallfahrten in der Antike und das Pilgerwesen in der alten Kirche*. 2d ed. Münster in Westfalen: Antiquariat Th. Stenderhoff, 1950.

Kozelka, L. "Die Behandlung der Passion Christi in der darstellenden und bildenden Kunst der ersten christlichen Jahrhunderte bis zur karolingischen Renaissance." *Römische Quartalschrift* 31 (1923):125–38.

Kraeling, Carl H. *The Synagogue*. 2d ed. Introduction by Jaroslav Pelikan. New York: Ktav Publishing House, 1979.

Kraft, Heinrich. "Kaiser Konstantin und das Bischofsamt." *Saeculum* 8 (1957):32–42.

Krücke, Adolf. *Der Nimbus und verwandte Attribute in der frühchristlichen Kunst*. Strasbourg: Universitäts-Buchdruckerei von J. H. E. Heitz, 1905.

Krumbacher, Karl. *Geschichte der byzantinischen Litteratur von Justinian bis zum Ende des oströmischen Reiches (527–1453)*. 2d ed. Edited by Albert Ehrhard and Heinrich Gelzer. Munich: C. H. Beck'sche Verlagsbuchhandlung, 1897.

Ladner, Gerhart B. "Der Bilderstreit und die Kunst-Lehren der byzantinischen und abendländischen Theologie." *Zeitschrift für Kirchengeschichte* 50 (1931):1–23.

———. "Origin and Significance of the Byzantine Iconoclastic Controversy." *Mediaeval Studies* 2 (1940):127–49.

———. "The Concept of the Image in the Greek Fathers and the Byzantine Iconoclastic Controversy." *Dumbarton Oaks Papers* 7 (1953):1–34.

———. "St. Gregory of Nyssa and St. Augustine on the Symbolism of the Cross." In *Late Classical and Mediaeval Studies in Honor of Albert Matthias Friend, Jr.*, edited by Kurt Weitzmann, 88–95. Princeton: Princeton University Press, 1955.

Landgraf, Artur Michael. *Dogmengeschichte der Frühscholastik*. 4 vols. Regensburg: Friedrich Pustet, 1952–56.

Lange, Günter. *Bild und Wort: Die katechetische Funktion des Bildes in der griechischen Theologie des 6. bis 9. Jahrhunderts*. Würzburg: Echter Verlag, 1969.

Lasareff, Victor, ed. *Russian Icons from the Twelfth to the Fifteenth Century*. New York: Mentor-UNESCO Books, 1962.

Laurdas, B. "Ho Arethas peri eikonomachias" [Arethas of Caesarea on Iconoclasm]. *Theologia* 25 (1954):614–22.

Laurent, Vitalien. "L'idée de guerre sainte et la tradition byzantine." *Revue historique du sud-est européen* 23 (1946):71–98.

Legrand, Emile. "Description des oeuvres d'art et de l'église de Saints Apôtres de Constantinople. Poème en vers iambiques par Constantin le Rhodien." *Revue des études grecques* 9 (1896):32–65.

Lipšic, E. E. *Očerki istorii vizantijskogo obščestva i kul'tury, VIII—pervaja polovina IX veka* [Studies in the history of Byzantine society and culture from the eighth to the first half of the ninth century]. Moscow and Leningrad: Akademija Nauk, 1961.

Loerke, William. "Observations on the Representation of *Doxa* in the Mosaics of S. Maria Maggiore, Rome, and St. Catherine's, Sinai." *Gesta* 20 (1981):15–22.

———. "'Real Presence' in Early Christian Art." In *Monasticism and the Arts*, edited by Timothy George Verdon, 29–51. Syracuse: Syracuse University Press, 1984.

Lossky, Vladimir. *In the Image and Likeness of God*. Edited by John H. Erickson and Thomas E. Bird; introduction by John Meyendorff. Crestwood, N.Y.: St. Vladimir's Seminary Press, 1974.

Lother, Helmut. *Realismus und Symbolismus in der altchristlichen Kunst*. Tübingen: J. C. B. Mohr (Paul Siebeck), 1931.

Lovejoy, Arthur O. *The Great Chain of Being: A Study of the History of an Idea*. Cambridge, Mass.: Harvard University Press, 1936.

———. *Essays in the History of Ideas*. New York: George Brazilier, Inc., 1955.

Lowry, Glenn D. "Introduction to Islamic Calligraphy." In *From Concept to Context: Approaches to Asian and Islamic Calligraphy*, by Shen Fu, Glenn D. Lowry, and Anne Yonemura, 102–09. Washington, D.C.: Freer Gallery of Art, Smithsonian Institution, 1986.

Mango, Cyril. *Materials for the Study of the Mosaics of St. Sophia at Istanbul*. Washington, D.C.: Dumbarton Oaks, 1962.

Mango, Cyril. *Byzantine Architecture*. New York: Rizzoli International Publications, 1985.

Mango, Marlia Mundell. *Silver from Early Byzantium: The Kaper Koraon and Related Treasures.* Baltimore: Walters Art Gallery, 1986.

Martin, Edward James. *A History of the Iconoclastic Controversy.* New York: Macmillan Company, 1930.

Mathew, Gervase. *Byzantine Aesthetics.* New York: Viking Press, 1964.

Mearns, James. *The Canticles of the Christian Church Eastern and Western in Early and Medieval Times.* Cambridge: Cambridge University Press, 1914.

Meer, Frederik van der. *Maiestas Domini. Théophanies de l'Apocalypse dans l'art chrétien.* Rome: Pontifical Institute of Christian Archaeology, 1938.

Mendelsohn, Henriette. *Die Engel in der bildenden Kunst.* Berlin: B. Behr, 1907.

Menges, Hieronymus. *Die Bilderlehre des hl. Johannes von Damaskus.* Kallmünz: M. Lassleben, 1937.

Meyendorff, John. *Christ in Eastern Christian Thought.* Washington, D.C.: Corpus Books, 1969.

————. *Byzantine Theology: Historical Trends and Doctrinal Themes.* New York: Fordham University Press, 1974.

————. "Byzantium as Center of Theological Thought in the Christian East." In *Schools of Thought in the Christian Tradition,* edited by Patrick Henry, 65–74. Philadelphia: Fortress Press, 1984.

Michelis, Panayotis A. *Aisthetikos: Essays in Art, Architecture and Aesthetics.* Detroit: Wayne State University Press, 1977.

Millet, Gabriel. "Les iconoclastes et la croix." *Bulletin de Correspondence Hellénique* 34 (1910):96–109.

————. *Recherches sur l'iconographie de l'Evangile aux XIVe, XVe et XVIe siècles.* Reprint ed. Paris: E. De Boccard, 1960.

Morey, Charles Rufus. *Early Christian Art: An Outline of the Evolution of the Style and Iconography in Sculpture and Painting from Antiquity to the Eighth Century.* 2d ed. Princeton: Princeton University Press, 1953.

Nabokov, Vladimir. *Lectures on Russian Literature.* Edited by Fredson Bowers. New York: Harcourt Brace Jovanovich, 1981.

Nersessian, Sirarpie der. "Une apologie des images du septième siècle." *Byzantion* 17 (1944/45):58–87.

————. "Image Worship in Armenia and Its Opponents." *Armenian Quarterly* 1 (1946):67–81.

Newman, John Henry. *An Essay on the Development of Christian Doctrine.* Edited by Charles Frederick Harrold; appendix on Newman's textual changes by Ottis Ivan Schreiber. New York and London: Longmans, Green and Company, 1949.

Nilles, Nicolaus. *Kalendarium manuale utriusque ecclesiae orientalis et occidentalis.* 2 vols. 2d ed. Innsbruck: F. Rauch (K. Pustet), 1896–97.

Nygren, Anders. *Agape and Eros.* Translated by Philip S. Watson. Philadelphia: Westminster Press, 1953.

O'Connor, Edward Dennis, ed. *The Dogma of the Immaculate Conception: History and Significance.* Notre Dame, Ind.: University of Notre Dame Press, 1958.

Oman, Charles William Chadwick. *The Art of War in the Middle Ages.* Ithaca: Cornell University Press, 1953.

O'Meara, Dominic J., ed. *Neoplatonism and Christian Thought.* Albany, N.Y.: State University of New York Press, 1982.

Onasch, Konrad. "Mythos und Wirklichkeit: Zur theologischen Methode der Sinndeutung orthodoxer Ikonendenkmäler." *Evangelische Theologie* 13 (1953):224–37.

Orwell, George. *1984.* New York: Harcourt, Brace and World, 1949.

Ostrogorsky, George. "Soedinenie voprosa o sv. ikonach s christologičeskoj dogmatikoj v sočinenijach pravoslavnych apologetov rannjago perioda ikonoborčestva" [The combination of the question of the holy icons with christological dogmatics in the works of the Eastern Orthodox apologists of the early period of Iconoclasm]. *Seminarium Kondakovianum* 1 (1927):35–48.

————. *Studien zur Geschichte des byzantinischen Bilderstreites.* Breslau: M. & M. Marcus, 1929.

————. "Über die vermeintliche Reformtätigkeit der Isaurier." *Byzantinische Zeitschrift* 30 (1929–30):394–400.

————. *History of the Byzantine State.* Translated by Joan Hussey. 3d ed. New Brunswick, N.J.: Rutgers University Press, 1969.

Otis, Brooks. "Cappadocian Thought as a Coherent System." *Dumbarton Oaks Papers* 12 (1958):95–124.

Ouspensky, Leonide, and Lossky, Vladimir. *The Meaning of Icons.* Translated by G. E. Palmer and E. Kadloubovsky. Rev. ed. Crestwood, N.Y.: St. Vladimir's Seminary Press, 1982.

Outler, Albert C. "The Sense of Tradition in the Ante–Nicene Church." In *The Heritage of Christian Thought: Essays in Honor of Robert Lowry Calhoun,* edited by Robert E. Cushman and Egil Grislis, 8–30. New York: Harper and Brothers, 1965.

Pelikan, Jaroslav. *The Light of the World: A Basic Image in Early Christian Thought.* New York: Harper and Brothers, 1962.

———. *The Christian Tradition: A History of the Development of Doctrine.* 5 vols. Chicago: University of Chicago Press, 1971–89.

———. *Jesus Through the Centuries: His Place in the History of Culture.* New Haven and London: Yale University Press, 1985.

———. "Mary—Exemplar of the Development of Christian Doctrine." In *Mary: Images of the Mother of Jesus in Jewish and Christian Perspective,* 79–91. Philadelphia: Fortress Press, 1986.

Peterson, Erik. "Christus als Imperator." In *Theologische Traktate,* 149–64. Munich: Kösel-Verlag, 1951.

———. *The Angels and the Liturgy.* Translated by Ronald Walls. New York: Herder and Herder, 1964.

Popova, Olga. *Russian Illuminated Manuscripts.* Translated by Kathleen Cook, Vladimir Ivanov, and Lenina Sorokina. New York: Thames and Hudson, 1984.

Prestige, George Leonard. *Fathers and Heretics: Six Studies in Dogmatic Faith with Prologue and Epilogue.* London: S.P.C.K., 1948.

———. *God in Patristic Thought.* London, S.P.C.K., 1956.

Quasten, Johannes. "The Painting of the Good Shepherd at Dura-Europos." *Mediaeval Studies* 9 (1947):1–18.

———. *Patrology.* 4 vols. Westminster, Md.: Newman Press and Christian Classics, 1951–86.

Réau, Louis. *L'iconographie de l'art chrétien.* 3 vols. Paris: Presses Universitaires de France, 1955–59.

Reil, Johannes. *Die frühchristlichen Darstellungen der Kreuzigung Christi.* Leipzig: Dieterich, 1904.

Rice, David Talbot. *Russian Icons.* London and New York: King Penguin Books, 1947.

———. *Art of the Byzantine Era.* New York: Frederick A. Praeger, 1963.

Richter, Jean Paul, ed. *Quellen der byzantinischen Kunstgeschichte.* Vienna: C. Graeser, 1897.

Robb, David Metheny. "The Iconography of the Annunciation in the 14th and 15th Century." *Art Bulletin* 18 (1936):480–526.

Rothemund, Herbert J. *Ikonenkunst: Ein Handbuch.* Munich: Slavisches Institut, 1954.

Runciman, Steven. "Some Remarks on the Image of Edessa." *Cambridge Historical Journal* 3 (1929–31):238–52.

———. *The Eastern Schism: A Study of the Papacy and the Eastern Churches during the XIth and XIIth Centuries.* Oxford: Clarendon Press, 1965.

Savramis, Demosthenes. "Der abergläubische Mißbrauch der Bilder in Byzanz." *Ostkirchliche Studien* 9 (1960):174–92.

Schoemann, Johann Baptist. "'Eikon' in den Schriften des hl. Athanasius." *Scholastik* 16 (1941): 335–50.

———. "Gregors von Nyssa Anthropologie als Bildtheologie." *Scholastik* 18 (1943):31–53.

Schönborn, Christoph von. *Sophrone de Jérusalem: Vie monastique et confession dogmatique.* Paris: Beauchesne, 1972.

———. *L'icône du Christ: Fondements théologiques élaborés entre le Ier et le IIe Concile de Nicée (325–787).* 2d ed. Fribourg: Editions Universitaires, 1976.

Schrade, Hubert. *Der verborgene Gott: Gottesbild und Gottesvorstellung in Israel und im Alten Orient.* Stuttgart: W. Kohlhammer, 1949.

Schwarzlose, Karl. *Der Bilderstreit: Ein Kampf der griechischen Kirche um ihre Eigenart und um ihre Freiheit.* Gotha: F. A. Perthes, 1890.

Ševčenko, Ihor. *Society and Intellectual Life in Late Byzantium.* London: Variorum Reprints, 1981.

———. *Ideology, Letters and Culture in the Byzantine World.* London: Variorum Reprints, 1982.

Ševčenko, Nancy Patterson. *The Life of Saint Nicholas in Byzantine Art*. Turin: Bottega d'Erasmo, 1983.

Shepherd, Dorothy G. "An Icon of the Virgin: A Sixth-Century Tapestry Panel from Egypt." *Bulletin of the Cleveland Museum of Art* 56 (March 1969):90–120.

Sherrard, Philip. *The Greek East and the Latin West: A Study in the Christian Tradition*. London: Oxford University Press, 1959.

———. *Athos: The Mountain of Silence*. London: Oxford University Press, 1960.

Speck, Paul. *Kaiser Konstantin VI: Die Legitimation einer fremden und der Versuch einer eigenen Herrschaft*. Munich: Wilhelm Fink, 1978.

Stange, Alfred. *Das frühchristliche Kirchengebäude als Bild des Himmels*. Cologne: Comel, 1950.

Stein, Dietrich. *Der Beginn des byzantinischen Bilderstreites und seine Entwicklung bis in die 40er Jahre des 8. Jahrhunderts*. Munich: Institut für Byzantinistik und Neugriechische Philologie, 1980.

Stephanou, P. "La doctrine de Léon de Chalcédoine et de ses adversaires sur les images." *Orientalia Christiana Periodica* 12 (1946):177–99.

Stommel, Eduard. "Die bischöfliche Kathedra im christlichen Altertum." *Münchener Theologische Zeitschrift* 3 (1952):17–32.

———. "*Sēmeion ekpetaseōs* (Didache 16,6)." *Römische Quartalschrift* 48 (1953):21–42.

Stubblebine, James H. "Two Byzantine Madonnas from Calahorra, Spain." *Art Bulletin* 48 (1966):379–81.

Stuhlfauth, Georg. *Die Engel in der altchristlichen Kunst*. Freiburg im Breisgau: J. C. B. Mohr, 1897.

Sulzberger, M. "Le symbole de la croix." *Byzantion* 2 (1925):337–448.

Thoby, Paul. *Histoire du crucifix des origines au concile de Trente*. Nantes: Bellanger, 1959.

Thunberg, Lars. *Microcosm and Mediator: The Theological Anthropology of Maximus the Confessor*. Lund: C. W. K. Gleerup, 1965.

Treadgold, Warren. *The Byzantine Revival, 780–842*. Stanford: Stanford University Press, 1988.

Troeltsch, Ernst. *The Social Teachings of the Christian Churches*. Translated by Olive Wyon; introduction by H. Richard Niebuhr. Reprint ed. 2 vols. New York: Harper Torchbooks, 1960.

Unger, Friedrich Wilhelm, ed. *Quellen der byzantinischen Kunstgeschichte*. Vienna: W. Braumüller, 1878.

Uspenskij, K. N. "Očerki po istorii ikonoborčeskogo dviženija v vizantijskoj imperii v VIII–IX vv.: Feofan i ego chronografija" [Studies in the history of the Iconoclast movement in the Byzantine Empire in the eighth and ninth centuries: Theophanes and his chronicle]. *Vizantijskij Vremennik* 3 (1950):393–438; 4 (1951):211–62.

Vasiliev, Alexander Alexandrovich. *History of the Byzantine Empire, 324–1453*. 2 vols. 2d ed. Madison: University of Wisconsin Press, 1958.

Visser, Anne Jippe. *Nikephoros und der Bilderstreit: Eine Untersuchung über die Stellung des Konstantinopeler Patriarchen Nikephoros innerhalb der ikonoklastischen Wirren*. The Hague: M. Nijhoff, 1952.

Walter, Christopher. "Two Notes on the Deesis." *Revue des études byzantines* 26 (1968):326–36.

Ware, Timothy [Kallistos]. *The Orthodox Church*. Rev. ed. Harmondsworth: Penguin Books, 1969.

Weitzmann, Kurt. *Illustrated Manuscripts at St. Catherine's Monastery on Mount Sinai*. Collegeville, Minn.: St. John's University Press, 1973.

———. *The Icon: Holy Images—Sixth to Fourteenth Century*. New York: George Braziller, 1978.

———, et al. *The Icon*. New York: Alfred A. Knopf, 1982.

Wellen, G. A. *Theotokos: Eine ikonographische Abhandlung über das Gottesmutterbild in frühchristlicher Zeit*. Utrecht: Academisch proefschrift Nijmegen, 1960.

Wendt, C. H. "Bilderlehre und Ikonenverehrung." *Zeitschrift für Religion und Geistesgeschichte* 2 (1949–50):23–33.

Wenger, Antoine. *L'Assomption de la très sainte Vierge dans la tradition byzantine du VIe au Xe siècle*. Paris: Institut Français d'Etudes Byzantines, 1955.

Wessel, K. "Christus Rex, Kaiserkult und Christusbild." *Jahrbücher des Deutschen Archäologischen Instituts Berlin* 68 (1953):118–36.

Whittemore, Thomas. *The Mosaics of St. Sophia at Istanbul*. Oxford: Oxford University Press, 1933.

Wiegand, Friedrich Ludwig Leonhard. *Der Erzengel Michael unter Berücksichtigung der byzantinischen, altitalischen und romanischen Kunst ikonographisch dargestellt*. Stuttgart: Inaugural-Dissertation Leipzig, 1886.

Will, Robert. "Le symbolisme de l'image du Christ : Essai d'iconographie chrétienne." *Revue d'histoire et de philosophie religieuse* 16 (1936) :400–28.

Wimsatt, William K., Jr. *The Verbal Icon : Studies in the Meaning of Poetry.* New York : Noonday Press, 1966.

Wunderle, Georg. *Um die Seele der heiligen Ikonen : Eine religionspsychologische Betrachtung.* 3d ed. Würzburg : Augustinus-Verlag, 1947.

Wuttke, Gottfried. *Melchisedech der Priesterkönig von Salem : Eine Studie zur Geschichte der Exegese.* Giessen : Beihefte zur *Zeitschrift für die neutestamentliche Wissenschaft und die Kunde des Urchristentums,* 1927.

Ziegler, Adolf Wilhelm. "Die byzantinische Religionspolitik und der sogenannte Cäsaropapismus." In *Münchener Beiträge zur Slavenkunde : Festgabe für Paul Diels,* edited by Erwin Koschmieder and Alois Schmaus, 81–97. Munich : Isar Verlag, 1953.

Index

(Because they appear so frequently throughout the book, the names of Jesus Christ and the Virgin Mary, as well as those of Rome and Constantinople/Byzantium, have not been indexed separately, although they do, of course, appear in other entries.)